Picasso
Rewriting
Picasso

Acknowledgements

Picasso Rewriting Picasso has been produced with the help of grants from the British Academy and The Elephant Trust. Claude Picasso's assistance was essential, too, and the book could not have been published in its present form without it.

Picasso Rewriting Picasso has had many silent collaborators over a number of years. Sarah Wilson kept faith with the project as it developed and followed the progress of the book through successive drafts. I am grateful for her academic and practical advice and her help in identifying the right publisher. My thanks goes, too, to Christopher Green, who gave the project his support and encouragement, and to George and Maria Embiricos, for the considerable role they played in making the book a reality. The Picasso Museum, Paris and the Courtauld Institute of Art greatly facilitated my research, and I benefitted from the co-operation of the Réunion des Musées Nationaux. The artist Jean-Jacques Lebel was very generous with his archive material. Antony Penrose supported the project through the Elephant Trust and with his kind permission to quote extensively from Roland Penrose's translations of Picasso's plays and his biography of the artist.

An important aspect of this book on Picasso's writing and art, a challenging subject for any publisher, involves the production and design. Black Dog Publishing have not shied away from the difficult material that Picasso's writings present. The ethos of Black Dog Publishing, motivated by Duncan McCorquodale, is very rare in the commercial world, and I very much appreciate their taking on this project and giving the book its visually stimulating form. A special mention, therefore, for Adrian Sharman and the creativity of his design that reflects the ideas of the book. I am particularly grateful to Catherine Grant, who worked with me in developing the book and taking the project to completion. The picture researchers Teresa Castro, Vicky Fox and Oriana Fox, who helped to source the images for the book and, in the case of Oriana Fox, who gave editorial assistance as well, all made a significant contribution.

Finally, I would like to express a special thanks to Spiro and Dorothy Latsis and Earleen Brunner. Without their support there would be no *Picasso Rewriting Picasso*.

Picasso
Rewriting
Picasso

Kathleen Brunner

Black Dog Publishing

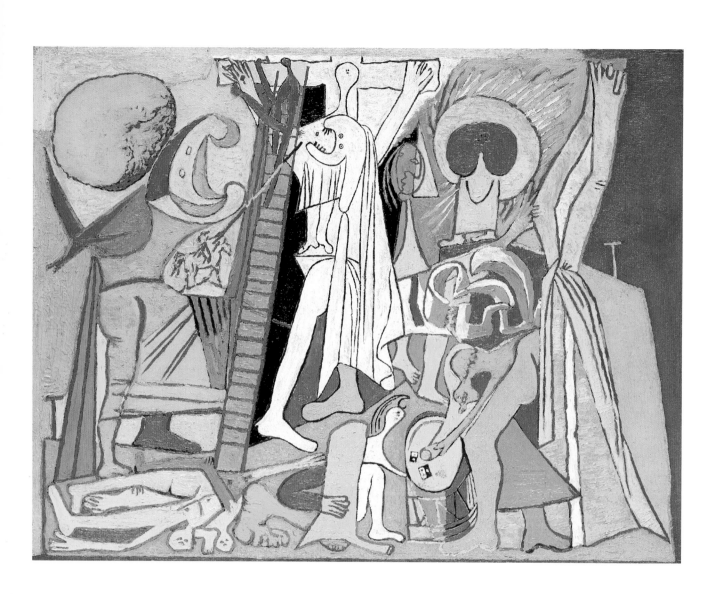

Introduction

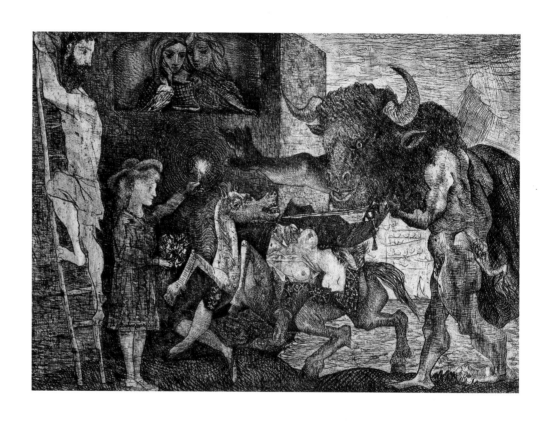

Minotauromachia,

March-April 1935,

Musée Picasso, Paris

If Picasso is remembered for one thing, he is remembered as the modernist artist most closely allied to the image. What, then, explains Picasso's turn from the visual in 1935 to express himself almost exclusively in writing? Picasso's dense body of writings— three plays and some 340 texts, only a quarter of which were published during the artist's lifetime—tells the story of his struggle with the image.[1] The *Minotauromachia*, the etching Picasso completed three days before starting work on his first text, *Boisgeloup 18 avril XXXV*, remains a record of this struggle. His struggle with the image is both personal and artistic, but it also has a metaphysical dimension related to the "rotten sun", a blinding sun. The rotten sun serves as a motivating force which unlocks the cultural and philosophical formation of the Spaniard Picasso, encouraging him to violate language and degrade the image, divorced from a support. Yet he chooses to disguise the seriousness of his project behind the mask of the burlesque. We come to realise that for Picasso writing is not simply a new approach to art but rather a means of overturning the system of classical representation. The process is ongoing and repetitive.

The rupture in Picasso's art opens up a new creative dimension for the artist, as he begins to examine the processes that underlie the work of art. The violence and eroticism recorded in Picasso's texts reveal the private life of the mind behind the work. Picasso, the most philosophical of modern artists, interrogates, in the manner of a diary, the coming-to-be of the work as well as the void of artistic identity. Suppressing his ego for the sake of philosophical inquiry, Picasso, known as an autobiographer, disappears from his work without eradicating the indices of the artist's diary, the date, hour and place of writing and his activities of the moment. Picasso's thought is worked out 'live' through graphic means, without becoming trapped in the prison of form. Paradoxically, there is more at stake in the creative process than the end result, the work of art.

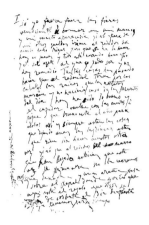 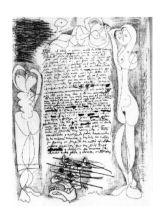

Picasso Rewriting Picasso illustrates the power of Picasso's writing and its intellectual equivalence to his art. The book is an analysis of Picasso's writings in several modes: the abject, existence, structure and the phantom. First, Picasso's repudiation of the image, an image that is seen, is set within the context of the epistemological avant-garde and the new philosophical thinking of the 1930s. Picasso alludes to the allegory of melancholia, and thus to metaphysics, as well as to his personal and artistic life, in the *Minotauromachia*, March-April 1935. Picasso chooses a traditional style in which to cast his modern preoccupations. We look for a similar attitude to Picasso's in the writings of other avant-garde thinkers and find striking parallels in the work of Martin Heidegger, Jean-Paul Sartre, Georges Bataille and Antonin Artaud, all of whom deal with a fundamental change in man's relationship with the world.

After setting the 'metaphysical' scene, the book explores the concept of the "rotten sun", a metaphor for the abject taken from Georges Bataille's essay "Rotten Sun" ("Soleil pourri"), 1930. What is the origin of the concept that imbues the Platonic sun with modern metaphysical and aesthetic concerns? Picasso first portrayed the rotten sun, or rather its effect, in a lurid painting, *The Crucifixion*, 7 February 1930, the tremendous impact of which is disproportionate to its small size.[2] The work has been considered blasphemous for its parodic depiction of Christ's suffering, surrealist imagery and sexual perversion. Picasso saturates the work with acidic orange and yellow to imply the dislocating effect of the sun on all the senses, as well

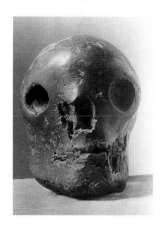

as physical rending. *The Crucifixion*, a barbaric, primitive act of sacrifice as Picasso depicts it, calls up a vision of monsters. *The Crucifixion* depicts an extreme situation, a level of erotic intensity that Picasso attains once again, and perhaps only, *Guernica* apart, in writing.

It was Georges Bataille, however, who employed the image in a philosophical 'system' of the abject and its dark erotic force. Picasso creates *The Crucifixion* in February 1930, and Bataille publishes his essay on the rotten sun in April that year. Picasso expresses, perhaps intuitively, what the young dissident thinker puts in concrete terms. Bataille makes no mention of *The Crucifixion* in his essay, and the painting, which always remained with the artist, only became known publicly in 1932, when Picasso exhibited it in his first retrospective at the Georges Petit Gallery in Paris. Picasso elaborated the idea of the rotten sun when he began to write in 1935, and variations on the phrase "soleil pourri" formed part of his poetic vocabulary.

Picasso's writings of the 1930s and early 1940s are infiltrated by the rotten sun and the abject, but this is only one, though a very important, aspect of Picasso's writings. For he uses writing to work his way through the abject and come to terms with it. The writings also complement his artistic endeavours in painting, sculpture, etching and ceramics. For example, Picasso refers to a "death's head" ("tête de mort") within the context of the 'philosophy of existence' that underpins his play *Desire Caught by the Tail*, 1941, and subsequently creates the actual object, *Death's Head*, cast in

Death's Head (*Tête de mort*), 1943, sculpture photographed by Brassaï, Musée Picasso, Paris

Desire Caught By the Tail, Portrait of the Author (*Le désir attrapé par la queue*, *Portrait de l'auteur*), 1941, private collection

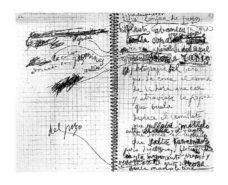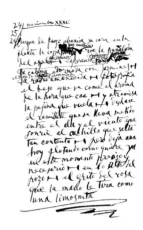

bronze and copper, 1943. Etching and ceramics, his most important media of the late 1940s, are instrumental in demonstrating the arising of consciousness and the creating of form in *The Four Little Girls,* 1947-1948. Perhaps the most important collaboration between text and image occurs in the writings of 1935-1937 and *Guernica*, the centrepiece of *Picasso Rewriting Picasso*. It might be fruitful to read *Picasso Rewriting Picasso* from the middle of the book, working backwards or forwards according to the reader's predilection.

Four texts or suites of texts—*Boisgeloup 18 avril XXXV;* the "lengua de fuego" ("tongue" or "flame of fire") suite comprising "24-28 noviembre, 5, 6, 24 diciembre XXXV"; "20 janvier XXXVI", from the suite "6 janvier-2 février XXXVI", and the suite "25 janvier-25 février XXXVII"—trace the trajectory of the rotten sun from 1935 to 1937. The texts display radically different approaches to artistic creation—the poetic, the philosophical, the ethical and political—once conventional visuality is deposed.

The texts prepare the way for the painting of *Guernica,* 1 May-4 June 1937. The trauma of the bombing of Guernica and the death of civilians unleashes the images related to his artistic struggle—the rotten sun (the mural's electric light), the bull-horse combat and the act of sacrifice. The effect of the bombing of Guernica is reiterated in the *Dream and Lie of Franco* text ("15-18 June 1937")—written after the mural was painted.

Images of abjection and the rotten sun remain with Picasso during the Second World War. In the texts in his *Royan Notebook* (*Carnet Royan*), December 1939-August 1940, and his *Parchment Notebook* (*Carnet parchemin*), Paris, 7 November 1940, the abject takes on cosmic proportions. During his stay in Royan Picasso painted sheep's skulls and female portraits, but from mid August 1940 to January 1941 he produced no works of art. So it is with great interest that we examine two Spanish texts dated 2 August 1940 and 7 November 1940, which form the background to his return to Paris and his Grands-Augustins studio. In hyperbolic baroque language Picasso speaks of the destruction of the classical universe and the degradation of the body, which impacts on the visual and on the artist himself.

The two French plays and long multi-voiced text in Spanish that complete *Picasso Rewriting Picasso* amount to three great statements by Picasso, written because he had something to say on the discourse of art at three particular moments: 1941, 1947-1948 and 1957-1959. Up to this point the rotten sun and the abject have figured prominently in Picasso's writings and account for the disappearance of the image in his art. But as early as January 1941, just after the New Year, during the darkest days of the Second World War, Picasso comes to an accommodation with the abject in a moment of catharsis. His humorous play *Desire Caught by the Tail*, 14-17 January 1941,

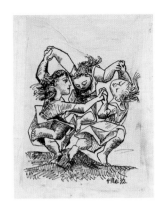

set among a bohemian group of Parisians, treats the theme of the abject and its negative effect on the artist's sexuality and creativity in a parody of Plato's *Symposium*. From January 1941 Picasso ends his artistic hiatus with a new phase of sculpture, in which he produces *Death's Head*, *Man with the Sheep*, 1943, as well as numerous drawings for *L'Aubade*, 1942, one of his most important wartime paintings.

In 1947 Picasso, now a high-profile member of the French Communist Party and a peace campaigner, addresses another intellectual shift from abjection to 'structure' in *The Four Little Girls*, an allegory of war and peace. (Four little girls appear in the *War and Peace* murals, 1952, together with Cold War images.) The era of existentialism is on the wane and the new rational discourse of the post-war era is about to emerge. In the play he begins to think 'rationally', in terms of the dialectic, which overturns the abject. The play is about the revival of art through the agency of four little girls. In the play the sun rises from its ashes as peace follows war and a new order of representation begins.

In his final suite of texts, *The Burial of the Count of Orgaz*, 1957-1959, Picasso puts an end to writing almost as he began, with a return to Spain, to the northern mountains associated with his early modernist art. An anti-authoritarian carnival spirit of nudity, drunkenness and raucous behaviour reigns in the texts, written in Picasso's habitually chaotic style. The abject dominates in the writing only to provoke laughter, as does the burial scene itself. The parodic tone of the *Burial*, which may

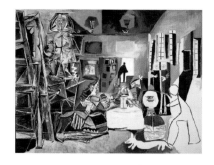
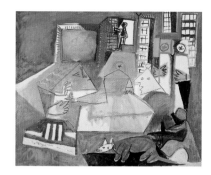

have been inspired by an art school prank (instead of copying El Greco's painting, Picasso created a caricature of it depicting his teachers), disguises Picasso's attitude to painting and the image in general. The mocking of authority in the *Burial*, which includes references to Velázquez, Goya and Courbet, belies Picasso's serious engagement with the art of the past in the Old Master series *The Women of Algiers, after Delacroix,* 1954-1955, and *The Meninas*, 17 September-30 December 1957, referred to in the *Burial*. Picasso is not as divorced from modernity in the 1950s and 60s as many have thought, for he continues his engagement with the technology of image-making, as he had done since 1901.[3]

Picasso's writings both complement and complete our understanding of the artist and his work. He plays sophisticated games with theoretical ideas: the Platonic dialogue on desire and lack, the origins of space and time, the dialectic, and the logic of the phantom. These paradoxes have never been resolved, as they have no solution. Picasso's thinking, therefore, always appears modern, even within the contemporary context.

Las Meninas after Velásquez, 17 August 1957, Museu Picasso, Barcelona

Las Meninas, 15 September 1957, Museu Picasso, Barcelona

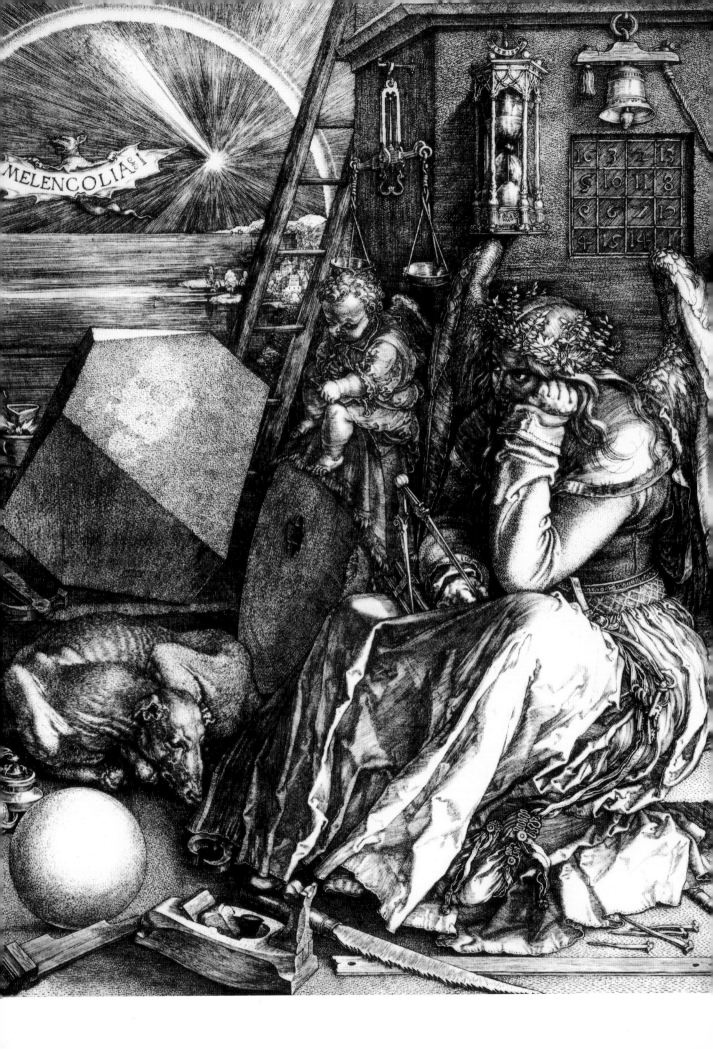

Melancholia, Metaphysics, Measurement

Minotauromachia, 1935

[Melancholia] is the reaction to the loss of a loved person, or to the loss of some abstraction which has taken the place of one, such as one's country, liberty, an ideal, and so on.

Sigmund Freud, "Mourning and Melancholia", 1915 (1917)

Metaphysics is inquiry beyond or over beings, which aims to recover them as such and as a whole *for our grasp* [my emphasis].

Martin Heidegger, "What Is Metaphysics?", 1929

If we describe the sun in the mind of one whose weak eyes compel him to emasculate it, that sun must be said to have the poetic meaning of mathematical serenity and spiritual elevation. If on the other hand one obstinately focuses on it, a certain madness is implied, and the notion changes meaning because it is no longer production that appears in light, but refuse or combustion, adequately expressed by the horror emanating from a brilliant arc lamp.

Georges Bataille, "Rotten Sun", 1930

… it is through the body that metaphysics will be made to enter the mind.

Antonin Artaud, "The Theatre of Cruelty (First Manifesto)", 1932

I must say how I see this table, the street, people, my packet of tobacco, since *these* are the things which have changed. I must fix the exact extent and nature of this change. For example, there is a cardboard box which contains my bottle of ink. I ought to say how I saw it *before* and how I [see] it now. I… Well, it's a parallelepiped rectangle, standing out against—that's silly, there's nothing I can say about it.

Jean-Paul Sartre, *Nausea*, 1938

In the 1930s, metaphysics was a newly revived category, revived only to be brought down in the world. The shift in perspective from the ideal world to the material world, to 'existence', provoked a serious dislocation and a sense of melancholia. There was a loss of perspective, a removal of the parameters that give form to things and of the barrier that divides the subject from the objective world; there was talk of an abyss of being, of groundlessness and impotence.

What sense of loss and mourning, what dysfunction brought Picasso to an impasse in April 1935? For reasons that are not known and will probably never be completely understood, he gave up art almost completely and continued in this state of artistic abstinence for nearly a year. The only art Picasso produced between April 1935 and the spring of 1936, as far as is known, were a number of etchings related to the *Minotauromachia* and the group of six portrait drawings of Marie-Thérèse and their new baby Maya dated 15 November 1935 to 5 June 1936 .[1] These last, however, would seem to have a private status for Picasso. Allusions to an impending crisis can be seen in the *Minotauromachia*, March-April 1935, a work that reiterates the tropes of melancholia, metaphysics and measurement.[2] The *Minotauromachia*, an Old Master etching for its time, may seem an anachronism for 1935, and it has been viewed as yet another, albeit very important, 'portrait of the artist'. However, given the date of completion of the work, in mid April 1935, the time of Picasso's apparent 'aesthetic breakdown', the etching must contain clues that will help us to understand his sudden severance from art.

Put on one side for the moment the *corrida* (bullfight) scene and all the biographical details highlighted in conventional interpretations of the *Minotauromachia,* such as references to Picasso's looming marital breakdown, precipitated by the pregnancy of his secret young companion, Marie-Thérèse Walter. Consider, instead, the background of the etching: the cubic building, the stormy sea, the foundering sailboat on the horizon and the heavily laden clouds. The dark, brooding atmosphere portends a period of crisis for a world undergoing great change. Dominating the etching in its layout and its images is an allegory of melancholia somewhat as Dürer conceived it in his etching *Melencolia I*, 1514, in which melancholia is provoked by the artist's inability to grasp the world, as the unused tools of measurement arrayed around the melancholic woman indicate.[3]

Picasso knew very well the language of melancholia. He paid great attention to geometric logic and perspective in the *Minotauromachia*, creating very specific relations between the figures (through intuition, apparently), with a view to subverting classical proportion and the serenity it induces.[4] Picasso's dynamic line, a kind of seismic script, would seem to be a register of psychic disturbance and disorder. With a frenzy of whirling strokes or fine etched lines, Picasso creates a complex graphic patterning to delineate an agitated sea, oppressive low clouds, various light sources and dark shadows, and the figures.

What was the cause of Picasso's melancholia? Biographical accounts cite the separation from his wife Olga, causing an upheaval in his life and work, and his impending fatherhood, as the traumatic events that precipitated his artistic hiatus. Either for legal or personal reasons Picasso stayed away from his studio at rue la Boétie while the separation proceedings were in progress. Or perhaps Picasso fell prey to the *'misère morale'* of the mid 1930s, as he described the mood of that era of political crisis and cultural stalemate.[5]

Overleaf: **Minotauromachia**, March-April 1935, Musée Picasso, Paris

But what of Picasso's anachronism, his being out of time and his dissociation from art—at a time of art's increasing politicisation—to devote himself to pure speculation in writing? Picasso's anachronism, it would seem, was a mark of his contemporaneity, which aligned him with Heidegger, the most original thinker of the period, Sartre, author of the still unpublished 'metaphysical' novel, *Nausea*, and with the excluded surrealists and outsiders Bataille and Artaud, who nevertheless came to define the 1930s. What links these figures was their identification with the malaise of the interwar years and their urgent pursuit of 'metaphysical' questions. Picasso was an artist of radical experiment: therefore his allusion to melancholia was not superficial, nor simply a metaphor for personal difficulties or for the turbulence of the 1930s. In this light, Picasso's, Heidegger's, and Sartre's loss of grasp on the real was an indication of a fundamental change in the perception of reality, a change that Picasso, as an artist, had to contend with. There is no other way to describe Picasso's catastrophic loss of the visual image in 1935. If the *Minotauromachia* dramatises the imminent loss of the artist's hold on reality, Picasso's first text, *Boisgeloup 18 avril XXXV*, 18 April 1935, envisions the aftermath of "the world become pieces" ("el mundo hecho trizas").[6] The tools of measurement and other artistic paraphernalia—"square rule" ("equerría"), "palette" ("paleta"), "copper plate" ("plancha de cobre"), "painting" ("cuadro"), "Indian ink" ("tinta china"), figure in the text as dissociated words. For Picasso, writing illustrates a loss of form.

And so, for these particular figures in the 1930s, metaphysics, traditionally associated with passivity or an inability to act, becomes combative and provocative. Heidegger, the 'metaphysical terrorist', woke a whole generation to 'existence' with his 'event' philosophy.[7] He advocated action to overcome the mood of "profound boredom" or "anxiety".[8] He defined metaphysics as the act of going outside, or surpassing the abyss of being. Artaud, too, favoured action: in "The Theatre of Cruelty", revolution and metaphysics go hand in hand. In "Production and Metaphysics" he referred to the new theatrical language of gestures, signs, attitudes, and sounds as "active metaphysics" ("métaphysique en activité").[9]

With the irruption of metaphysics across the avant-garde epistemological and artistic fields, it is not surprising that Picasso, the artist most concerned with the meaning of art, was wrestling with the concept in his own domain. Picasso joins metaphysics to artistic struggle, and to eroticism, for which the *corrida*—the bull and the horse with a slit belly, guts trailing—stands as a symbol. In the *Minotauromachia*, he draws the two themes together in a single allegory. The *corrida* imagery intrinsic to Picasso's art evokes his childhood passion for the bullfight and his early depiction of a violent goring. There, where Picasso induces tedium through endless repetition, his subject demands closer inspection. In Picasso's shift from art to writing, the image of the bull and the horse remain, worked through in countless permutations. In writing, Picasso explores questions that have no answer, an inquiry of a metaphysical nature. That same spirit of combat, seen in the work of his intellectual contemporaries, presides over the ruin of his art and the return of the image in another place.

Halasz Gyula Brassaï

Entrance to Boisgeloup

(*Entrée a Boisgeloup*), 1932,
Musée Picasso, Paris

I si yo fuera fuera las fieras
vendrían á comer en mis manos
y mi cuarto aparecería si no fuera de
y mis otros sueldos irían al rededor del
mundo hecho trizas pero que se ha de hacer
hoy es jueves y todo está cerrado hace frío
y el sol azota al que yo pude ser y no
hay remedio Tantas cosas han pasado
hacer que al redondel Tiran por las
calles las raices que los retratos
marcan y no haciendo caso de las presentes
del día hoy ha sido lo bueno y
el cazador vuelve con las cuentas á
pique que bueno está el año para
idolos así y siempre están las cosas
que dejando unas las lagrimas están
que ríen sin hacer inventos otra
vez si no que al rededor del marco
que han llegado noticias que esta
mas ya primavera no la veremos
que se en noche y una araña pasa
sobre el papel donde escribió que
aquí está el regalo que otra se
de corbata el día de fiesta
que tenemos para tiempo

The Rotten Sun

From *Boisgeloup* to the Civil War texts, 1935-1937

Soleil pourri, rotten sun: the image defines Picasso's 'fall' to writing in April 1935. "Rotten sun" implodes with a weight of meaning. The rotten sun, the sun at noon, corrupted and deteriorated, calls up a whole metaphysical scene related to melancholia, trauma and the crisis of symbolisation.[1] In writing, Picasso, the most autobiographical of artists, documents his aesthetic breakdown. The texts, dated like a diary, sometimes to the hour of the day, describe obliquely Picasso's life as he is living it at that moment, even at the very instant of writing.[2] Picasso is more than challenged by the threat to representation and to the subject posed by the crisis, relying on the medium of writing to come back from the void.

Picasso borrowed the phrase "soleil pourri", as he so often did with the ideas of others. He took "soleil pourri" from Georges Bataille, who used it to describe Picasso's art in a special "Hommage à Picasso" issue of *Documents* in 1930.[3] Bataille considered Picasso, alone of his contemporaries, to be the artist who conveyed a sense of rupture opening pathways to madness, eroticism and transgression. Bataille associates the rotten sun with "refuse", "waste", "combustion", "sacrifice" and "decomposition". His theory embraces Platonic philosophy, Mithraism and the myth of Icarus. Bataille sets out the theory in dialectic form:

> The sun, from the human point of view (in other words, as it is confused with the notion of noon) is the most elevated conception. It is also the most abstract object, since it is impossible to look at it fixedly at that time of day. If we describe the notion of the sun in the mind of one whose weak eyes compel him to emasculate it, that sun must be said to have the poetic meaning of mathematical serenity and spiritual elevation. If on the other hand one obstinately focuses on it, a certain madness is implied, and the notion changes meaning because it is no longer production that appears in light, but refuse or combustion, adequately expressed by the horror emanating from a brilliant arc lamp. In practice the scrutinised sun can be identified with a mental ejaculation, foam on the lips, and an epileptic crisis. In the same way that the preceding sun (the one not looked at) is perfectly beautiful, the one that is scrutinised can be considered horribly ugly.[4]

In naming the sun, the prime metaphor of Western philosophy, Bataille identifies a metaphysical problem: two suns (one abstract, one material, or rotten); two ways of looking at it (averting the eyes or staring fixedly) and two categories of aesthetics (beauty and ugliness). In sum two inimical types of thought.

The mental and physical crisis brought about by staring at the sun— "mental ejaculation, foam on the lips, and an epileptic crisis"—is actively sought, Bataille implies, not only by the individual, but also by the whole community. He goes on to illustrate his theory of the rotten sun with the bull sacrifice of the ancient solar cult of Mithras. Bataille also associates solar sacrifice with a cock, and even with a man who slashes his own throat, literally losing his head, and with it, his reason. Bataille describes the moment of sacrifice in terms of a dialectic of elevation (of spirit) and fall (into madness, death), two movements that become impossibly confused. The fall of Icarus, his wings of wax melted by the sun as he soars upwards, gives some sense of this simultaneous event.

Bataille's essay concludes with the reference to Picasso:

> In contemporary painting, however, the search for that which most ruptures the highest elevation, and for a blinding brilliance, has a share in the elaboration and decomposition of forms, though strictly speaking this is only noticeable in the paintings of Picasso.[5]

We don't know what part Picasso played in the "Hommage" issue of *Documents* or what he made of Bataille's theory of the rotten sun.[6] In any case, five years after Bataille published "Rotten sun", the violent movement of elevation and fall that, according to Bataille, preceded the decomposition of forms in Picasso's painting is reiterated in his 'fall' to writing in April 1935, coincident with his repudiation of art and of the visual.

The rotten sun, coupled with the bull's goring of the horse's belly, seen so recently in the *Minotauromachia*, opens the space of writing. Picasso's fall to writing marks the suspension of mimesis—the replication of the real—and the reproduction of a materialist space. Picasso writes as he used to draw, in the medium of Indian ink on *papier d'Arches*.[7] The elements of art, without a support, break down into the component parts of line and colour, or into the words that refer to them. He organises the writing into blocks, with no punctuation or markers to interfere with the flow of words. Language itself becomes the focus; it is both visual and aural—a plastic material to be moulded physically and speech, song or sounds to be voiced.

Picasso's trademark spidery hand runs the gamut of moods from a broad, hurried script to a more careful, cramped writing. Picasso himself compares his handwriting to a spider: "a spider passes over the paper on which I'm writing" ("una araña pasa sobre el papel donde escribo"), *Boisgeloup 18 avril XXXV*, manuscript page one. What negative associations of spinning and fate does Picasso confer on his tangled, drawn line, employed in the etchings as well as the writings, when he writes on 10 January 1936: "spider's webs that become entangled mathematically around the rope of the well and pull from the ball the best and the worst" ("los hilos de araña que se enredan a la cuerda del pozo y tiran del olvillo lo mejor y lo peor")? He uses the word 'mathematically' as though to suggest the involvement of some rational organisation or technical expertise in the creation of the tangled lines. Picasso only needs to mention "the well", a popular Andalusian metaphor for the female, to bring into the metaphor eroticism and fate, either good or ill—drawing up the rope of the well being like pulling on fate's 'ball of thread'. Picasso's writing may seem to go out of control as erasures and ink-blots contribute to the chaotic appearance of the text. These marks remain even when a text is transcribed from a previous version, for example from a small notebook.[8]

There is nothing straightforward about Picasso's language, a mixture of Spanish, with its baroque intonations and Andalusian argot, and French, a language in which he was extremely competent and which he manipulated for his own purposes. Picasso's almost private language creates a barrier to meaning, and defies translation, driven as it is by sound and rhythm. We can hear Picasso's own voice, his rhetoric, if you like, as his friend and biographer Roland Penrose describes it:

As you listen you realise that Picasso appreciates that truth is never easily accessible. Direct statements imply falsehoods too often for them to be trusted. The truth can be better understood by subtle manoeuvres which catch it alive instead of trampling it to death…. To record these conversations would be difficult. They rely on glances, expressions, gestures, a quick laugh which introduces a relevant absurdity, and above all on the reactions of his listeners to ambiguities and paradoxes which can become the threshold of new ideas. The pleasure Picasso takes in presenting the reverse side of a problem can reduce the over-serious questioner to despair. 'You mustn't always believe what I say,' he once told me. 'Questions tempt you to tell lies, particularly when there is no answer.' [9]

On rare occasions, drawings and texts appear together. On the sheet dated 9, 11 octobre XXXVI (*Study of a head and two toothed eyes*) words accompany drawings of two eye/vagina dentata, a vulva with long trailing hair and a female head shaped like a sort of flaccid phallus.[10] The images sum up the eroticised visuality of Picasso's writings—the collapsing of the painter's eye with his subject. The parodic eroticism of the drawings exposes what is usually hidden in the female portraits on canvas, their bodily essence. The accompanying French texts numbered I and II reveal Picasso at his most playfully surrealist as he describes the "favourite woman" ("femme de chevet") in both mundane and sacred terms.

I:

wearing knotted around her neck like a scarf a bathtub of boiling water wearing knotted around her neck like a scarf a cupboard of dirty linen wearing knotted around her neck like a scarf a dining table set for lunch the tablecloth in flames.

II:

favourite woman dove filled with clear water in the liquid plumage lit by a bright lamp burning oil from hives.[11]

Picasso's project was unique, and contrary to what was going on at the time in Paris, when artists were examining the social purpose of art. Picasso chose instead to investigate the meaning of art—and whether it was possible to create art. His project was one of dismantling; he dispensed with the support of the work of art and dealt with the chaos that remained. Four texts by Picasso plot the artist's progress from the moment of rupture in April 1935 to the painting of *Guernica*, May through June 1937, as he emerges from a period of solipsism to connect with the social.

"9, 11 octobre XXXVI",

Study of head and two toothed

eyes (*Etude de tête et deux yeux*
dentés), 9, 11 October 1936
Musée Picasso, Paris

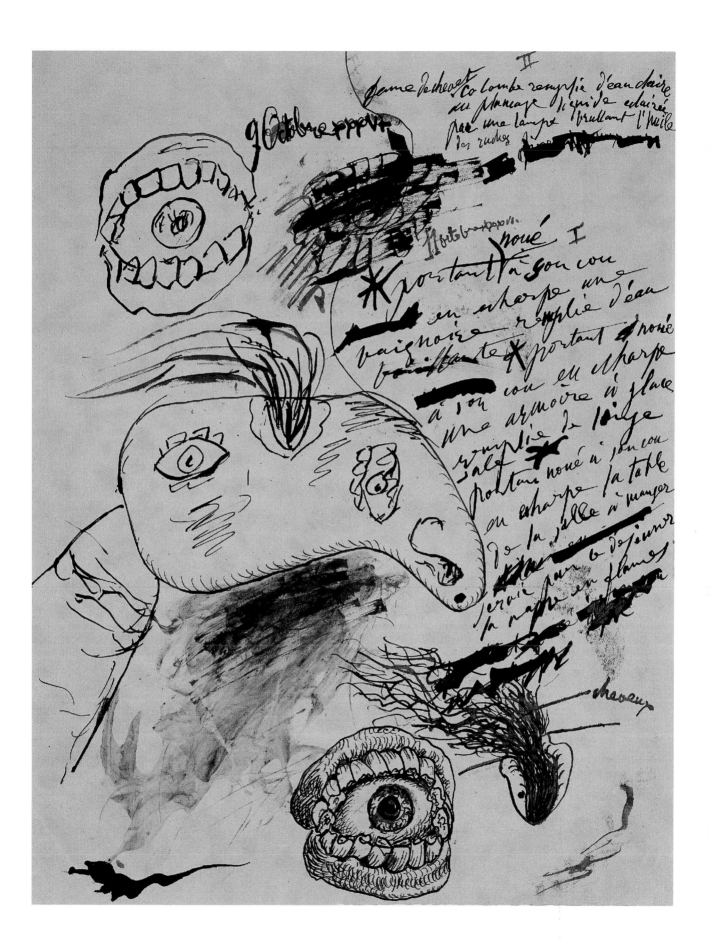

Boisgeloup 18 avril XXXV: the dissemination of the rotten sun

In April 1935 Picasso began to write, furtively at first. Never having composed any poetry before, Picasso produced 34 pages of disjointed poetic images in a single day, 18 April, no other date being given along the left-hand side of the title page. In *Boisgeloup 18 avril XXXV*, Picasso tips over into mania, the complementary pole of Freud's economy of melancholia.[12] He turns his struggle to find form and meaning into a bravura performance of Spanish speech, poetry, song, dance, and a bravura sexual performance. It would be easy to miss what Picasso is doing in *Boisgeloup* without a grasp of his use of Spain, and Andalusia in particular, its popular culture (fiestas, bullfighting and flamenco), its Renaissance literary heritage and philosophical formation, as an extended metaphor for the 'fall' to materiality and writing. Spain is exemplary in this respect, due to its nonconformism to classicism and rationalism. Although the subject Picasso disappears, Picasso personally implicates himself in writing, cagily constructing the writer as "yo" or "mi" ("I" or "myself").[13] Picasso is at the beginning of an idea that rotten sun can only dimly name, an idea that he demonstrates through images of materiality and language that are "hors de ses gonds" (unhinged).[14] The rotten sun opens up the work to reveal the frenzy that underlies the final, visual form of a work of art.

Three times in *Boisgeloup* (pages I, XIX and XXXIV) Picasso refers to the rotten sun or some manifestation of it. In the opening, Picasso writes the solar metaphor, or rather its parody (not forgetting that Bataille's rotten sun itself is a parody). Does Picasso identify with the figure in Van Gogh's *The Sower*, 1888, a man sowing under a large, radiant sun, and by association with the artist's madness?[15] The sun communicates directly with Van Gogh, that exemplary auto-mutilator, and dictates the act of self-sacrifice. In the first passage of *Boisgeloup* the sun attacks the writer (Picasso) with its rays, after which madness unfolds in the medium of writing:

if I were outside the wild beasts would come to eat out of my hands and my room would seem to be outside of myself other workers would go around the world become pieces but what can you do about it today is Thursday and everything is closed it's cold and the sun is beating the one I could be and there's no help for it so many things have happened to make them drag the roots by the hair that frame portraits as they do in the bullring and not paying any attention to those present today has been good and the hunter returns with his booty on his back how good this year is for marinades that's how things always are some shedding tears while others laugh without making anything out of it again but around the frame news has come that we won't see the spring any more except at night and a spider passes over the page where I'm writing here's the gift that others wear a tie on the day of the fiesta and we have it already for a while[16]

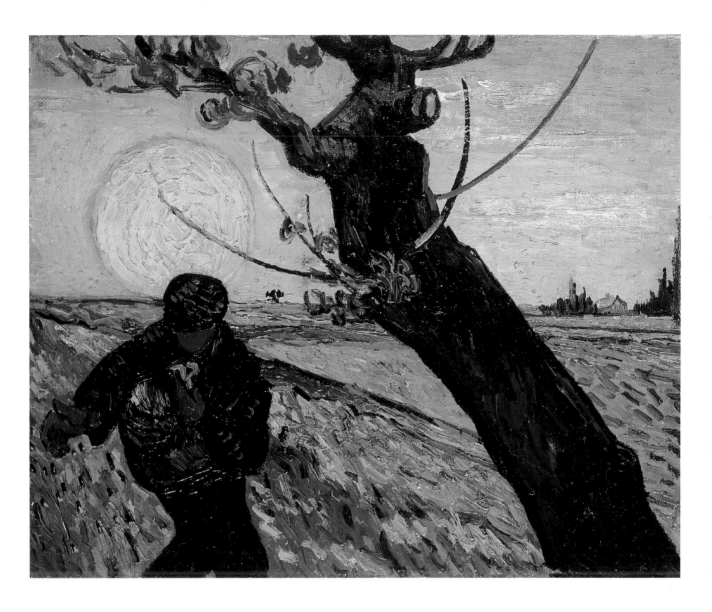

Vincent Van Gogh, **The Sower**, 1888, Van Gogh Museum, Amsterdam

On page XIX, Picasso writes "a sun that splits exploding seeds" ("un sol que parte estallando semillas"). The sun splits open like a germinating pod, detonating its content of seeds. Picasso's phrase, buried in the impenetrable verbiage of *Boisgeloup*, recalls one of the oldest metaphors of philosophy, employed by Plato and Aristotle. Plato himself conceived the sun as two suns, one abstract ("one looks at it on pain of blindness and death") and one material, simultaneously "the source of life and visibility, of seed and light".[17]

 With his simile of the sun and seeds Picasso, too, evokes a metaphysical scene of a materialist inflection and charged with eroticism. When Picasso writes "a sun that splits exploding seeds", he explodes the hierarchy of the visual and the rational and imagines the origin of the text out of a void. The elements of the rotten sun—the notion of the cut or, in this case, a split, and ensuing madness—are implicated in Picasso's simile. With each successive phrase the text shifts to another idea, as the contents of Picasso's head—memories of Andalusia, undirected thought, banalities, his erotic life—spill out

in a stream onto the page. Literal language and metaphor alternate as Picasso enacts metaphysical collapse in writing. For Picasso, as for Plato and Aristotle, the structure of metaphor has philosophical implications.[18]

It is significant that Picasso uses the phrase "a sun that splits exploding seeds" as a metaphor for the consummation of the sexual act that follows on page XIX and for the creative process. The phrase would seem to illustrate 'dissemination', a kind of semantic explosion symbolised by the random projection of seeds, or words, that works against textual unity, rationality and intelligibility.[19] Picasso's exploding sun/seed pod turns the sun into a generating force, a kind of round pre-phallus whose 'split' or division opens the way to diversification—of language, of gender, of life in general. The sun's random disseminating force opens the text to the enriching of meaning, as well as a possible lack of meaning.

Yet there is meaning in Picasso's methods in *Boisgeloup*: the apparent surface confusion belies the precise patterning of the images. Pages I and XIX of *Boisgeloup* illustrate this point. When the sun appears in the text, Picasso brings on the *corrida* and some variation of the act of copulation disguised in a metaphor, as he tries to delineate, however obtusely, the male and female space of representation. The *Minotauromachia,* with its central *corrida* against a background of melancholia—a reminder of the artist's problem with form and his personal difficulties (the reasons for his turn to writing)—is not far off. After the first appearance of the sun on page I of *Boisgeloup*, Picasso alludes facetiously to the 'arrastre', the moment in the *corrida* when the dead bull is dragged off: "so many things have happened to make them drag the roots by the hair that frame portraits as they do in the bullring" ("tantas cosas han pasado hacer que al redondel tiren por los cabellos las raíces que los retratos marcan"). (Picasso may be referring to a row with Olga, when he claimed that he dragged her across the floor by her hair.)[20]

On page XIX of *Boisgeloup,* the 'events' cited include the arrival of the postman (letters from Olga's lawyers arrived almost daily), the appearance of the concierge, a situation the writer ("me") has to deal with ("to get out of here any other way more gracefully") and a kind of parodic goring:

more than a hundred years that were again the target the thorn that offers itself to the hatred twisted around the spider's thread your voice softens picks up the smile that the postman brought you and here comes the concierge flag gathered in and pomegranate exploding in your hands a hundred fingers that plane down the years that gather your glove voice for if six ten and fourteen make two and a half at least if they tell me that it's ready and there's no more to do what I've already written since there's no other way to get out of here any other way more gracefully ole ole ole give in give in give in good go on go on go on ole ole and what joy this is what's so good it's going quickly ole ole with castanets ole and a sun that splits exploding seeds and making the drums roll with savage pecks the kisses and ole and ole it's all right now [21]

Boisgeloup 18 avril XXXV, page XXXIV, third state, 9 May 1939, Musée Picasso, Paris

In 1939 Picasso illuminated pages of his texts from 1935-1939 for a *livre d'artiste* to be published by the dealer Ambroise Vollard, whose death in 1939 put an end to the project.

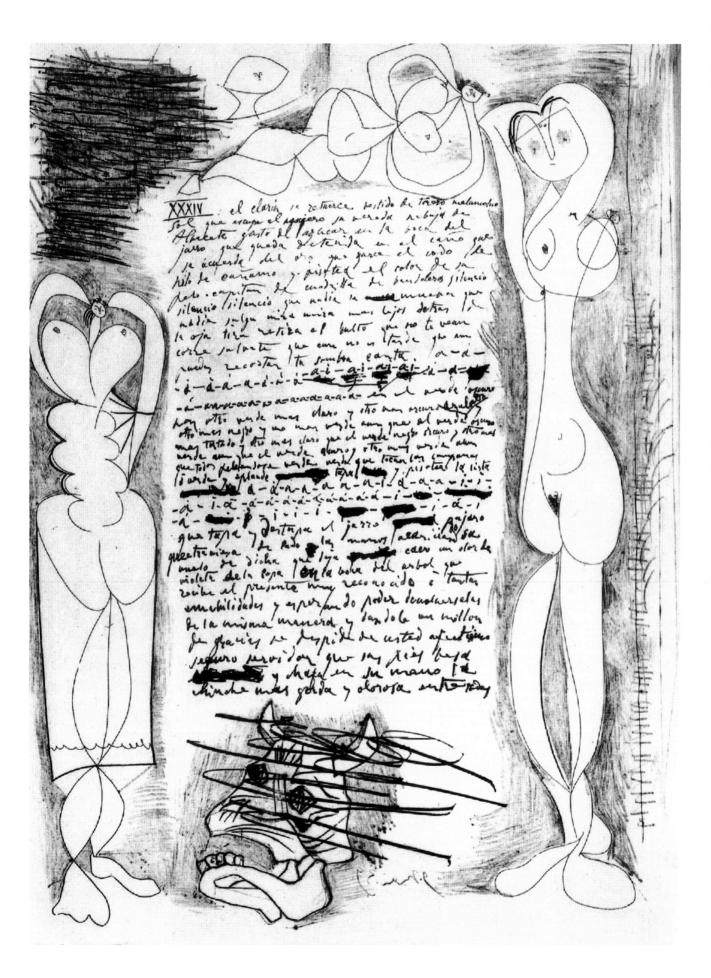

The cheers and *olés* provide the sound effects of an image we cannot see—not a bull goring a horse, but a parallel image, a sexual climax to the roll of a drum made by violent pecks ("picotazos", a derivative of "pico", a Spanish slang word for "penis") on the skin of the drum, or the horse's belly. The climax occurs when the split sun explodes its contents of seeds, a companion image of the "pomegranate [the fruit of illicit desire associated with Aphrodite, the goddess of love] exploding" a few lines above. Once the climax passes, Picasso writes: "bravo and bravo it's all right now" ("y que ole y que ole que ahora está bien"). Eroticism, that which usually gets covered over in the work of art, drives *Boisgeloup*: the union of the male and female (there are almost no innocent phrases in the text) is repeated from the beginning to the end.

Picasso's eroticism, while parodic and silly, is serious as well. The elements of form, dispersed after the fall to writing, desperately try to come together in the finale on page XXXIII: "the air of the harp meticulously measures out the oil that spreads its drawing eternally on the *mantilla* of blood clicking its heels on the floor" ("el aire de su arpa mide minucioso el aeite que extiende su dibujo eternamente en el manto de sangre taconeando el suelo"). The blending of oil and blood, two material substances, will the formless 'drawing' into existence through the *taconeo* (heel-clicking and strutting dance step) of flamenco. Picasso brings *Boisgeloup* to a climax on page XXXIV with the passion and fire of a live erotic performance:

the bugle writhes dressed as a melancholic *torero* sun that spits into the hole its pathway Albacete knife taste of sugar in the mouth of the jug that holds back in the channel that remembers the gold that unravels the reel of rope and tramples the colour of your hair captain of the gang of bandits silence silence silence nobody move nobody leave look look further away behind the leaf pull out and put back the "bulto" [literally "pouch", "purse" or "bust", and also Andalusian slang for "penis" and "testicles"] don't let anyone see you run save yourself it's still not too late you can still cut out your shadow a-a-a-a-i-a-i-a- in the dark green there is another paler green and another dark bluish green another blacker and another greener although the dark brownish green and another paler that dark black green and another greener although all of them are fighting each other green green the bells are ringing out green and applaud cover and trample the stripe a-a-a-a-i-a- cover and uncover the jug bird that crosses on one side hands caressing its joyful flight that drops a violet odour from the cup into the mouth of the tree that receives the present very grateful for the many kindnesses and hoping to be able to return them to you in the same way and giving you a million thanks take leave of you [your] very affectionate faithful servant who kisses your feet and crushes in your hand the fattest and smelliest bedbug of all[22]

The sun, again in the guise of the male, makes a final appearance in the text: "sun that spits into the hole its pathway". Once again, the sun is associated with the *corrida* and its appearance precedes an extended erotic scenario. The phallic sun with its lubricant, semen-like "spit" precedes the 'sweet' climax of the "Albacete knife" (the preferred weapon of Spanish gypsy men) and the "jug": "Albacete knife taste of sugar in the mouth of the jug". The round, wet

rotten sun, brought down from its elevated position to the horizontal plane, plays out the artist's fixation on female genitals, rather than the excremental fantasy associated with Bataille.[23]

Picasso associates the act of sexual intercourse, poetic recitation and the climax of a flamenco song and dance display. Silence and stillness are called for and the flamenco wail begins, interrupting the flow of words with the stretched-out vowels of the song. The chanting of the different words for the colour green—dark green, pale green, bluish green compete with each other—encourages form back to life by means of the *duende* (the demonic spirit of creativity) that possesses the flamenco performer.[24] The chant evokes Federico García Lorca's famous poem of gypsy rivalry and fatal love, "Somnambular Ballad" ("Romance Sonámbulo"), from *Gypsy Romancero* (*Romancero Gitano*), 1928, each verse of which repeats the sinister intonation: "Green I love you green" ("Verde que te quiero verde").[25]

At the height of the song's intensity, the jug reaches climax through the movement of the knife ("cover and uncover the jug") and, like a defecating bird, as the text implies, drops "a violet odour" into the "mouth of the tree". The tree thanks the bird graciously with all the falderal of a Spanish formal letter: "giving you a million thanks take leave of you [your] very affectionate steadfast servant", ending with the absurd phrase "crushes in your hand the fattest and smelliest bedbug of all". The whole of *Boisgeloup*, a parodic formal document and a live performance, invokes the power of the voice and sound as a proposal for what art can be, for what guarantees its survival after the debacle of the rotten sun. Picasso unveils the erotic impulse driving all art forms. Picasso puts himself forward in *Boisgeloup* as the bearer of the erotic charge that remains in readiness, an open possibility for art.

"Lengua de fuego", "24-28 noviembre, 5, 6, 24 diciembre XXXV":
the mechanics of the rotten sun

The rotten sun, then, has everything to do with lack of form and vision and the failure of rationality and light. The rotten sun, a concept that can scarcely be defined or represented, can, nevertheless, be demonstrated—at least this is what Picasso attempts to do—in language. Through his unique use of language, and the Spanish language in particular, Picasso sinks into the depths of materiality, sexual perversion and death. A candle flame replaces the sun as the only source of light. Picasso's Spanish suite of texts from the end of 1935, "24-28 noviembre, 5, 6, 24 diciembre XXXV", coincides with Christmas—the final piece is dated 24 December—and with the winter solstice and the yearly descent of the world into darkness. "Lengua de fuego" ("flame", or "tongue of fire"), the phrase that links the four texts could easily serve as the title of the suite.

Picasso chose this moment, November 1935, to compose a number of short texts in French which show a different dimension of his writing. He also translated his suite of Spanish texts, "24-28 noviembre, 5, 6, 24 diciembre XXXV", into French. This sudden to-ing and fro-ing between French and Spanish occurred at the time Picasso agreed to publish his texts in Christian Zervos's *Cahiers d'art*, a luxury modern art review, with editorial assistance from André Breton, the leader of the surrealist movement.[26] This somewhat rejuvenated, public Picasso allowed a new audience to observe the process

of composition. Illustrations in *Cahiers d'art* of typed drafts of the suite, with Picasso's handwritten additions in black, green and red ink, corresponding to the date of composition, show the artist's way of working.[27] The working sheets, which display the initial hierarchy of images and their subsequent levelling down, demonstrate the mechanics of the rotten sun as a fall from the metaphoric (abstract) to the metonymic (concrete). The ideal and the material are collapsed on the written page.

An erotic charge initiates each text of the "Lengua de fuego" suite, unleashing a torrent of dissociated phrases. Barely disguised sexual acts are associated with words for Spanish food, low or banal images ("overdue bills", "frying pan", "chamber-pot", "farts"), and with events in Picasso's life ("get him out of a tight spot", "after quickly packing his bags"). As the text evolves, the initial idea is repeated in more graphic and perverse language. The words that represent ideal love at the outset of the matrix text are driven further and further apart, their allusive meanings altered when placed in a new syntax. The end result, however, is a seamless rhetorical surface on sheets of *papier d'Arches*.

Picasso jots down his first poetic ideas in thick black pencil in a small blue spiral notebook dated "24, 25, 26 noviembre XXXV". He starts with the ambiguous image using the phrase "flame", or "tongue of fire" ("lengua de fuego")—both an abstract flame and a physical tongue, the tongue that speaks. The words of the text are formed on the tongue—the making of poetry is no more than a physical activity. The "tongue of fire" evolves in "5 diciembre" into the "tongue that makes its bed" ("lengua que hace su cama") and finally becomes in "6 diciembre" and "24 diciembre" the "most evil tongue" ("lengua más mala"), changing gender along the way. And speaking of tongues, Picasso for the first time speaks in tongues. He wrote the text in Spanish, translating it into French verbally for Breton, who copied it down "word by word" exactly as the artist spoke it, without altering his original syntax.[28] Picasso forced the French to conform to the twistings and strains imposed on his mother tongue, as "lengua de fuego" becomes "langue de feu". From the child-like scribbling in the small blue spiral notebook, "lengua de fuego" turns into a tale of two cultures, with Picasso writing in the gap between the two. Somehow Picasso's free movement between the cultures of Spain and France is implicated in the fall to writing. The augmented matrix text (the seventh state) reads:

24-28 noviembre XXXV: flame of fire fans its face in the flute the cup that singing to it gnaws the stab of blue so lovely that seated in the eye of the bull inscribed on its head adorned with jasmine waits for the sail to swell the piece of crystal that the wind wrapped up in its mandoble cloak dripping caresses divides the bread between the blind man and the lilac-coloured dove and presses with all its spite against the lips of burning lemon the twisted horn that frightens with its goodbye gestures the cathedral that faints in its arms without an ole exploding in its gaze the radio awakened by the dawn that photographing in the kiss a bug of sun eats up the aroma of the hour that falls and crosses the page that flies undoes the bouquet that is carried tucked under the wing that sighs and the fear that smiles the knife that leaps with pleasure leaving it still today floating however it will and in whatever way at the precise and necessary moment at the top of the well the cry of the rose that the hand throws it like a little alms[29]

Picasso copies the matrix text in broad strokes of Indian ink onto a sheet of *papier d'Arches*, separating each poetic idea with a long dash. The first line reads: "flame [tongue] of fire fans its face in the flute the cup". He generates the text with allusive words—"flame", "fan", "flute", "cup", and further on—"sail", "piece of crystal", "aroma", "page"—words of poetic refinement and poetic reduction, a Mallarméan inspiration. In the "Hommage" issue, Breton compares Picasso to Mallarmé as though they were two sailboats, taking off from the metaphor "voile" in "A Throw of the Dice Will Never Abolish Chance" ("Un coup de dés jamais n'abolira le hasard"), 1897. Breton writes that Picasso's suite evokes:

> [Mallarmé's] sail, by turns swollen with meaning as well as intentions beyond meaning and seen in profile, but this sail [Picasso's] is no longer the white sail, it is really that of a pirate-ship—to complete the allusion it flies, indifferently, a French and a Spanish flag—it is no longer a sail thought of as an end in itself, in love with its own reflection, but one that laughs at the storm and heads out into the dark and magnificent night of our era, to face all that remains to be conquered.[30]

"24-25-26 noviembre XXXV",

first state, 24-26 November 1935,

Musée Picasso, Paris

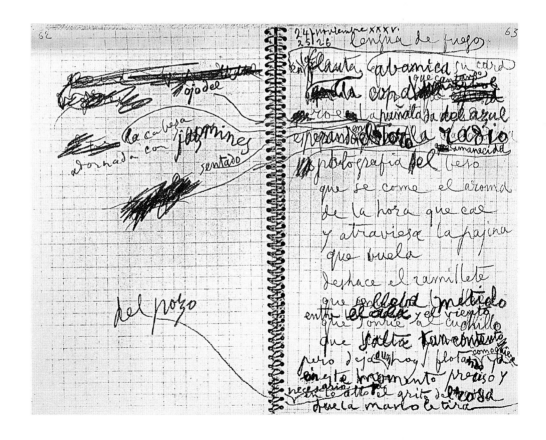

24/ lengua de fuego abanica su cara en la
planta la copa ~~mira~~ *que cantando* roe la puñalada
del azul *tan gracioso* i perando *sentado en el ojo del* ~~toro~~
el trozo de cristal chorreando de la cabeza adornada con jazmines ⊢⊣
la radio amanecida ⊢⊣ fotografía
el beso que se come el aroma
de la hora que cae ⊢⊣ y atraviesa
la pajina que vuela ⊢⊣ deshace
el ramillete que se lleva metido
entre el ala y el viento que
sonrie al cuchillo que salta
tan contento ⊢⊣ pero deja aun
hoy flotando como quiere ya
en este momento precioso y
necesario ⊢⊣ en lo alto del
pozo ⊢⊣ el grito del rosa
que la mano le tira como
una limosnita

Picasso plays on the difference between French condensation and Spanish excess, inflected by his Andalusian vocabulary and his baroque, 'gongoresque' style of writing (after the Andalusian poet Luís de Góngora, 1561-1627).[31] Picasso uses Mallarmé as a springboard to take himself in the opposite direction, from poetic distillation to poetic inflation. The initial images of "24-28 noviembre", with their semantic suggestiveness, disguise the eroticism that underlies the poetic process, driving the text to its conclusion. Yet the two poets have more in common than it at first appears, for both are sensitive to the way language functions, and to its material existence. Mallarmé, the poet of crisis ("Crisis of Verse", "Crise de vers", 1886), frees language from the strictures of verse with the prose poem. His final poem, "Un coup de dés", is an operation on the word, using the device of 'spacing', an abstract typography that breaks down linear semantic structure and emphasises the white spaces between the words. The visual aspect of this concrete poetry and the act of writing are part of the process of signification, while the meaning remains "undecided".[32]

But is Picasso, with his cluttered, spontaneous manuscripts, the words thrown together just anyhow, any less calculating in his attention to form? In order to make room for the additions to the original text, Picasso takes a two page typed version, dated "28 noviembre XXXV", with each line set out according to his phrase breaks, and with a wide gap between each line. He fills most of the available space with long hand-written passages enclosed in bubbles that connect to the points of insertion in the text, interrupting the rhythm and the syntax of the original text, and altering the meaning. You can never be certain where one poetic phrase begins and another ends. Picasso's further augmentations on another typed sheet take in turn the new syntax of "5 diciembre" as a point of departure that results in the texts of "6 diciembre" and "24 diciembre". With each poetic inflation, the text becomes more transgressive and more daring.

In "28 noviembre XXXV", idealist eroticism permeates the first line of the suite—"flame [tongue] of fire [male] fans [female] its face in the flute [male] the cup [female] that singing to it [climax] gnaws [cunnilingus] the stab of blue so lovely [an allusion to Marie-Thérèse]". Even when Picasso veers off into a more Spanish style of writing—"presses with all its spite against the lips of burning lemon [female] the twisted horn [male]"—the images depend on the principle of condensation and semantic richness.

In "5 diciembre XXXV" Picasso introduces concrete, low images, debasing the tone of the erotic scene. At the beginning of the text, between the words "tongue" and "of fire", he inserts the following passage: "[tongue] that makes its bed when it doesn't care any more the dew that beats the mare making its rice and chicken in the frying pan and organises in love the night with its gloves of laughter around the line [of fire]". The "tongue" is no longer a "flame or tongue of fire", rigid and upright, but a "tongue that makes its bed", soft and prone, that "doesn't care any more about the dew" (saliva or semen). What are we to make of Picasso's references to Andalusian food and kitchen implements—"rice and chicken in the frying pan", "ham" and "cheese" and "Extremaduran sausages"—mixed in with the words that describe a night of love-making?

Picasso alters the meaning of the "tongue" in "6 diciembre XXXV" by placing it in a new phrase: "never has there been such an evil tongue". The opening of this section of the suite repeats the same idea as the opening of the first text in a more graphic and vulgar register: "the tender friend licks the little bitch of wool twisted by the palette of the ash-coloured painter" ("el amigo cariñoso lame a la perrita de lanas retorcidas por la paleta del pintor ceniciento").

In the final text of the suite "24 diciembre XXXV"—set out on another typed sheet dated "28 noviembre" and including the penned additions of "5" and "6 diciembre"—Picasso writes the final amplifications in red ink. The dissociation of images drives the original metaphors of the matrix text "24-28 noviembre XXXV" even farther apart. The final text begins:

never has there been such an evil tongue that if the tender friend licks the little bitch of wool twisted by the palette of the ash-coloured painter dressed in hard-boiled egg colour and armed with foam that makes many faces when the tomato no longer warms to him nor does it matter a bit that the dew that doesn't even know the winning number of the lottery that the carnation beats the mare making its rice and chicken in the frying pan tell him the truth and get him out of a tight spot sing to him the 'zambomba' [a kind of drum] and organise in carnal love the night with its gloves of laughter, but if around the half-finished painting of the line shameless daughter of a whore insatiable never tired of licking and eating the balls of the murder victim[33]

The "evil tongue" belongs to a woman (Olga), an "hija de puta" ("daughter of a whore"). In one narrative strand of "tongue of fire" Picasso, Olga and Marie-Thérèse assume the roles of three allegorical characters—Malebouche or Evil Tongue, the Lover and the Rose—from the *Roman de la rose*, 1526.[34] Picasso's "evil tongue", like the *Roman*'s Malebouche, prevents the "tender friend" ("amigo cariñoso" [Picasso]) from consummating his love for the "Rose" ("la rosa" [Marie-Thérèse]). The erotic scene at the beginning of "24 diciembre" opens the way for the text's repeated couplings and perversions of couplings. The words suggestive of ideal love at the outset of the matrix text are debased further, as "evil tongue" not only speaks evil, but commits unspeakable acts. At the end of the above quotation from "24 diciembre", "evil tongue" is the "shameless daughter of a whore insatiable never tired of licking and eating the balls of the murder victim" ("sin vergüenza hija de puta insaciable nunca harta de lamer y comer cojones del interfecto"). The "tongue of fire", upright and burning, is transformed through the process of alchemy into something soft and wet—a salivating, fellating, necrophiliac "evil tongue". There is great confusion here over the change in the tongue's gender. The tongue, in female guise, turns on the dead man and eats his balls. Picasso writes the phrase "around the half-finished painting" ("alrededor del cuadro medio hecho") before this extraordinarily grotesque description of, presumably, Olga, feeding on her victim Picasso. Picasso's painting is in abeyance, 'half-done', a kind of *corpus interruptus*.

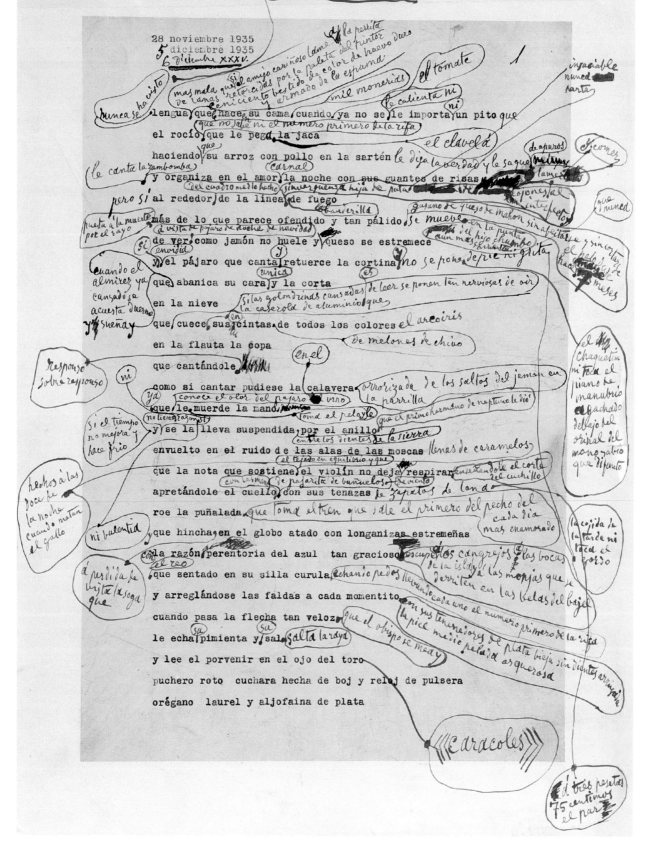

Picasso refers to his artistic activities again, in reference to the bullring, but not to the pairing of the bull and the horse. Instead, he alludes to the ritual dressing of an anti-heroic bullfighter by his valet: "doesn't put on the jacket [of the bullfighter] or play the player piano crouched under the chamber-pot of the bullfighter's valet that dead on his feet doesn't cheer the afternoon's death or draw the winning number except when the 'almirez' [wood-engraver's tool] goes to bed, sleeps and dreams and fans its unique face". Here, the phrase "fans its face" sounds more like a euphemism for masturbation. The phrase "almirez… fans its unique face" loops back to the first phrase of the suite, "flame of fire fans its face". Cunnilingus, fellatio and masturbation pervert the aim of sexual intercourse—the act of penetration in Freud's analysis—and, to complete Picasso's analogy, the making of the work of art.[35]

Now, the fall from the ideal to the material is also a matter of culture, of Picasso's culture. Picasso tries to reconcile two incompatible systems of belief, Christianity (the metaphysical) and paganism (the material), when he writes in "24 diciembre": "at midnight when they kill the cock" ("a las 12 de la noche cuando matan al gallo"). The midnight Mass on Christmas Eve is called the *misa del gallo* (literally "mass of the cock"), so termed because Christmas and the winter solstice coincide. Picasso refers to the killing of a cock to ensure that the sun will rise again. Earlier in the text, Picasso writes "the zambomba sings to it" ("le canta la zambomba"). A zambomba is a kind of drum, made by placing a wet skin over the mouth of a narrow jar, which gives a low, moaning sexual sound. The instrument is played in processions in Spain to celebrate the winter solstice. In "24 diciembre" Picasso identifies himself and his marital problems with the sacrificial cock (the preceding phrases have to do with "a hand… carried off suspended… by the ring… wrapped up in the noise of the wings of flies full of caramels [Picasso's favourite sweets] made at midnight when they kill the cock…"). It is too easy to be diverted by Picasso's marital strife, the narrative attached to the structuring principle that is the rotten sun. At this point Picasso draws the suite—all erotic charge and no result, no work of art—to its conclusion.

"20 janvier XXXVI": the drama of the rotten sun

Picasso creates the drama of the rotten sun in "20 janvier XXXVI", 20 January 1936, in which rape and violence, blood and gore are associated with the aborted birth of art, pregnancy and birth, subjects still weighing heavily on his mind.[36] The text illuminates the visual, but not yet visible (it is only writing), the elements of visuality remaining in disarray.[37] The erotic drive of the work of art is arrested with a blow of tremendous force and resounding tumult as within the text words become image and image becomes scene. With the grandest of staging—the production of "20 janvier XXXVI", with its fireworks and illuminated boats, is not dissimilar to the kind of performance that took place on the lake of the Gran Retiro Park at the Royal Palace of Philip IV in the 1620s—Picasso expands the thematics of the rotten sun (sacrifice, auto-mutilation, crisis) to include the cosmic and the universal.[38] He returns to the themes of the *Minotauromachia*—melancholia and the *corrida*—but relinquishes his personal narrative for an altogether more spectacular subject, although there is nothing to see. Unable to convey in painting the assault

(on the elements of form and on the artist himself) that the concept of the rotten sun represents, Picasso, in "20 janvier XXXVI" exploits poetry as *mise en scène*, or staging, to describe the liminal existence of art. The text is painting-in-waiting.

For Picasso language and painting are equivalent—let us not forget that painting, the first of all the arts, and particularly metaphysical painting, was at the origin of Artaud's "The Theatre of Cruelty (First Manifesto)".[39] Like Artaud's theatre, Picasso's "20 janvier XXXVI" lies somewhere between text and *mise en scène*—a reworking of the scenario of the rotten sun as *corrida* as sacrificial banquet as crucifixion. The violent overlapping images, condensed as in a dream, put us in mind of Artaud's directions on technique in the "The Theatre of Cruelty (First Manifesto)". Artaud writes:

> The problem is to turn theatre into a function in the proper sense of the word, something as exactly localised as the circulation of our blood through the veins, or the apparently chaotic development of dream images in the mind by an effective mix, truly enslaving our attention. Theatre will never be itself again, that is to say will never be able to form truly illusive means, unless it provides the audience with truthful distillations of dreams where its taste for crime, its erotic obsessions, its savagery, its fantasies, its utopic sense of life and objects, even its cannibalism, do not gush out on an illusory, make-believe, but on an inner level.[40]

Picasso begins "20 janvier XXXVI":

and at the first thrust of the bull into the horse the curtain goes up and all the boats light up filled with footlights in the fireworks of the sheaves of rockets that reap their harvest of lights doing the splits between the sheets of colours that make their bed and the bouquets of flowers of the glass cup *banderillero* that stabs his fan that becomes entangled with the loose shock of hair of the drawing of its dance and the bull with its key seeks the eagle eye of the drum that resounds at the blow given by the horn in the uproar of its belly like the deliberate chiming of the revelry....[41]

A goring, inevitably, opens to an interior vision, and a vision of the interior. When the curtain goes up ("levanta el telón"), a hallucinatory lighting of footlights and fireworks illuminates an orgy of "rockets" ("cohetes", masculine) and "lights doing the splits" ("luces espatarradas", feminine) on "sheets of colours that make their bed" ("sábanas de los colores que le hacen la cama"). The lines of a "drawing" ("dibujo"), like a "loose shock of hair" ("la madeja deshecha"), are in disarray as in a "dance" ("baile"), due to the force of the initial "shock" ("rempujón"). The passage continues with a scene of sacrifice:

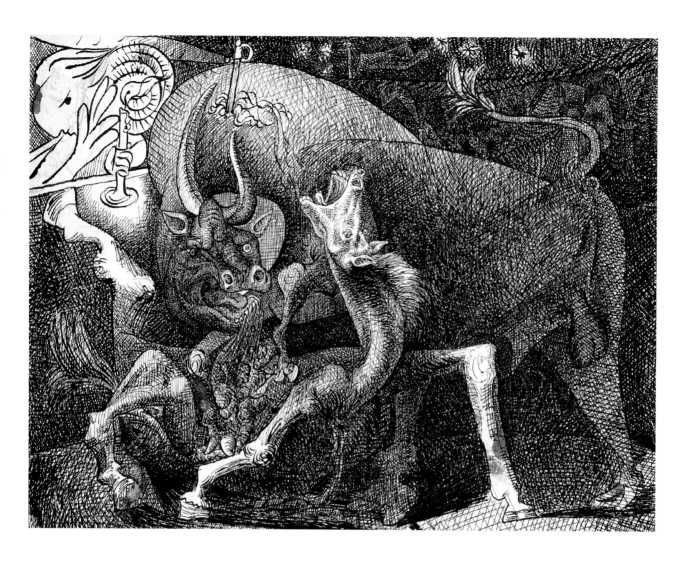

fine and delicate banquet of death and [the bull] opens wide the door of the dance of the mare's belly and raises the curtains and discovers the feast and arranges the table and chairs and gathers the forgotten rags and cleans with its snout the tablecloths stained with the spurting blood collected in the cups through the highways and byways of the intestines plaiting them so carefully and arranging them and tying them to the ribs hanging little lamps and flags from them his eye wiping clean the interior of the details discovers the back of the cave in the most profound interior depth stuck to the twisted roof of the dry tree and sponge drowning in blood the hard-boiled egg of the little white and blue horse....[42]

Woman with a Candle, Fight between Bull and Horse
(*Femme à la bougie, combat entre le taureau et le cheval*), Boisgeloup, 24 July 1934, Musée Picasso, Paris

Inside the belly of the pregnant mare about to give birth in its death throes, a formal banquet of blood and guts awaits the bull. Picasso's burlesque *mise en scène* imagines the scene behind the "slit": the site where representation takes place. First the snout and then the eye of the bull—an abject vision of what cannot be seen—poke around in the interior. The "eye" "discovers" a foetus (a "hard-boiled egg" ["huevo duro"]) "stuck to the twisted roof of the dry tree" ("pegado al techo retorcido del árbol seco"). The mare's spine doubles as the Cross ("dry tree") on which the unborn foal seems to die, its birth aborted. The cannibalistic image casts us back to the *Minotauromachia* and to another *corrida* etching (*Bullfight*, 24 July 1934) of a bull, pierced by a sword, eating the intestines of a gored horse. The text continues as Picasso gets closer to the heart of the rotten sun:

the broken boat moving its feet and undoing the jumble of beautiful bloody intestines that become more and more entangled around the labyrinth of the great mast of suffering prisoner of the game of chess that swims champion among the waves of 'oles'….[43]

Picasso goes in another direction now and, it seems, touches on the reason he no longer paints, and indeed on the impossibility of painting in 1936. The "broken boat" doubles as the womb and spilling guts. The "boat" moves its feet in its death throes, undoing its "beautiful bloody intestines that become more and more entangled around the labyrinth of the great mast of suffering". The labyrinthine mass of guts is the "prisoner of the game of chess". No better description can be found of the abject underlying the geometry that gives form to the work of art, and no better image of melancholia. And so Picasso finds a way to express the power of the abject that has impeded him from making art in the conventional sense.

When making art becomes impossible, Picasso takes representation to another level—the level of the psyche. This 'interior representation', like that of the layered images of the 'scene' above from "20 janvier XXXVI", seems to take on form in an Indian ink and gouache drawing: *Wounded Minotaur, Horseman and Figures*, 8 May 1936.[44] At first, the drawing looks like a study sheet of disparate images. On the left of the sheet is a boat and mast with a 'crucified' female figure (replacing the "intestines" of the text). And overlapping the mast and female figure, a man with his arms extended in the form of a cross reaches out towards the dying Minotaur in a Roman arena. The technique of overlapping forms a kind of pictograph, a condensed visual image of Picasso's poetic phrases. The text and image could operate like Freud's "dream-work": the text's "dream-thoughts" and the drawing's "dream-content"— a "pictographic script" that is in no way "pictorial"—"are presented to us like two versions of the same subject-matter in two different languages".[45] Freud compares the language of dreams (a return to a more primal state of the psyche) to the hieroglyph, a kind of writing which is equally phonetic and pictorial.[46] Picasso's *mise en scène* in the bullring is literally a primal image for him, his first impression as a small child of the eroticism of violence and death in the struggle of the bull and the bullfighter, or the horse. He began to draw and paint the scene at the age of 11 in La Coruña, if the dates of the drawings are accurate, and the subject returned in almost every phase of his art. Picasso, arriving at the heart of the matter, writes:

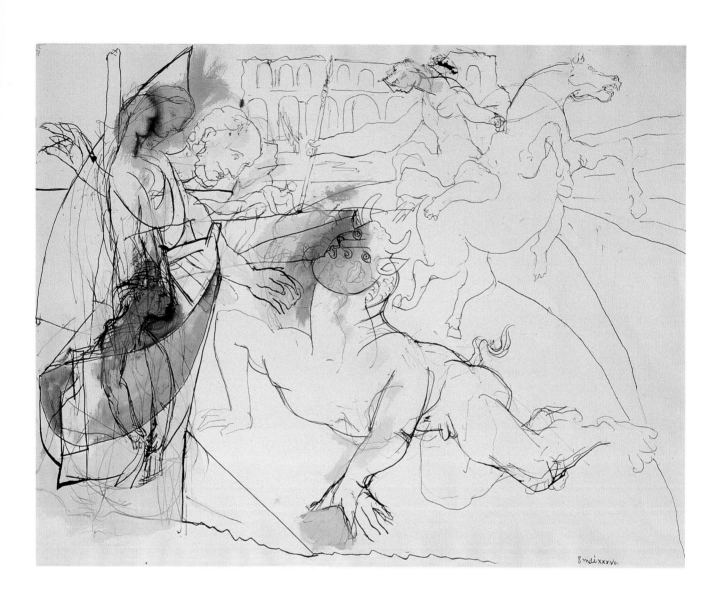

**Wounded Minotaur, Horsemen
and Figures** (*Minotaure blessé,
cavalier et personnages*), 8 May
1936, Musée Picasso, Paris

open book frightened by the sun that opens its mouth and looks at its throat its truth-speaking tongue drawing perspective planes and lines of flight its head turned back and says look at me since you're looking at me look at me since you're looking at me look at me that me now you're looking now look at me that me you're looking at me if now me now me looking look at me that if you're looking at me and if he's looking at her now looking at her if now looking la si la la si la mi si si mi si la si....[47]

"Open book", "sun", "throat" and "tongue" (again, the tongue), "perspective planes and lines of flight" (and thus rational representation) are images that remind us of melancholia, the problem of perspective, the rotten sun, sacrifice and the collapse of the visual. The book (traditionally the symbol of the unity of knowledge or of the classical universe) and the act of reading form part of the traditional imagery of melancholia, an image also depicted by Picasso in painting (*Woman Reading*, Paris, 9 January 1935). The "open book" has a "truth-speaking tongue"—a limp phallic tongue (again speech or words make the art)—with which to draw "perspective planes and lines of flight". The book is frightened of the sun that looks at its throat and its tongue speaking the truth of art. The book and the sun associate the scene with Van Gogh and his paintings of books on a chair (*The Armchair of Gauguin*, December 1888), not forgetting his solar obsession and auto-mutilation.[48]

Then a sacrifice takes place in an arena under a burning sun: a mare is gored by a bull. The book (which becomes confused with the bull) "its head turned back" (like the Christ figures of Picasso's 1929 and 1932 *Crucifixion* drawings) prepares to have its throat slit. With the solar sacrifice, all sense goes and Picasso lets glossolalia take over: the open book commands, or dares the sun, "look at me since you're looking at me" ("mírame ya que me miras").[49] The passage reiterates the presence of the sun, sacrifice/castration and the loss of meaning. The words of the phrase—"ya", "que" "la", "me", "mi", "si"— altered and made senseless, are spoken like an incantation. The sounding out of the dissociated syllables precedes a recitation of musical notes ("la, si, la, fa, mi, re") and numbers written as both numerals and words ("32 33 24 0 2 21" and "2 and 2 are six and three *reals* more and 2 are 10 and six 498678").[50]

Just at the moment of sacrifice, when representation becomes impossible, sounds and numbers fill the space. Does Picasso refer, in the words that follow, to his artistic disruption and to his thinking on representation? Picasso writes: "don't say that you have to sit down and not ever do anything more that you have to see what is good and bad and bad taste…" ("no digas que hay para que sentarse y no hacer nunca más nada que hay que ver lo que es bueno y lo mal y el malo gusto…"). How does representation continue in this uneasy state? At the end of the text the mare's slit belly becomes an open "sewer" ("the sewer that drips from the belly" ["la cloaca que chorrea del vientre"]). The cave-womb-theatre, simultaneously the site of birth and death, becomes abject. Picasso returns representation in its material form to the bull's body, his curling mane forming the script that is "20 janvier XXXVI". The text concludes:

and each little curl of the mane taking the form of a letter combined in a certain way here is the difficult thing they would form the complete page of truth of the story passed through the sieve of the mathematics of the exact poetry of his eye....[51]

The text comes back to the act of writing, as the male protagonist of this drama becomes the site of representation. Each curl of the bull's mane forms a letter that combines to create the "page of truth of the story passed through the sieve of the mathematics [exactitude] of the exact poetry of his eye [the bull's and Picasso's]". The text is formed on the body of the bull, its curling mane replacing the hand of the artist and denying the support of the work of art. Melancholia, abjection, formlessness, writing: Picasso's anxiety over the viability of painting is palpable.

"25 janvier XXXVII- 25 février XXXVII": the ontology of the rotten sun

rage de dents aux yeux du soleil pique—pique rage du soleil de dents aux yeux— yeux aux dents pique du soleil de rage du soleil pique yeux aux dents de rage aux dents—du soleil pique de rage yeux… ("20.2.37")[52]

I quote first in Picasso's original French to emphasise the importance of the original syntax of the passage. Rotten sun, madness, fury, abjection: Picasso's text, written against the background of the Spanish Civil War (declared 18 July 1936) and most poignantly, the fall of Málaga (8 February 1937), goes to the heart of the problem of the image, of rationality and idealism. The rotten sun and the aesthetic of sacrifice, madness and death, becomes, for Picasso, an ontological problem.[53] By separating matter from form, with extreme violence, Picasso lays bare the "concrete fact" ("fait concret") of things and analyses 'existence' in as original a form as you will find in the 1930s. Picasso's artistic activity was not completely dormant in 1937, yet the non-viability of painting remained a live, raw issue.[54]

What crisis of subjectivity and representation is Picasso recording here, in the month of February 1937? Where identity and the structure of the image (the lines that give it form) collapse, in the case of "20.2.37", blown apart in an explosion, the abject materialises. Several times Picasso refers to art, and specifically to drawing, but only to recount art's powerlessness or demise ("drawings feigning indifference to the proper words designating the open mouth of things showing themselves in all their anger in the full crisis of rage").[55]

A cry from an eye/mouth dentata under a rotten sun ("rage de soleil" or sun madness) unleashes a text in which images disintegrate violently. Representation is verbal, a dissociated poem spoken like a cry or a lament. We know the mouth is female—Picasso writes that the "open mouth" in full rage is "lovelier than the sight of a woman in a mirror putting rouge on her lips" ("plus joli que voir une femme dans une glace mettant du rouge sur ses lèvres"). The verbal image precedes the many drawings produced later in 1937 of disembodied female heads thrown back, screaming at the death and destruction of war. We have already seen Picasso's drawings of "teeth with eyes" ("dents aux yeux") and "eyes with teeth" ("yeux aux dents"), on a blue sheet with texts and several eye/mouth/vagina dentata dated "9, 11 octobre XXXVI". The modality of the wide-open mouth, a kind of oral-genital vision, speaks the collapse of the visual—vision, by implication, is shifted downwards, towards a lower organ (the vagina dentata)—and descent into abjection.

The Remains of the Minotaur in Harlequin Costume (*La dépouille du Minotaure en costume d'arlequin*), 28 May 1936, Musée Picasso, Paris

Subject vs. object.
Subject vs. abject.[56]

How will subjectivity (Picasso, the painter) get in touch with objectivity once again? How will meaning be established between these two entities, now that rationality has disappeared, eradicating the distance between subjectivity and objectivity? The artist places himself face to face, not with objects, but with the abject. He reduces himself to a 'crucified' "tartan thread" ("thick planks held together by a tartan thread" ["gros madriers tenus par un fil à l'étoffe ecossaise"]). (Picasso depicts himself as a slumped harlequin/minotaur dressed in tartan in *The Remains of the Minotaur in Harlequin Costume*, 28 May 1936, a model for the backdrop of Romain Rolland's play, *Le quatorze juillet*, performed in Paris, July 1936.)[57] The "tartan thread somehow fallen into the soup of tangled hair of the narrative" ("un fil à l'étoffe écossaise on ne sait pas comment tombée dans la soupe des cheveux emmêlés du récit") situates the subject inside the text made abject. Picasso expresses the negative value of "tangled hair" in a drawing of a woman seated at a mirrored sideboard, *Woman in front of a Dresser*, 10 April 1936, accompanied by a short text that begins with the words "sole sun toothache" ("seul soleil rage de dents").[58] Picasso obscures the image with scribbles, a cross between drawing and writing, that resemble matted hair. The sinister tangled hair effect that 'smothers' the art work in *Woman in front of a Dresser* overwhelms Picasso, the "tartan thread", in "20.2.37". Picasso is emasculated, first by toothache ("rage de dents"), a kind of castration, "sun madness" ("rage du soleil"), and a "sting" ("pique") in the eyes—the body emasculated, vision impaired, language disordered.

20 AVRIL XXXVI.

Seul Soleil rage de dents double la mise
et peint ~~dorade~~ sur la plume du regard
fixe le point de chute et délaie ses
ongles à la danse

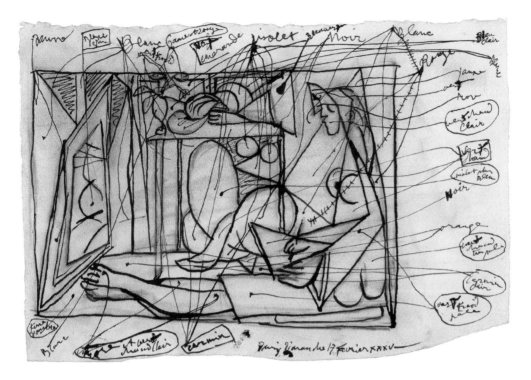

This page: **Young Girl Drawing in an Interior** (*Jeune fille dessinant dans un interieur*), 17 February 1935, Musée Picasso, Paris

Opposite page: **Woman in Front of a Dresser** (*Femme devant un dressoir et poèmes en français*), 10 April 1936, Musée Picasso, Paris

Picasso then turns his attention to the object, writing an objective description of reality—what Sartre refers to as 'quality' of being—as if there were no perceiver, no human reality, or put simply, objectivity without subjectivity. Do objects have meaning in and of themselves, independent of thinking beings (Sartre's "being-for-itself" ["etre-pour-soi"])? Picasso records a phenomenological description of the elements of form in "20.2.37":

the colours numbered in hierarchical order keep dying one by one as they touch the reality of the objects which designate them like the female companion destined to untangle the threads of the drawing imprisoning the images of the phantoms hardened on the fire of the light....[59]

When he writes about colours in the quotation above, Picasso tries to decipher what colour actually means as a property divorced from the "reality of the objects which designate them". Picasso, in discussing his writings with Jaime Sabartés, his secretary, said, "Do you see this tube of paint? The label reads 'Apple Green', yet it is neither an apple nor a colour, but a combination of words and a title to sidetrack one's ideas."[60] Picasso 'deconstructed' the elements of colour and form very specifically in the drawing, *Young Girl Drawing in an Interior*, Paris, Sunday, 17 February 1935, which displays the words for the colours to be used written in 'hierarchical order'. The words for colours appear in bubbles, arranged in an orderly fashion across the top and down the right-hand side of the central image, one underneath another. A line connects each word to the object or area of the work to be coloured. There are five other 'deconstructed' pencil and pen studies for female portraits, with colour notations, dated 4 April-1 May 1936, the period of Picasso's clandestine stay in Juan-les-Pins with Marie-Thérèse after his year's

abstinence from painting. In these anomalous studies dated just before and after his artistic hiatus, Picasso seems to be thinking about deconstructing painting, an activity he carries out in his poetic texts. Picasso's ideas on art are certainly of the moment (although his manipulation of colour and form goes back to his cubist days and his invention of *papiers collés*), predating the publication of Sartre's contribution to phenomenology, *Being and Nothingness*, 1943. Sartre, with obvious links to the German phenomenologist Edmund Husserl, tries to understand the meaning of things and their relation to human reality. Sartre describes the nature of a lemon:

> But the yellow of the lemon is not a subjective mode of apprehending the lemon; it is the lemon. And it is not true either that the object X appears as the empty form which holds together disparate qualities. In fact the lemon is extended throughout its qualities, and each of its qualities is extended throughout each of the others. It is the sourness of the lemon which is yellow, it is the yellow of the lemon which is sour.[61]

Whereas Husserl believes that colour and form are separate qualities, Sartre views these qualities as interpenetrating the whole 'being' of the object. Picasso's "colours numbered in hierarchical order"—colour as an abstraction, independent of the object—"keep dying one by one as they touch the reality of the objects which designate them". Picasso's colours die when they fall from the plane of the abstract into 'existence'. The tangled "threads" of *Young Girl Drawing in an Interior*, as it is described in "20.2.37", imprison "images of the phantoms hardened on the fire of the light". Released from the work of art, the "images of the phantoms", twice removed from reality, playfully rocket around a kitchen, which is a place with a particular significance for Picasso, for it is the scene of his writing and the subject of a number of important paintings.[62] In free fall the phantom images of the drawing hit the windowpanes and their breasts detonate like bombs, causing shattered glass to reduce the kitchen to bloody shreds. Picasso writes:

with what eagerness and what joy and what cries of pleasure and happiness not knowing where to put its head putting its arse in the wind and veils over their eyes letting themselves fall from the ceiling to the floor on their breasts bouncing off the window panes breaking them injuring themselves cutting themselves staining with their blood the walls the floor the ceiling the cooker cutting it in pieces chopping it finely pressing it with their weight....[63]

Now Picasso brings on the abject: "stinking warm excrement" ("puant les excréments chauds"), "rottenness" ("pourriture"), a "drain shimmering with grease" ("l'égout gras et luisant"), a "fine court coat of shit" ("le beau manteau de cour de sa merde"), "the vilest odours" ("odeurs les plus infâmes"), "farts" ("pets"), "fleas" ("puces") and "guts hung in garlands" ("entrailles pendues en guirlandes"). This last relates directly to a "story of flags torn by bullets" ("histoire aux drapeaux déchirés par les balles"). Human waste tinged with death and refuse is the sort of matter that seeps out of form. We don't know where Picasso is going with this hyperbole of abjection, until he introduces images of war into the narrative. The image of

decorously arranged "guts" that hang on nails "stuck in the heart of the story" returns Picasso to his problems with the image, symbolised elsewhere by a horse's intestines and womb. Disturbance and disorder now dominate the whole of existence. The explosion that rips the kitchen apart undoes the logic of the "concrete fact", or reality, as Satre puts it. The kitchen is the centre of Picasso's domain, almost a studio. Picasso writes:

guts hung in garlands on nails stuck in the heart of this story of flags torn by bullets stifled cries of the forks and spoons in the madness of the every-man-for-himself of the concrete fact of the lines drawn with the ruler and the square rule of the plumb line and the compass....[64]

The lack of a framework brings us face to face, once again, with melancholia, a loss of control over reality, symbolised by the tools of measurement rendered useless, and the dissolution of the self. Picasso, in the texts of February 1937, reaches the nadir of baseness and abjection. With a terrible explosion—rather than a cut—colour, line and form are blown apart. No object, no subject, only the abject remains.

Where does this negative state of things leave Picasso and how does the artist make sense of the "sliminess" ("le visqueux", to cite Sartre's exact word) of existence? Picasso's suite of texts "25 janvier XXXVI- 25 février XXXVI", which includes "20.2.37", prefigures Sartre's compelling description of the "slimy" at the end of *Being and Nothingness*.[65] Sartre's "slimy" starts out as a psychological state of repugnance (disgust at a slimy handshake). Certain substances, such as pitch, "an aberrant fluid", honey or glue, as Sartre explains, combine the repugnance of the slimy or sticky with liquidity, or the almost liquid. Picasso, drawing together the moral and physical universe of Sartre and Bataille's 'base materialism' has a rich vocabulary of such substances.[66] With as much black humour as disgust Picasso commands a canary (the bird and the colour that it represents) "to wash yourself in the sink of itinerant menstrual fluid" ("te laver dans l'évier des menstruations itinéraires", "10.2.37"). On the debasement of truth and reason Picasso writes: "sad truth reduced to dust and stuck to the spider webs of pitch-like reason that insinuates itself under the armpits of the plate of shit" ("la triste vérité réduite en poussière et collée aux toiles d'araignée de la raison poisseuse qui s'insinue sous les aisselles du plat de merde", "11.2.37"). "Pitch" and "shit", which furthermore have some semblance of human form, are equivalent substances in the dark world that Picasso portrays. Revelling in the misery of total abjection, Picasso curses:

shit and shit more shit equal to all shit multiplied by shit egg-white gloss pestilential breath of the rose from the winds of its anus double cream cocoon sharpened by the perfect love stuck to its pustules simmering on the low flame of its eyes horror and despair...[67]

Even in such extreme nihilism, as Sartre points out, there can be meaning. Recognising that the slimy has come to represent the whole of existence, he posits: "it is a possible meaning of being".[68] Sartre writes:

> From the first appearance of the slimy, this sliminess is already a response to a demand, already a bestowal of self; the slimy appears as already the outline of a fusion of the world with myself. What it teaches me about the world, that it is like a leech sucking me, is already a reply to a concrete question; it responds with its very being, with its mode of being, with all its matter.[69]

Sliminess is matter without form, soft matter that sticks to us, that absorbs us into itself, threatening and finally dissolving identity. But the slimy is at the same time "a bestowal of self", and herein lies the connection between the subject and the objective world: subjectivity connects to objectivity in this anti-rational manner. For the artist Picasso the formal elements of art, colour and line, are deconstructed, blown apart and returned to matter, to baseness.

We can begin to perceive, if not a pattern, at least coherence in Picasso's thinking which turns on the rotten sun of this alternative universe. The rotten sun provides the key to Picasso's writings, to his relationship with the image and its disappearance from his art. Picasso's decomposition of form, the mark of his contemporaneity as cited by Bataille, has taken him to the limit of his artistic investigations. The strategy, however, has left him mired in the abject, morally debased and unable to act.

"15.2.37", 15 February 1937,
Musée Picasso, Paris

15.2.37. et quel festin dans les tripes du ciel tombé à genoux par terre
et quel ~~vide~~ ~~sepecone~~ sa panse en traversant le coeur la
corne ~~de~~ abondance ~~████████████████████████~~
~~████████████████████████~~

de la fête, du coup muete d'amour et glacée de ~~bonheur~~
~~██████████~~ ~~nordant aux ████ levres~~
~~du bouquet ██████~~ en folie ~~████████~~ la étendue
imense du sucrière disparaisant sous la neige ~~fondue~~ de la glace brisée
en pussière ~~plus~~ quatre chaises une table une armoire deux etageres, un
placard peint en blanc escalier à gauche le tout ~~████████~~
~~██████~~ prix globale ~~████████~~ francs 90 centimes
plus les frais de transport et le pourboire à donner

18-2-37 (mais quel cheval traine ses tripes avec tant de grace envoyant
~~tant~~ ~~tant~~ des baisers et sourires et tant d'oeillades incendiaires et
tant des ventosités si odorantes et perfumées de tant d'aromes
au moment de la mort que ~~le~~ bord du torchon si inquiet mais si
sage ~~████████~~ se derroule dans l'histoire qui nous occupe en ce moment
quand le soir arrive cachant ses intentions colle son oeil à l'oreille de tant
de musiques étouffées sous le coton idrofobe de la couleur ~~que~~ ~~du ciel~~ ~~qui~~ promene à son
bras et quelle fessée ne donne à la creme d'huile qui étend sa tache sur
la robe de tous les jours de la cuisine l'allumete ouvrant son bec à son coeur
~~████~~ par les racines ~~████████████████████~~ bien au chaud
bien peigné bien labé bien chaussé les ongles faites pret à la dance deguisé
en maison publique au gros numero de la date de ce jour à l'odeur d'huile
rance qu'on fait dans le bruit des morsures de fourmies rongeant le
papier de soie l'envelopant l'scene qu'on est en train de chanter sur
l'enclume du bouquet de roses les crachats des lis et des brioches macarrons
petits pains de seigle confiture d'oranges grandes come l'ongle du puce
corbeille d'argent et d'or de diamants et de perles et zafirs d'amétistes
de choux de choufleures et carotes beure fondu sel et la
mesure exacte du tour de passe passe du coup d'aile à donner
sur le feu pour allumer la torche d'eau froide coupée en ronds
de saucisson diablement seduisante dans son deguisement
de larmes et chapotée à merveille par les coups des
destin andouille detrousseur ~~de~~ ~~rôti~~ ~~████████████~~ et
parfait chevalier suant la peur ~~████████████~~ s'oubliant
dans les nuages et pas piqué des vers pour un sou sous son
costume de cristal ~~████████████████~~ mis à secher sous la douche
des ~~████~~ cercles excentriques des mille et une raisons de tout repos ~~████~~ et des
autres ~~████████████~~

The Trauma

Guernica, 1937

Numancia, Freedom![1]

With a great shattering the image appeared. The shattering was provoked by an actual event, the bombing of Guernica, on 26 April 1937. Within five days Picasso had outlined his first idea for the commissioned painting, a *corrida* scene. He began with the rudimentary symbols of his artistic breakdown, an impassive bull and a dying horse, together with others: a young woman holding a lamp and, almost imperceptible, two, or possibly three figures trampled beneath the bull and the horse. Picasso dated the sketch "1er Mai 37", May Day, a day of social solidarity. Now the task of art could begin.

How would Picasso convey the tragedy? And how would the artist, who so recently had not even been a 'subject' (recalling his state of dissolution and abjection in the texts of February 1937), comply with his obligation to express a sense of the social? On the political level, as on the individual, there was crisis and disintegration. Disorder, frenzy and madness threatened to overtake society as a whole as will be seen in the second half of the chapter. And it was along these lines that Picasso seemed to connect himself to the social. Art would no longer be impotent, as Picasso had implied in his text "20.2.37", not even in competition with the immediacy and power of the media images that conveyed the death and destruction of the bombing, seen in *Ce Soir* and *L'Humanité*, and in Josep Renau's mural-sized agit-prop photographic art set to dominate the Spanish pavilion.[2] Picasso's painting, too, would be a very public response to trauma, as the act of rending, of flesh and of the image, is inscribed symbolically in the work. Tragedy is nevertheless undercut by Picasso's satirical cartoon style of the *Dream and Lie of Franco* etchings *I* and *II*, 8, 9 January-7 June 1937.

Trauma and the Image

Impact and trauma, the physical effect of bombing, produced the images of *Guernica*: a bull and a horse, a cock, a young woman with a lamp, a fallen 'soldier', a mother and child, a bare-bottomed woman (rushing from the toilet, Picasso joked), and a plunging figure in flames.[3] Picasso placed these symbolic figures, most, but not all from his recent texts and etchings, in an aesthetic arrangement that took many sketches and seven states to resolve its final form. Picasso's figures are frozen, as though at a moment of impact, a split second before obliteration. The *corrida*, the image of disintegration that had so consistently appeared in Picasso's etchings and texts, would be the centre from which the rest of the work would unfold. In order to unblock himself, it would seem, Picasso painted a work about disintegration, about the collapse of the visual and the impossibility of depicting the destruction of war, the problems that had been haunting him through the winter of 1937.

Picasso surrounds the wounded horse, the central image of the completed work, with a harsh triangle of light emanating from an arc lamp, just as Bataille describes it in "Rotten Sun":[4]

> If, on the other hand one obstinately focuses on it [the sun], a certain madness is implied, and the notion changes meaning because it is no longer production that appears in light, but refuse or combustion, adequately expressed by the horror emanating from a brilliant arc lamp.[5]

Dream and Lie of Franco I
(*Sueño y mentira de Franco I*), 8 January 1937, Musée Picasso, Paris

Dream and Lie of Franco II
(*Sueño y mentira de Franco II*), 9 January-7 June 1937, Musée Picasso, Paris

This material, negative symbol of the sun turns production to waste, to the abject, overturning rationality and rupturing classical form. The lamp, similar to the one that hung in Picasso's new studio at 7 rue des Grands-Augustins, and depicted in Picasso's series of sketches, *The Studio: the Painter and his Model*, 18 April 1937, lights the focal point of the mural.[6] The triangular construction at the centre of *The Studio* evolved from the tripod of an easel and was extended from the ceiling to the floor to define the space in which the artist was painting. The arc lamp is depicted to the right of this space. In the final state of *Guernica*, Picasso fuses the arc lamp, which presides like an all-seeing eye, complete with a light-bulb pupil, with the large triangular cast of its strong light.

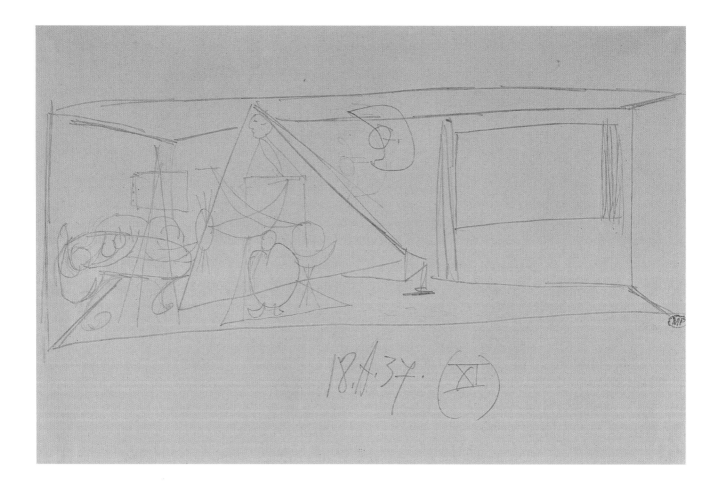

The Studio: The Painter and His Model (*L'atelier: le peintre et son modèle*), 18 April 1937, Musée Picasso, Paris

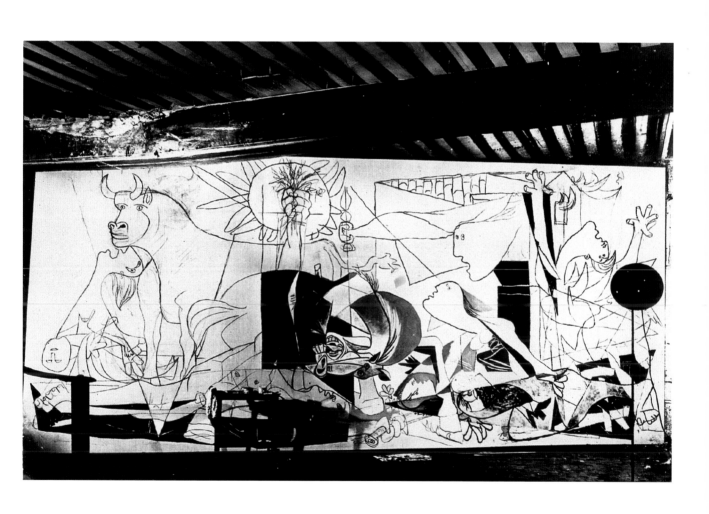

Dora Maar, **Guernica in progress**,
state II, May 1937, Musée Picasso,
Paris

Picasso joins the lamp and the triangle, you could suppose, because the image of the artist isolated in his studio and the artist's sense of rupture, symbolised by Bataille's arc lamp, were uppermost in his mind and took precedence over the earlier political conception of the mural. The lamp takes the place of the sun/sunflower of *Guernica*, state II, and the horse replaces the large fist thrusting a shaft of wheat up to the sun, a reference, of course, to the Republican salute. Picasso's powerful Republican image competes overtly with the raised arm, brandishing a hammer and sickle, of the statue on top of the Soviet pavilion, lifted from his final drawing of *The Studio* series (*The Studio: the Painter and his Model: Arm Holding a Hammer and Sickle*, 19 April 1937) which includes a drawing to scale of Picasso's pavilion space. Picasso had evidently visited the pavilion site for empirical inspiration and roughly outlined the Soviet statue on the front page of his evening newspaper *Paris-soir* dated 19 April 1937. The agonising horse, an image of the Spanish people, as Picasso claimed in his 1944 interview, was altogether more ambivalent.[7] The horse's rhomboid-shaped wound, starkly geometric and black, reflects a light that penetrates no further than its chiselled edge. The screaming cock with an elongated neck 'cut' through by a slice of greyish white colour, reiterates the theme of the rotten sun. Picasso, as we will see, depicts sacrifice and auto-mutilation, an aesthetic as well as a political choice. Death and eroticism—all that Picasso had to suppress to create a work of art—are at the origin of the painting, entitled *Guernica*.

The problem at the heart of *Guernica* was how Picasso would represent the events and emotions that so recently he had found impossible to transcribe into visual form. He had the example of *mise en scène*, a form that combines both the verbal and the visual, demonstrating the equivalence of painting, theatre and language. Picasso first achieved this equivalence in writing, for example "20 janvier XXXVI", 20 January 1936, in which the bullring, and even

The Studio: The Painter and His Model: Arm Holding a Hammer and Sickle (*L'atelier: le Peintre et son modéle: bras tenant une faucille et un marteau*), 19 April 1937, Musée Picasso, Paris

the horse's interior, took on the guise of a theatre. That text conflates words, painting, and performance as sacrifice, a subject close to that of *Guernica*. *Mise en scène*, in Artaud's theory, as we have seen, was a kind of 'active' or 'spatial' poetry that appealed directly to the senses rather than to the mind.[8] Painting, specifically 'metaphysical' painting, was the primary example of this poetic language and eventually music, cries, gesture, architecture, lighting, and so forth.[9] In *Guernica*, each figure is frozen in an exaggerated, highly expressive posture of shock, anger or surprise, a language both visual and aural as Artaud might have presented it.[10] Roland Penrose recalls that "Picasso discussed the movements of the figures as though the painting were alive."[11] This aspect of live performance, of action and sound within stasis and silence, is a factor in *Guernica*'s power to generate raw emotion.

Picasso represents a sense of impact (of the bombing?) or rending, states difficult to represent, through the expressions and gestures of the figures, especially those of the enraged mother and her dead child. Picasso continued to produce drawings of the mother's head as independent works even after *Guernica* was completed, taking the idea to its conclusion in the famous oil painting, *Weeping Woman*, October 1937. The *Guernica* weeping mother stretches her neck upwards, throws her head back and lets out a silent scream. The wide-open mouths of the *Guernica* figures replace the eye at the top of the upturned heads: the aural supersedes the visual. In this sense *Guernica* is a unified, silent scream.

We may recall Artaud's 'war' on the theatre: he reduced representation to the gesture and the scream, acts of the body, rather than the intellect. That war was also a war against himself, against his own body. Artaud describes the physical experience of the scream, an activity that requires feminine weakness, rather than masculine strength: "I want to attempt a terrific feminine. The cry of claims, of trampled down rebellion, of steeled anguish at war."[12] The scream is also silent: "To vent this cry I must exhaust myself. Expelling not air but the very capacity to make sound."[13] In the scream, the actor falls down: "I must fall to scream thus. The scream of a warrior struck down, brushing past the broken walls with the sound of whirling mirrors."[14]

Picasso depicts the grieving mother, the falling figure, the prone warrior and the horse of *Guernica* with their mouths full open in a mute cry. He gives voice to their cry in the Spanish text "Dream and Lie of Franco", 15-18 June 1937, a surrealistic stream of ill omens and base, negative images, including references to the war, art and Spanish food (the frying pan being a place of torment). In this coda to *Guernica* Picasso alludes to the gored horse, "the horse open wide to the sun", and speaks of the "abduction of the meninas", referring to the evacuation of the contents of the Prado to Valencia by the Republican militia. (Picasso had been the museum's honorary director since September 1936.) Screams bring the enraged lament to a close: "cries of children cries of women cries of birds cries of flowers…". José Luis Sert, the pavilion architect, recalled the force and emotion of Picasso's own reading of his poem.[15] As though to emphasise the importance of the scream, Picasso also copied the text in Indian ink above a coloured pencil drawing of the weeping woman.[16] She lies moribund, flat on her back in a position of weakness, with tears streaming from her eyes. Out of her mouth, reduced to a black hole, the echoes of her voice, made with coloured pencil scribbles, rise upwards:

fandango of owls marinade of swords of octopus of ill omen scouring pad of hairs of tonsures standing in the middle of the frying pan naked on the cone of sorbet of cod fried in the mange of its ox heart—mouth full of the jelly of bedbugs of its words—silver bells of snails plaiting guts—little finger in erection neither fish nor fowl—*comedia del arte* of ill weaving and dying clouds—beauty products from the rubbish cart—abduction of the meninas in tears and sobs—over the shoulder the shroud full of sausages and mouths—anger twisting the drawing of the shadow whipping it teeth nailed in the arena and horse wide open to the sun that reads it flies that baste the knots of the net full of anchovies rocket of lilies—street lamp of fleas where the dog is knot of rats and palace hiding place of old rags—flags that fry in the frying pan twist around in the black of the sauce of the ink shed in drops of blood that shoot it [by firing squad]—the street goes up to the clouds tied by the feet to the sea of wax that rots its guts and the veil that covers it sings and dances mad with sorrow—flight of fishing rods and the *alhiguí alhiguí* of the first class burial of the removal cart—broken wings circling over the spider web of dry bread and clear water of the *paella* of sugar and velvet that paints the whiplash on the cheeks—the light covers its eyes in front of the mirror that apes it and piece of nougat of flames bites the lips of the wound—cries of children cries of women cries of birds cries of flowers cries of wood and rocks cries of bricks cries of furniture beds chairs curtains cooking pots cats and paper cries of odours scratching each other cries of smoke biting the neck of the cries cooking in the cooking pot and rain of birds that inundates the sea that gnaws the bone and breaks its teeth biting the cotton that the sun wipes in the plate that the stock exchange and the pocket hide in the footprint that the foot leaves in the rock.[17]

Picasso visualises the cry of the female, her words like images emanating from an orifice—suggesting the eye/mouth/vagina dentata—proof of his investment in poetry as a means of conveying the effect of the bombing. This image of the weeping woman screaming the words of the text "Dream and Lie of Franco" points to a new type of language, part visual, part aural that uses the voice, intonation, colour and drawing, as well as words. This is the extent to which the complex relationship of text and image is implicated in the painting of *Guernica* and the problems of visuality as Picasso experienced them in 1937.

"Dream and Lie of Franco"

(*Sueño y mentira de Franco*),

15-18 June 1937, Musée Picasso,

Paris

fandango de lechuzas escabeche de espadas de pulpos de mal agüero
estropajo de pelos de coronillas de pie en medio de la sartén en
pelotas — puesto sobre el cucurucho del sorbete de bacalao
frito en la sarna de su corazón de cabestro — la boca llena de
la jalea de chinches de sus palabras — cascabeles del plato
de caracoles trenzando tripas — meñique en erección ni uva
ni breva — comedia del arte de mal tejer y teñir nubes
productos de belleza del arce de la pajara — rapto de las meninas
en lágrimas y sen lágrimas — al hombro el ataud relleno de chorizos
y de bocas — la rabia retorciendo el dibujo de la sombra que le azota los
dientes clavados en la arena y el caballo abierto de par en par
al sol que lo lee á las moscas que hilvanan á los nudos de la
red llena de boquerones el cohete de azucenas — farol de piojos
donde está el perro nudo de ratas y escondrijo del palacio de trapos
viejos las banderas que fríen en la sartén se retuercen en el negro
de la salsa de la tinta derramada en las gotas de sangre que lo fusilan
— la calle sube á las nubes atada por los pies al mar de cera que pudre
sus entrañas y el velo que la cubre canta y baila loco de pena el vuelo
de cañas de pescar y alhiguí alhiguí del entierro de primera del carro de
mudanza — las alas rotas rodando sobre la tela de araña del pan seco y
agua clara de la paella de azúcar y terciopelo que pinta el latigazo en
sus mejillas — la luz se tapa los ojos delante del espejo que hace
el mono y el trozo de turrón de las llamas se muerde los labios
de la herida — gritos de niños gritos de mujeres gritos de pájaros
gritos de flores gritos de maderas y de piedras gritos de ladrillos gritos de
muebles de camas de sillas de cortinas de cazuelas de gatos y de papeles
gritos de olores que se arañan gritos de humo picando en el morrillo
de los gritos que cuecen en el caldero y de la lluvia de pájaros
que inunda el mar que roe el hueso y se rompe los dientes
mordiendo el algodón que el sol rebaña en el plato
que el bolsín y la bolsa esconden en la huella que el pie
deja en la roca

In the panel on which I am working, which I shall call *Guernica*, and in all my recent works of art, I clearly express my abhorrence of the military caste which has sunk Spain in an ocean of pain and death.[18]

Pablo Picasso, May 1937

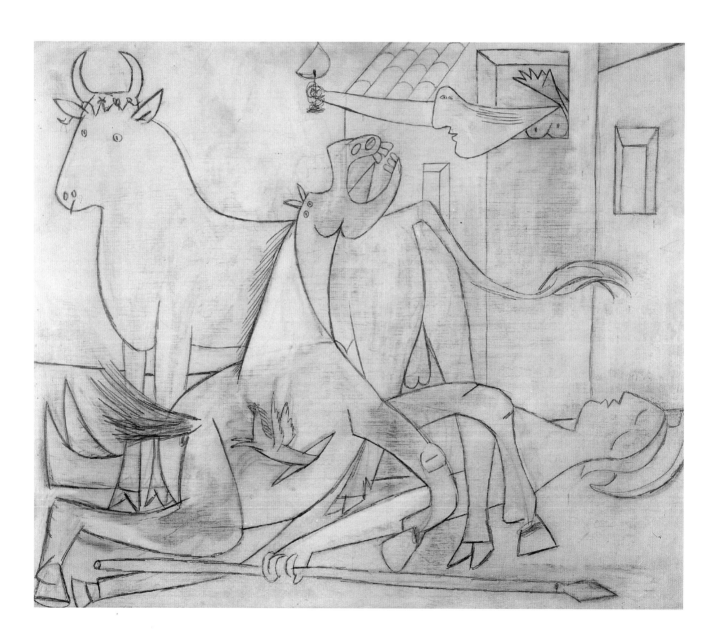

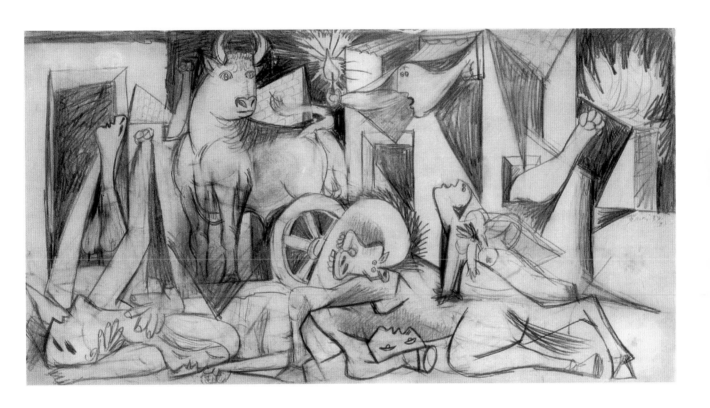

This page: **Guernica: Composition
Study VII**, 9 May 1937,
Museo Nacional Centro de Arte
Reina Sofía, Madrid

Opposite: **Guernica: Composition
Study IV**, 1 May 1937,
Museo Nacional Centro de Arte
Reina Sofía, Madrid

It is apparent that *Guernica* is related to the rotten sun, Picasso's shorthand for the problem of form and his own difficulties with painting, specifically the representation of the trauma of war. This would seem to account for the position of the arc lamp, a symbol of the rotten sun, at the centre of his painting commissioned to inspire a political cause. But what effect does the rotten sun of *Guernica* have on the community, represented here by the female protagonists and horse? As we learn from Bataille, the frenzy that overtakes the individual leading to auto-mutilation and death can also be a communal experience centred on sacrifice.[19] A similar fissure within the collective also seems to be at issue in *Guernica*. Picasso's first idea for his commission, evident in the preliminary drawings of 18 to 19 April, placed the artist, the model and the studio at the centre of the painting. This scheme brings to the fore the idea of Picasso's solipsism, so evident in his writings preceding *Guernica*. Now he was forced to respond to the demand for social content in his painting. As the states of *Guernica* unfold, we can observe how Picasso bridges the chasm between the individual and the social, as well as between subject and object and word and image.

What determined Picasso's response to the bombing of Guernica, given that his painting contains no overt references to the event? Further confusion about Picasso's subject arose, according to the accepted view, from his recycling of figures representing his erotic life. However, it is likely that the subject of *Guernica* occurred to Picasso by another route. A 'hidden' allegory, it would seem, presented itself to Picasso in the legend of Numancia, sacred town of the Iberian Celts, which was seen at the time as a direct parallel to the bombing of Guernica, the spiritual and cultural capital of the Basque region.[20] The Numantinos, besieged by a Roman army led by General Emilianus Scipio, c133 BC, committed mass suicide by the sword rather than surrender. The heroism of Numancia was retold in popular accounts, Latin epic and history and in the play by Cervantes, *El Cerco de Numancia* (*The Siege of Numancia*, 1580), which inspired Spanish nationalism ever after.[21] Spanish Republicans, facing exile or obliteration after the bombing of Guernica, referred to themselves as 'Numantinos', citizens of Numancia, in solidarity with the legendary town.[22] 'Numancia' was the password of the Loyalist troops, and the Basque country, including its capital Guernica, was known as a modern Numancia.[23]

The reference to Numancia, of which there are a number of examples among the preparatory sketches for *Guernica*, appears from the outset. In *Composition Study IV*, 1 May 1937, Picasso depicts an anachronistic fallen figure wearing a classical helmet and clutching a spear, possibly the Roman soldier in Cervantes's play killed and cannibalised by the Numantinos at the beginning of the siege.[24] Picasso seems to follow Cervantes's version of *Numancia*, as he develops his ideas for *Guernica*, which may explain the painting's sense of theatre.[25] Plays from the Spanish Golden Age, c1550-1650, such as those of Cervantes, also had a populist, pro-Republican dimension, which involved government sponsorship of theatrical performances as part of a literacy campaign in the Spanish regions in the early 1930s.[26]

In the pencil sketch *Composition Study VII*, 9 May, Picasso develops his idea for the background, simple geometric dwellings with open doorways. A fire rages from the rooftop on the extreme right. The development of *Guernica* state I, 11 May, is now underway. The image of fire, used for the first time here, is significant, recalling the bonfire in *Numancia* lighted by the townspeople to consume their possessions and deny Scipio booty. The woman

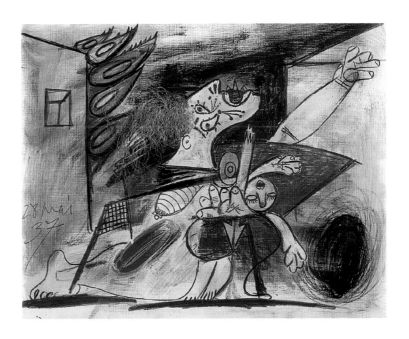

Mother with Dead Child IV

(*Madre con niño muerto IV*),

28 May 1937, Museo Nacional

Centro de Arte Reina Sofía, Madrid

with the lamp, the mother and dead child and the bull remain the same. The horse and most of the figures are stretched out in their death throes, united as they give a defiant Republican salute. Such is Picasso's first attempt to address the social in tribute to the solidarity of the vanquished community, although this image does not figure in the final painting. Picasso radically changes his mind and alters the passive horizontality of the figures in this sketch and in the earlier states of *Guernica* to the verticality and extreme tension of the final state. The necks of the figures stretch upwards, as though to receive the final blow and their arms are held in rigid positions.

Picasso seems to portray the dénouement of Cervantes's *Numancia*, which focuses on the women and children. As the stage directions indicate: "Four women enter, each with a child in arms and others by the hand. They embrace."[27] These words could describe the final four plates of Picasso's etching *Dream and Lie of Franco II*, 7 June 1937, completed a few days after *Guernica*. Each plate depicts a weeping woman and her children. The death of women and children, a strong anti-war image, featured in other paintings in the Spanish pavilion, as well as in the newspaper photographs of the devastation of Guernica.

As they agree to die, the Numantino women declaim: "We offer our necks to your swords first, which is better than seeing ourselves dishonoured by enemies."[28] One of the women shouts: "Numancia, freedom!"[29] Another woman tries to run away, but a Numantino soldier draws his dagger and kills her. Whether by coincidence or intent, Picasso's protagonists could be described as 'offering their necks'. Death by the sword, a curious image in a work responding to a bombing, is evident in a number of Picasso's sketches. The gruesome death of a child features prominently in his studies for the mother and child. In *Mother with Dead Child IV*, 28 May, a finished work in its own right, a bare-breasted weeping woman holding her dead child cries out to the heavens while the buildings around her burn. A large broken spear, like the one held by the fallen 'Roman' soldier in *Composition Study IV,* impales the child's body.

Falling Man (*Hombre Cayendo*),
27 May 1937, Museo Nacional
Centro de Arte Reina Sofía, Madrid

In the final version of *Guernica* it is the horse ("the people", as Picasso later said) that is run through with a broken spear, while the other part of the weapon is clutched by the figure trampled under the horse. As *Guernica* nears completion, Picasso seems to leave the *Numancia* allusion vague, while retaining the power of female emotion. Rather than portraying the sacrificial act, Picasso shows the effect of violent death on the women's faces. The mother with dead child on the extreme left of *Guernica* vents her rage against the impassive bull. "The bull represents brutality", Picasso said in 1944, (although in a sketch dated 10 May 1937, the bull has a sympathetic, human face with eyes like Picasso's).[30] In the final state of *Guernica* the bullring protagonists, a male and a female persona, seem to take on cosmic proportions, evoking something like human suffering (the horse) and blind power, or fate (the bull).

One possible allusion to Cervantes's *Numancia* remains. The plunging figure in flames on the extreme right of *Guernica* goes through several transformations in Picasso's sketches. The figure may refer to Cervantes's character, a boy named Bariato, the last Numantino, who chooses to die by setting himself alight and jumping from the highest tower in the town in a final act of martyrdom.[31] In the *Guernica* sketch *Falling Man*, 27 May, the head of a screaming bearded man and his raised arms protrude through a roof, its horizontal lines resembling, possibly, Picasso's signature striped t-shirt. The sketch prefigures the flaming rooftop of the building on the right of *Guernica*. The roof is wrapped around the plunging figure (a woman in earlier states of *Guernica*) as he falls. Can the human torch really be identified with Picasso? It is difficult to say, although the bearded head in the sketch resembles that of the Christ figure on the ladder in the *Minotauromachia*, said to be the 'artist'.

Now we may be getting closer to Picasso's strategy in *Guernica,* his desire to resist the demand for a literal piece of propaganda art in order to take the tragedy to a more universal level. Picasso went beyond conventional political discourse to arrive at something more complex, and more ambiguous, closer to Bataille's ideas of auto-mutilation, sacrifice and the sacred society. There was at least a confluence of Picasso's thinking on the social in *Guernica* with Bataille's in his essay "Nietzschean Chronicle", *Acéphale*, July 1937, in which he discusses Numancia. Bataille, having seen Jean-Louis Barrault's avant-garde, pro-Republican production of *Numance de Cervantès*, performed in Paris, coincidentally, at the time of the bombing of Guernica, 22 April to 6 May 1937, referred to Numancia as a myth of community for the times.[32] Numancia also proved to be a perfect example of Bataille's theory of sacrifice. Picasso did not really need to have seen Barrault's *Numance* to draw an analogy between the events of Numancia as represented in Cervantes's play and the bombing of Guernica, although the idea is tantalising. The surrealist poet Robert Desnos, who assisted with the direction, and André Masson, who created the sets and costumes, as well as Barrault himself, were friends of Picasso. (It so happens that the studio at 7 rue des Grands-Augustins, where Picasso painted *Guernica*, was on the floor below the attic studio that had been occupied previously by Barrault's fledgling company.)[33]

We must appreciate the timing of Bataille's comments in his *Acéphale* essay, published a few months after the debacle of the Popular Front, a weak anti-fascist alliance of leftist factions and Communists, in March 1937. Bataille, searching for a way beyond the Communist-Fascist dilemma, and believing democracy to have failed, proposed Numancia as a model of community for contemporary society. This was political commitment of an unusual kind in that era of hyperbolic calls to arms. As if to distance his comments from

Numance de Cervantès,
22 April-6 May 1937,
Jean-Louis Barrault production,
Théâtre Antoine

Barrault, a friend and former collaborator of Artaud, wrote about *Numance* as his manifesto: "I found what I had been looking for, a classic off the beaten track. On the social plane I would be bringing my contribution to the Spanish Republicans; in the play the individual was respected, liberty glorified. On the plane of the metaphysics of the theatre I would be going right into the world of the fantastic, death, blood, famine, fury, frenzy. There would be song, mime, dance, reality, the surreal. The river, fire, magic, my total theatre. I threw myself into it without reserve. *Numance (La Numancia):* the confirmation that might very well enable me to go further."

71

'history', a totalising synthesis of events, Bataille uses the title "Nietzschean Chronicle", a radical riposte to the plethora of essays dealing with the theme of Western civilisation in crisis, of which Otto Spengler's influential, proto-fascist *Decline of the West*, 1922, is the primary example.[34] Bataille's "Chronicle", a break with a rational, linear Hegelian concept of history, pits 'Caesarism' (authoritarianism), Roman as well as Fascist, "associated with the glory of the sun", against the 'acephalic' (headless or leaderless) community of Numancia, associated with Night and the Earth, and united by a passion for death. Bataille's concept of the sacred here is orgiastic-Dionysian and Nietzschean, an attempt to wrest Nietzsche's philosophy away from the Nazi ideologues.[35] The fascist myth is directed towards the past, the other towards the future and the hope of renewal. Romans against Numantinos and Fascists against Republicans: two eras of crisis and two struggles for freedom against oppression intersect here.

In his article Bataille elaborates his myth of community into an economic system based on Marxism and the potlach.[36] Bataille describes the economic organisation of Numancia in these terms: "the fundamental object of the communal activity of men, death and not food or the production of the means of production".[37] As in the potlatch economy, the Numantinos sacrifice themselves in exchange for eternal honour and glory, conferred by the figure of Fame at the end of Cervantes's play. Their society achieves unity, Bataille writes, through "a communal awareness of profound existence: the emotional and riven play of life with death".[38] Such ideas, derived from the anthropologist Marcel Mauss, were in 1937 an avant-garde kind of thinking (a precursor of the human sciences) that tried to address objectively the whole life of man and the place of the individual within society.[39] Bataille, realising how illusory that unity is, contends with the 'riven' nature of existence, its insoluble contradictions.

Bataille had grasped the essence of Numancia and the economy of sacrifice, but how are we to decide the extent to which these ideas are relevant to Picasso and *Guernica*? Is their mutual reference to Numancia mere coincidence or is there a genuine confluence of thinking on the aesthetic and social implications of the myth? We might suppose that the relationship of the individual—in Picasso's case, the artist—to the community was problematic for Picasso, considering that he was accused of lacking political commitment. The issue of art and the social had troubled Picasso, as we know, at least from the spring of 1935 onwards, when he turned to writing. This relationship was just as problematic for Bataille, who continued to argue so paradoxically and perversely for communication between the individual and the community through eroticism and sacrifice.[40]

Sacrifice was extremely important for Picasso in *Guernica*, as it offered him a means to connect himself to the social. According to Bataille's theory of the rotten sun, the cut of sacrifice is the motivating act of representation, which Picasso represents as the bull's slitting of the horse's belly. Joined to the allegory of Numancia, sacrifice is elevated to a social theory. Picasso shows his true political colours here. Although he may have been traditionally apolitical, he was emphatically on the side of freedom, rebellion and revolution, not forgetting that only through sacrifice do the Numantinos achieve freedom. (We recall the woman's cry, "Numancia, Freedom!" as the slaughter begins.)

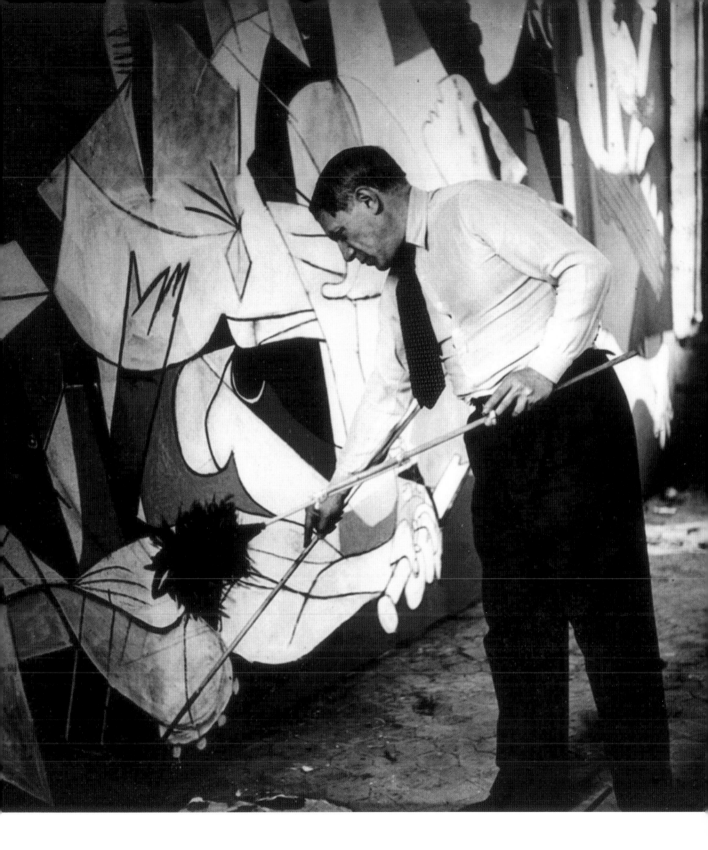

Dora Maar, **Picasso painting**
Guernica, May 1937,
Museo Nacional Centro de Arte
Reina Sofía, Madrid

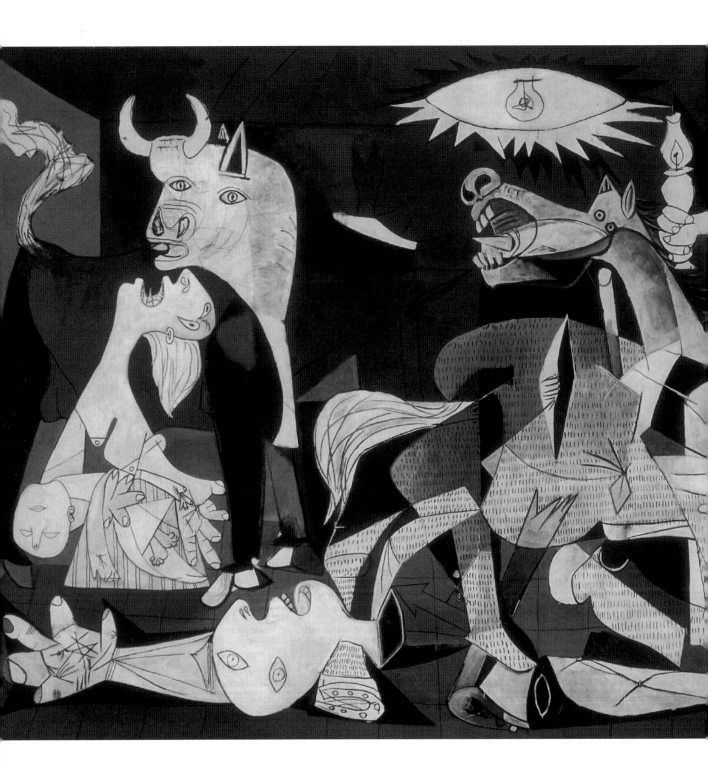

Guernica, 1 May-4 June1937,
Museo Nacional Centro de Arte
Reina Sofía, Madrid

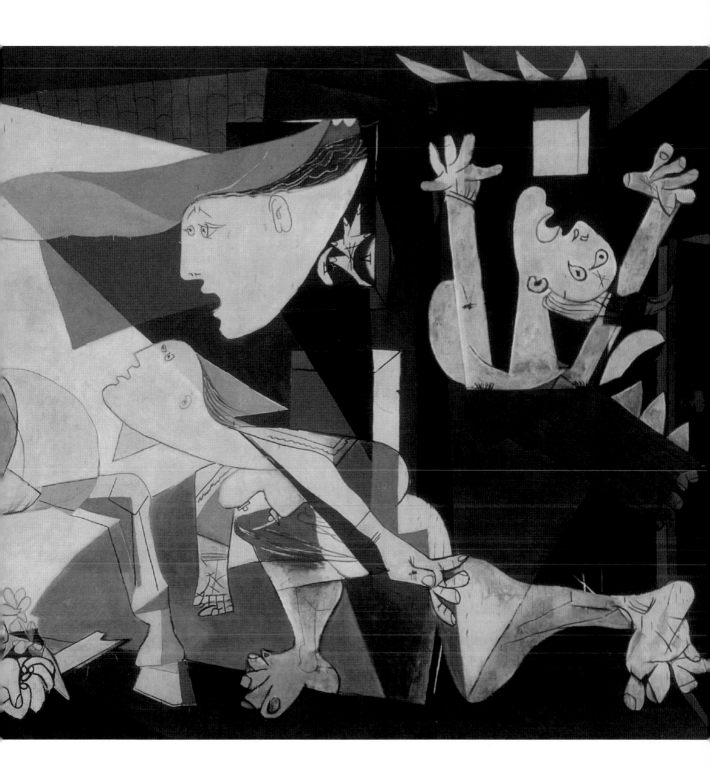

Picasso reveals a passionate populism that places the people above political parties or the state. How much of Bataille is in this reading of *Guernica* (not forgetting that Michel Leiris was a close friend of both Picasso and Bataille) is open to question. The fact that Picasso associates the allegories of the rotten sun and Numancia in *Guernica* encourages us to suppose he may be in sympathy with Bataille's views. More expressly, Picasso seems to be making a statement unique to himself about the role of the artist within society, and that somehow the demise and rebirth of art and society are closely implicated one with the other. It seems fruitless to speculate further on Picasso's position, as his project as an artist was very different to Bataille's.

To understand the finished work in its entirety, we must abandon the close scrutiny of the two halves, as the specific allusions to Numancia (the fallen figure with the Roman helmet) and to Republican Spain (the sunflower/sun, the shaft of wheat, the raised fist) were tried and then eradicated in favour of a purification and compression of the figures and symbols into a unified whole. The strong contrasts of the architecture and the ash-like *grisaille* of the figures remain in tension, the effect of the extraordinary lighting that creates areas of blinding glare and deep shadows. This lighting gives *Guernica* a sense of immediacy, of a sudden flash that implicates the viewer in a liminal experience at the moment of impact before death. Picasso conveys the sense of the people of Guernica taken by surprise from the air in a new kind of warfare, a benchmark atrocity for humankind.

Picasso allowed the destruction of Guernica and the inevitable defeat of Republican Spain to take on a mythic quality by obscuring obvious references to the town and any sense of the historical present. A cosmological and cyclical view of time superseded history. Numancia and its communal sacrifice and the bombing of Guernica converge, broadening the timeframe of the event depicted in the mural. We should refer once again to Artaud, who advocated a return to myth and the ancient conflicts it embodies, up-dated for the modern day.[41] And we should not forget that Barrault's *Numance de Cervantès* professed to carry out Artaud's ideas, insofar as that was possible in the conventional theatre. Bataille commented that Masson's stage sets brought out the essential themes of mythic existence, the conflict between the opposing worlds of Rome and Numancia.[42] On one side of a mobile wall, a vast, rocky sierra in a distant era formed the background to a Mediterranean-style town, Numancia, identified by its emblem of a bull's head with horns enclosing a skull. On the reverse side, Scipio's camp was represented by the emblem of Roman authority, the fasces. Is it possible that Barrault's production of *Numance* could have influenced Picasso? Only the coincidence of the performances of *Numance* with the bombing of Guernica on 26 April 1937 allows us to speculate.

In his tending towards the mythic and the universal, Picasso was able to imagine a kind of multi-dimensional painting, a new approach to representation after his long struggle to find artistic form. "Myth", Bataille wrote, almost paraphrasing Nietzsche, "remains at the disposal of one who cannot be satisfied by art, science, or politics."[43] Numancia exemplified for Bataille a community that replaced these activities with an orgiastic drive towards death.

In *Guernica* Picasso tried to convey in painting ideas that the medium was ill equipped to express—a sense of live performance, of tragedy, in which the whole community could participate. Picasso recognised the forces of conflict, of oppressors against the oppressed, that led to the disintegration of society. Disintegration and dissolution were also responsible for the loss of the

image and the debacle of painting, an activity that had ceased to have any viability in the modern world, or so Picasso seemed to imply in his writings. *Guernica* includes within it extreme contradiction: "the horror emanating from a brilliant arc lamp" and its association with the "elaboration and decomposition of forms"(the aesthetic); and Numancia, a collective form of existence that sought solidarity in suicide (the social). The painting is a radical moment in Picasso's art, as he makes visual the contradictions that lead him away from visuality and into the morass of the verbal, solipsism, and the denial of subjectivity. Picasso tries to reproduce the unity and coherence of the world using symbols that indicate the impossibility of that unity.

In a reversal of the disintegration expressed in his writings, Picasso imbues *Guernica* with a raw power, making the work a compelling witness to conflict. Under the influence of the atrocity of Guernica, he explodes the limits of painting. There can be no other work of art that circulates so freely, whenever and wherever conflict arises in the world. What gives *Guernica* this mythical, iconic status may perhaps be explained by the fact that Picasso seems to have captured poetically the moment before violent death. The bombing of Guernica transformed the nature of conflict for the world. Picasso's response to the bombing transformed the world's view of the representation of war.

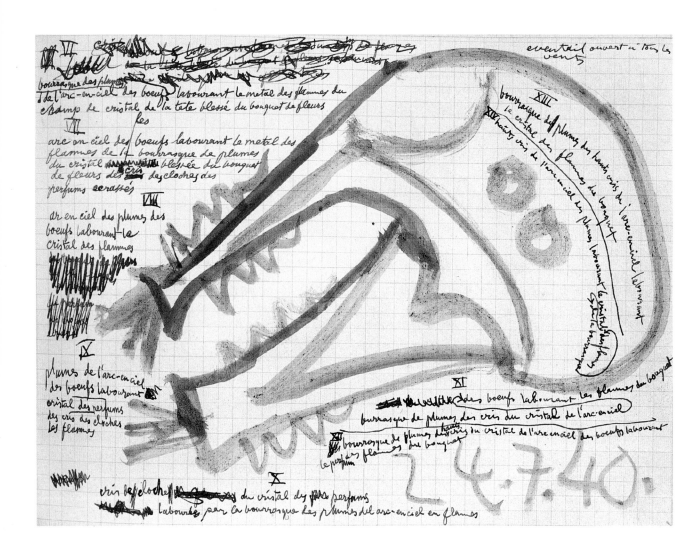

VI VII

bourrasque des plumes
de l'arc-en-ciel des boeufs labourant le métal des flammes du
champ de cristal de la tête blessé du bouquet de fleurs

VII
les
arc en ciel des boeufs labourant le métal des
flammes de la bourrasque de plumes
du cristal blessée du bouquet
de fleurs des cris des cloches des
perfums écrasés

VIII
ar en ciel des plumes des
boeufs labourant la
cristal des flammes

IX
plumes de l'arc-en-ciel
des boeufs labourant
cristal des perfums
des cris des cloches
les flammes

X
cris des cloches du cristal des perfums
labourées par la bourrasque des plumes de l'arc-en-ciel en flames

XIII
bourrasque des plumes des hauts cris de l'arc-en-ciel labourant
le cristal des flammes du bouquet

XI
des boeufs labourant les plames du bouquet
bourrasque de plumes des cris du cristal de l'arc-en-ciel
bourrasque de plumes des cris du cristal de l'arc-en-ciel des boeufs labourant
le perfum flames du bouquet

24.7.40.

The Fall

The *Royan* and *Parchment Notebooks*, 1940

After a sudden cataclysm, the image falls into oblivion. The shift of perspective downwards and the destruction of the classical view of the world occur at the same time. War becomes an obvious symbol of this event. On the day the Germans invaded Poland, 1 September 1939, Picasso travelled to Royan. He worked in a studio in the Atlantic coast town in the months that followed, a period of uncertainty known as the "drole de guerre" (phoney war). In Royan he painted sheep skulls (October 1939), grimacing female portraits (October, November 1939, June 1940) and the famous monumental nude, *Woman Dressing Her Hair*, June 1940. Distorted female faces and nudes, as well as skulls and scenes of rape fill his sketchbook of May to June 1940, produced as the Germans reached Paris on 10 June and Royan on 23 June. The following month Picasso wrote the surrealist-style French text "26.7.40", inscribing it in his sketchbook around a menacing sheep's skull, its sharp teeth jutting out of canon-shaped jaws emitting smoke. During the year he spent in Royan Picasso had three spells in Paris, and from 25 August he finally settled there for the duration of the Occupation.

At this bleak time writing again became an important medium for Picasso, a means of compensation when, as in 1935-1936, he found himself unable to create art. In fact there is no recorded work between his departure from Royan in August and January the following year, that is, between *The Café* at Royan, 15 August 1940, and *Reclining Nude*, Paris, 25 January 1941, the first study for the violent *L'Aubade* or *Woman with Mandolin and Reclining Nude*, Paris, 9 May 1942, considered his most important wartime painting.[1]

Among the key writings of this interval are the short Spanish text "2.8.40" from the *Royan Notebook* (*Carnet Royan*); the single, though substantial Spanish text "7.11.40" from the *Parchment Notebook* (*Carnet parchemin*), and the French play *Desire Caught by the Tail* (*Le désir attrapé par la queue*), 14-17 January 1941, discussed in the next chapter. In "2.8.40" Picasso deals with the problem of rationalism and form, alongside cosmological speculations and, in "7.11.40", enquiry into the mind itself. "2.8.40" includes a geometry exercise with figures as Leonardo might have drawn them in one of his notebooks, although Picasso's freehand geometry is a parody of mathematical exactness. In "7.11.40" Picasso returns to the image of the rotten sun and the charting of mental space, which leads us to the diametric opposite of geometric clarity at the furthest extreme of linguistic dissociation. Shifting to a somewhat more literal, though no less ironic register, *Desire Caught by the Tail*—a Platonic dialogue set as a tragic farce—forces us to confront the effect of 'existence' on art and the artist's life in occupied Paris. Extreme negativity and black humour are Picasso's weapons in a play that works through the aporia (contradictory or irreconcilable positions) of the ideal and the material, at a turning point in Picasso's thinking.

Halasz Gyula Brassaï, **Pigeon on the steps of Picasso's Grands-Augustins studio** (*Un pigeon sur une marche de l'escalier, atelier des Grands-Augustins*), 1943, Musée Picasso, Paris

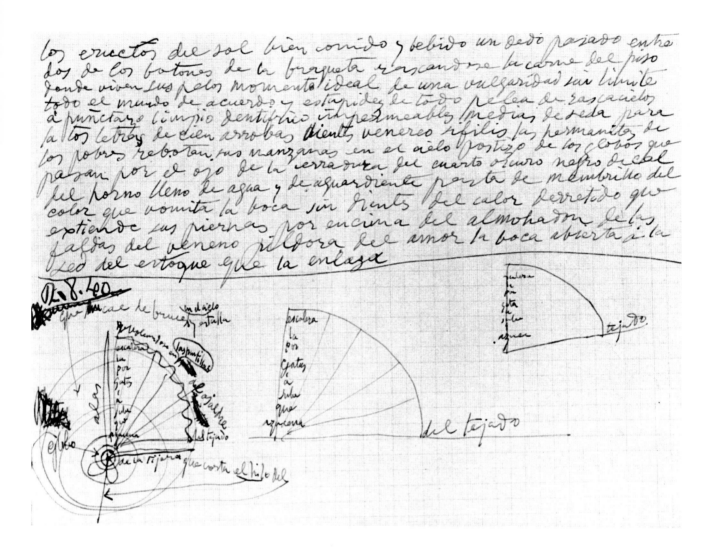

Royan Notebook: "2.8.40"

It is with some surprise that we come across the anomaly of the text "2.8.40", one of a suite of 36 Spanish texts dated "3.7.40-20.8.40"—surprising because words appear with geometric images, or more precisely schemata, that which makes form visible.[2] Each schema is a drawing of concentric circles that represents a plan of the cosmos. The words are written on the diameter and radii within the circle and alongside the points and undulating lines on the circumference, and these words form the beginning of the text written underneath the eleventh drawing.[3] We will examine the drawings and the seven states of "2.8.40" to understand how the diagrams and words work together to create a scenario of elevation and fall, in which the artist is blinded and returns to an androgynous state.[4]

 It is significant that Picasso wrote "2.8.40" about three weeks before he moved back to Paris and his Grands-Augustins studio. Grands-Augustins became the main location where, over the next four years, he produced some 1,000 works, including sculpture (in the bathroom of the apartment attached to the studio). According to Brassaï, who took many photographs of the artist in that studio, Picasso was drawn to it because it fed his nostalgia for the

"2.8.40", **Royan Notebook**
(*Carnet Royan*), page 49 recto,
Musée Picasso, Paris

Bateau-Lavoir (the "laundry-boat"), his bohemian studio of 1904 to 1906 and 1911 to 1912, his pink and Cubist periods.[5] The Grands-Augustins apartment was, of course, a studio of very grand scale with a high ceiling and heavy beams, which reminded Brassaï of a large ship with gangways, storerooms and a hold.[6] The photographer also recounts the building's historic literary connection, another attraction for Picasso. Grands-Augustins provided the setting for Balzac's *The Unknown Masterpiece* (*Le Chef-d'oeuvre inconnu*), a novel about an obsessive artist who, secluded from the world, creates and then destroys his masterpiece and dies.[7] (Picasso illustrated a 1931 edition of *The Unknown Masterpiece* published by Ambroise Vollard.)

We will now see how Picasso maps the Grands-Augustins studio and the sinister fate of the artist living there (Picasso, that is) on to his plan of the cosmos. In earlier texts Picasso dealt with measurement and metaphysics, but now, in 1940, he introduces the abstract language of geometry into his poetic texts and creates an absolute equivalence between them. While geometry contains and rationalises space, words bear the burden of what cannot be incorporated into a system, the material and the contingent. What do "lily" ("azucena"), "flaky pastry" ("ojaldre [hojaldra]"), "scissors" ("tijera") or "fried egg" ("huevo frito")—taken from the first state of the text—have to do with the diameter, quadrant, radius and right angle of the schema to which they are appended? Picasso opposes sensory language, using words to evoke the senses, to the abstract language of geometry, which returns his art to the problem of metaphysics. It seems plausible to assume that words—the register of the sensory or the material—are at the origin of "2.8.40", while the abstract came after.[8]

The schemata are polyvalent and their geometric lines, which might otherwise suggest stability of meaning, are open to various interpretations. Picasso alters the meaning of the lines by substituting a word or interpolating a phrase that takes the text in the opposite direction. We might imagine that Picasso's plan of the cosmos posits an entity like the *primum mobile* (prime mover), the love of God, designated by the outermost sphere in Aristotle's conception of the heavens. The words written on Picasso's diagram introduce the other and eroticism into the system, suggesting that eroticism, a force essential to the existence of the image or the work, is the prime mover of the artist's universe. The drawings give a sense of rotation, of spiral movement around a central axis, of mortality, becoming and infinity, and of male and female entities that never meet, in a repetitious process. As with Bataille's parodic world-view in "The Solar Anus", 1931—another text on the fall—sexual movement, rather than divine love, and planetary rotation are the primary motions of a degraded universe.[9]

The drawings of "2.8.40" appear to be a gloss on the second century Ptolemaic schema of the cosmos, popularised by Dante, in which the static earth is surrounded by seven rotating planets, the fixed stars and, beyond that, the heavens. Picasso's drawings also incorporate the older notion of the universe as a sphere with the divinity at the centre. The phrase "to the roof" ("del tejado") that labels the diameter of the circle indicates that Picasso places his studio and its spiral stairway at the centre of the cosmos. The narrow, crumbling stairs were a prominent feature of the dilapidated seventeenth century building at 7 rue des Grands-Augustins, as can be seen from Brassaï's photograph, October 1943. The photographer describes the dark, steep climb, just as in Balzac's novel, to Picasso's apartment on the top two floors, the main entrance to the building having been condemned.[10]

In the first state of "2.8.40" on sketchbook page 49 recto, the following phrases are appended to the drawing with no indication as yet of their linear order:

lily that climbs cat-like the stairway to the roof rolling round and round on the small points of the flaky pastry wings of the scissors that cut the string of the balloon that falls flat on its face into heaven [or the sky] and explodes[11]

Each of these phrases, which have an association with Picasso's studio, label a part of the first schema, sketched imperfectly in the left-hand corner of the page. The eight words of the first phrase, "lily that climbs cat-like the stairway" ("azucena que sube a gatas por la escalera"), are written one above the other in ascending order like the rungs of a ladder. The 'ladder' of words, considered in geometric terms, forms the radius that extends from the centre of the circle straight upwards. This radius, which overlaps with the 'ladder', could be considered the topmost step of a spiral stairway created by the radii fanning out in the top right-hand quadrant of the circle. The ladder of words is therefore at the top of the "stairway". The "lily", a female persona, stealthily winds her way up the stairway. The phrase "to the roof" appears to the right of the circle. These phrases, it would appear, refer to Picasso's actual studio stairway and the ladder that provided access to the roof. This gives a different perspective of the drawing, which can be viewed both horizontally and vertically, in plan and elevation.

We know the layout of the Grands-Augustins studio from Françoise Gilot's description of her first visit there in June 1943.[12] Picasso guided her around the large apartment downstairs, which included the cluttered salon where he kept an assortment of musical instruments—a reminder, he said, of his cubist days—on Louis XIII chairs; the sculpture room with his painting collection (Matisse, Vuillard, Rousseau and Modigliani) and the large painting studio above. Other rooms contained his famous glass vitrine of curiosities and his etching equipment. Apart from the covered spiral stairway leading up from the courtyard, there was another connecting the two floors of Picasso's apartments. A ladder was used to go up through a small door into a beamed attic room—the "forest" Picasso called it—that overlooked the rooftops of the Left Bank.

In the first schema that pertains to the first state on page 49 recto, the phrase "rolling round and round on the small points of the flaky pastry" curves around the circle, following the undulating line that demarcates the "points of the flaky pastry", or edges of the steps. The stairway's loose, crumbling plaster, visible in Brassaï's photograph, must have reminded Picasso of flaky pastry. The undulating line also mimics the lily's spiralling progress up the stairs. Tracing points, placed at intervals on each outer curve of the line, provide the geometric equivalent of the word "points". Picasso emphasises the edges of the steps in the eighth, ninth and tenth schemas on page 50 recto. Note the upper right-hand quadrant of these drawings that have either a zig-zag or ribbon-like line and tracing points along the arc.

Continuing the first state written on the first schema, the words "wings of the scissors that cut the string of the" appear along the arms of the open scissors superimposed on the circle. An arrow attaches the word "string" to the line drawn from the centre of the circle downward. The arms of the scissors are fully opened to form two sides of a right triangle that fit into the upper right quadrant of the circle. The scissors are ready to cut the string of the balloon: the word "globo" ("balloon") designates the centre of the circle, together with another arrow between the word and the innermost circle of the schema, which doubles as the hinge of the scissors. The final phrase of the first state is written across the top of the schema and is connected by an arrow to the second outer circle: "that falls flat on its face into heaven [or the sky] and explodes". In the punch line of the first state, the scissors, a female persona, identified by the opening and closing motion it makes, 'castrates' the balloon by cutting its "string". The deflated balloon then becomes the larger outer circle that is also "heaven". (In the sixth and eighth states of the text the word "heaven" refers to the outermost circle). "Globo" can also be translated as "eyeball", in which case the cut string would refer to the severed optic nerve.

"2.8.40", Royan Notebook (*Carnet Royan*), page 49 verso, Musée Picasso, Paris

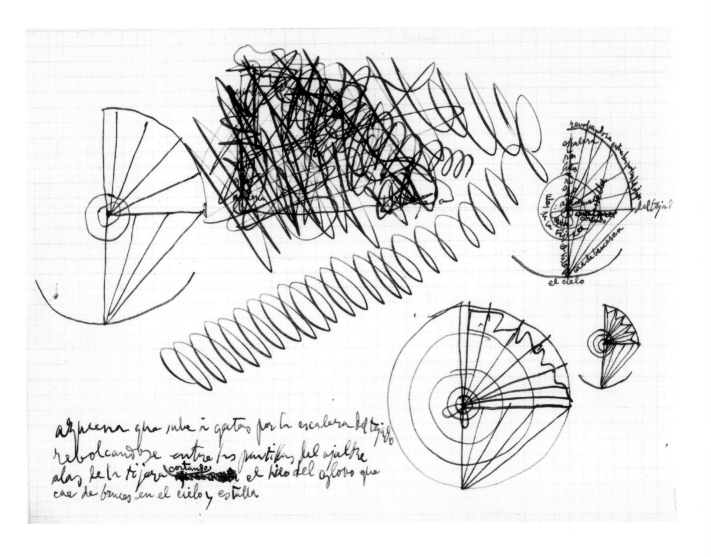

In the second state on sketchbook page 49 verso Picasso writes the text in full for the first time in the lower left-hand corner with two minor changes: the preposition "in" ("en") becomes "between" ("entre") and the phrase "that cuts" ("que corte") becomes "cutting" ("cortando"). Four schemata and scribbling appear on the same page. On sketchbook page 50 recto the third, fourth and fifth states of the text appear successively in the top right-hand and the lower left-hand corners. A small change occurs in the third state, in which "flaky pastry" ("ojaldre [hojaldra]") is replaced by "sweet pastries" ("hojas del dulce"). In the fourth state the word "wings" takes the place of "scissors" in the text and on the ninth drawing, so that the "wings" cut the string. In the same state the balloon falls "helplessly" ("desamparado") before it lands.

In the fifth state written in the bottom left-hand corner of sketchbook page 50 recto, Picasso introduces the idea of the lily cutting the string with its teeth (a kind of vagina dentata):

lily that climbs cat-like the stairway to the roof rolling its wings between the honey pastries that cuts with its teeth the string that enchains the balloon that falls helplessly flat on its face into the heavens and explodes[13]

The increasingly erotic direction of "2.8.40" is indicated in words, but the added words do not appear on the drawings on the same sketchbook page. The lily, with the balloon in thrall, voluptuously rolls its wings between the "honey pastries", giving the sense of female sensuousness and the "sticky" (Sartre's word for the viscous). When the lily cuts the balloon free from the centre of the circle, it becomes "enchained" by its loose string and falls "helplessly" with the same fatal result.

In the sixth state written on sketchbook page 50 verso Picasso reorients the drawing and changes the fate of the balloon which, rather than falling helplessly into the heavens, belly-flops into a pan of boiling oil, represented by the outer ring of the final schema. Picasso abandons the notion of heaven and the cosmos and the reference to the studio for a catastrophic fall into the "frying pan" of hell. No words appear on the eleventh schema, the most abstract, while the basic geometric features are plainly visible: the outer circle (partially shown), central globe within a small inner circle, diameter and radial lines, some of which have pointed edges. The text of the sixth state, deletions and all, is written to the right of the schema:

lily that climbs cat-like the stairway to the roof rolling its wings between the honey pastries that explodes upon falling flat on its face the balloon onto the boiling oil in the frying pan fried egg of the fan[14]

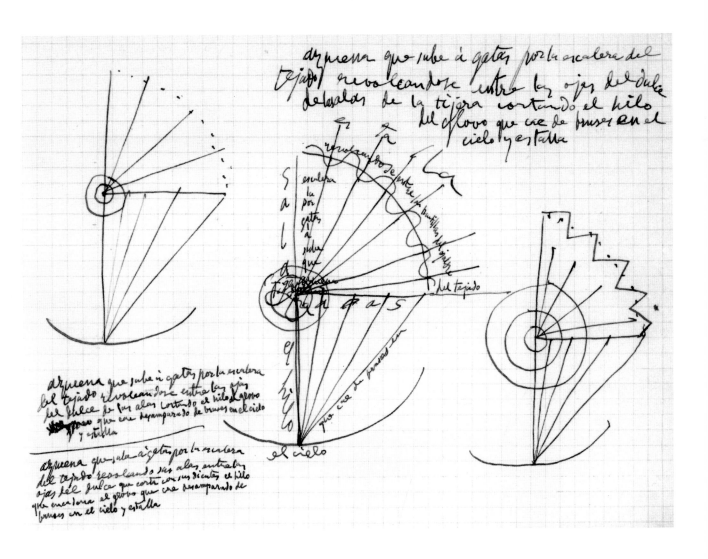

This last drawing, it seems, relates to the final phrase of the sixth state "fried egg of the fan". The radial lines, with jagged edges and tracing points that formed the spiral stairway in previous drawings, turn into an open fan—again a female persona and one that often figures in Picasso's poetry. He alters the previous understanding of the inner circle and its outer ring as balloon or eyeball which becomes a "fried egg" ("huevo frito"), a collapsed phallus/eye, possessed by "the fan" ("del abanico"), indicating with the Spanish preposition "de" ("of"), the possessive, the "fan's fried egg". The circle and its radii no longer refer to the plan of the cosmos, but to a prison with bars made by the "fan" to contain the "fried egg". The eleventh drawing, conceived as plan, shifts the view downwards, so that the radial lines could indicate a bottomless spiral stairway, a conduit to the frying pan of hell.

After the decentring of vision, the seventh state, which takes yet another direction, completes "2.8.40":

"2.8.40", **Royan Notebook**
(*Carnet Royan*), page 50 recto,
Musée Picasso, Paris

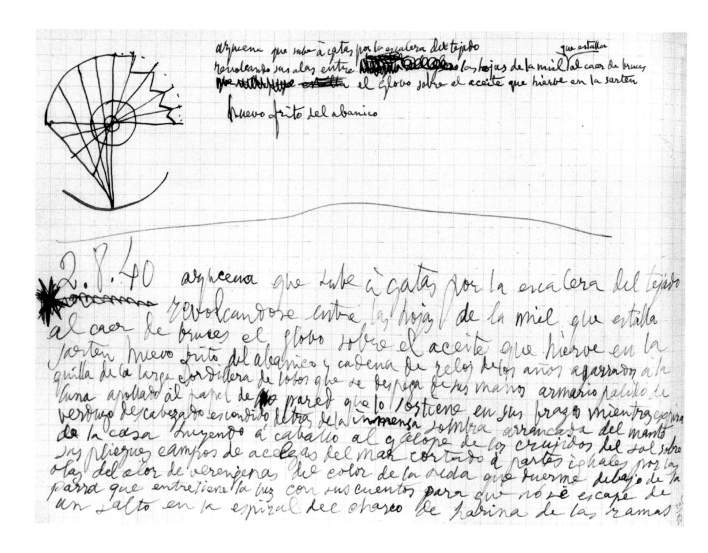

lily that climbs cat-like the stairway to the roof rolling round and round between the honey pastries that explodes upon falling flat on its face the balloon onto the boiling oil in the frying pan fried egg of the fan and watch chain of years hanging on the hull of the long mountain range of wolves that detaches its hands pale cupboard of glass leaning on the wallpaper that holds it in its arms while it expires decapitated executioner hidden behind the immense shadow torn from the cloak of the house fleeing on horseback at a gallop from the cracklings of the sun on its folds beet fields of the sea divided in half by the waves of the odour of aubergines of the colour of silk that sleeps under the trellis that entertains the light with its stories lest it escape with a leap into the spiral puddle of flour of the branches of the lemon-tree of the feather duster of ribbons hanging on the convulsive play of the trail that floats its mane of varnish on the burnished metal of the bitter taste that the light deposits on its forehead pull the curtain and put out the lights [15]

In the seventh state Picasso reverts to words alone, and the tone of the text enters another register, the stability of geometry and structure having been removed. He writes of fantastic landscapes and a vast space 'outside' that alternate with intimate interior spaces suggesting, from the information provided by Brassaï and Gilot, the studio.

With the phrase "watch chain of years" (the eleventh drawing also resembles a pocket watch and chain) the seventh state takes us into deep time and, presumably, Picasso's mental or unconscious life. The "watch chain of years" hangs on the "hull", a reference to the studio's beamed ceiling that resembles a ship, but the image takes him far away to a "mountain range of wolves". The phrase "pale cupboard of glass" sounds very like Picasso's cabinet of curiosities, a well-known accoutrement of his studio, proudly shown to visitors. The text grows darker as the cupboard "expires" and a "decapitated executioner" lurks in "the immense shadow torn from the cloak of the house". As soon as Picasso writes the phrase "decapitated executioner", he thinks next of the sun whose "cracklings" snap at the folds of the cloak. Again to the 'outside' and "beet fields" like a "sea" and "the odour of aubergines of the colour of silk".

The final conceit of "2.8.40" takes place at the end of the day in a Mediterranean-style house in which the light literally dies, however much the 'trellis' tries to make it stay by telling it stories. The light is made visible inside the house because of "the convulsive play of the trail" left by a feather duster on a varnished surface. The fading light deposits a "bitter taste" like "burnished metal" on "its [the surface's] forehead". These images refer to the embodiment of light, or the material effect of light on objects, ultimately the condition that makes vision possible, although there is no evidence of a viewer. Picasso ends with a theatrical allusion: "pull the curtain and put out the lights", an indication, perhaps, of darkness descending on the world and his longing for the security of his artistic universe.

"2.8.40", **Royan Notebook**
(*Carnet Royan*), page 50 verso,
Musée Picasso, Paris

While "2.8.40" equates the text with the cosmos, the opening page of "7.11.40" in the *Parchment Notebook* presents a map of the mind which, once again, illustrates the fall of the elevated.[16] As to the content of "7.11.40", metaphor itself collapses as concrete and abstract images become entangled. The repetition of the preposition "de" ("of") at the beginning of most phrases creates a sense of levelling and endlessly extends the text. There is no apparent order in the way words are linked in this dissociated space, no hierarchy of the vertical over the horizontal. Picasso brings the notion of metaphysical terror to a crescendo, as heavy bombing occurs elsewhere and a feeling of threat prevails in Paris.

Picasso centres his aesthetic activity in this text on the orifice: the rotten sun collapses with the anus to create an orifice on to which the other bodily orifices pertaining to the senses—eye, ear, nose and mouth—and genitals, converge. Taking on the full implications of the rotten sun—the collapse of form—in "7.11.40", Picasso could not have expressed this negative aesthetic in a more extreme fashion. Anal eroticism, of course, was a subject closely associated with Bataille, the author of "The Solar Anus", 1927, an essay published as a *livre d'artiste*, *L'Anus solaire*, 1931, with illustrations by Andre Masson, in Daniel-Henry Kahnweiler's (Picasso's dealer) Editions de la Galérie Simon. In the parodic universe of Bataille's essay, "The Solar Anus", opposites attract and collide and hierarchies are deposed. Bataille sets down the scheme in verse form:

> Everyone is aware that life is parodic and that it lacks an interpretation.
> Thus lead is the parody of gold.
> Air is the parody of water.
> The brain is the parody of the equator.
> Coitus is the parody of crime.[17]

According to Bataille's world-view the anus is "the filthy parody of the torrid and blinding sun".[18] The "solar annulus" needs only to drop several letters to become the "solar anus".

Picasso, unlike Bataille, was not known to harbour violent excremental fantasies, rather his aim in "7.11.40" seems to be more ascetic, though no less obsessional. Picasso detonates form, revealing the raw elements of rhythm, sound and colour, particularly the colour yellow, the colour associated with the sun, as a universal. Picasso's "7.11.40" deals specifically with the rupture of form, during the unsettled period in the autumn of 1940 when (the exact date is not known), due to the problems posed by the wartime curfew and the difficulty of transport, he left the greater comfort of his apartment at rue la Boétie on the right bank to live as well as work in his Grands-Augustins studio.[19] Brassaï's photographs of mid September 1939 reveal an almost empty apartment, apart from an enormous antique stove, his antique printing press from Boisgeloup and the large collage *Women at their Toilette*, 1938.[20] Picasso must have installed himself—including his artwork and other paraphernalia mentioned in Françoise Gilot's and Brassaï's accounts—over a period of time.

With the five-month gap in Picasso's artistic work in mind, presumably due to these difficulties at the beginning of the Occupation, we will try to make sense of the long, tightly packed text written in such a maddening way in the *Parchment Notebook*.[21] He connects the many additions to the text with lines

and arrows, sustaining the momentum over 44 notebook pages. The lines and arrows give a very tenuous sense of form to the dissociated images in Picasso's mind, a kind of self-cartography. Turning the notebook sideways to use its full width, Picasso divides each page into an upper and lower section, writing first on the lower page and then adding to the text in the space above. He loads the images to the point of bursting, both visually and linguistically. The word "full" ("lleno") appears with great frequency, as in "belly so full of shit that it overflows with fat and spits out the little palace of its guts'" ("la barriga tan rellena de mierda que revienta de gordo y escupe el palacete de sus tripas"). Or, "the cart full to the bottom of the well of the huge belly of bones" ("la carreta llena hasta el fondo del pozo del panzurrón de huesos"). Disgust at the material body is extreme.

But what is the logic to the additions? If there is a pattern, it has to do with the levelling of opposites, the bringing down of the elevated to the most base level. Picasso opens the text with a playfully erotic passage, a kind of preamble on the origin of the text, written on the top right-hand corner of the page, in the opposite direction to the rest of the writing, beside the date "7.11.40":

leap and jump between the legs of the cardboard wheels of the day that open the chains of its leaves a handful of perfumes so heavy chicken broth and soups of mercury so light that the merry-go-round that milks the wine of the wings between the pages of the book crumbles between its teeth the blood that bursts from the laurel leaf of the wounded knife[22]

The day dawns—a form of parturition, it seems—and, like a chain reaction, sets off the words of the text composed with "wine" on "the pages of the book". The passage that follows, crammed into a space on the top left-hand corner of the page, is an altogether more sinister 'unchaining' of the text:

from between the lips of the nozzle of haemorrhoids of the leaves of slate singing their litanies in these flea-ridden rotten clouds.[23]

The anal orifice, the "nozzle of haemorrhoids", as Picasso calls it, places the anus in the text in the most concrete terms.[24] We would laugh at the irony of conceiving a text out of this painful hole, if it were not so serious. The "nozzle" furthermore has "lips", giving the hole the semblance of a mouth, or female genitals. The text emerges from "between the lips of the nozzle" like "leaves of slate", the antithesis of the burgeoning leaves of the opening passage. There is something sacred here, "the leaves of slate singing their litanies", but Picasso prefers to lower the tone and thus strip away any pretentions about the sacredness of art or the elevated in general with the phrase 'in these flea-ridden rotten clouds". He sets a pattern that continues throughout the text as the elevated is debased. And so he proceeds to write: "the verruca-ridden and miraculous fountain" ("la fuente verruguera y milagrosa"), "the feather duster farting incense of plain chant" ("plumero pedorreando el incienso del canto llano") and "syphilitic rockets" ("sifilíticos cohetes" ["rocket" being the Spanish slang for penis]).

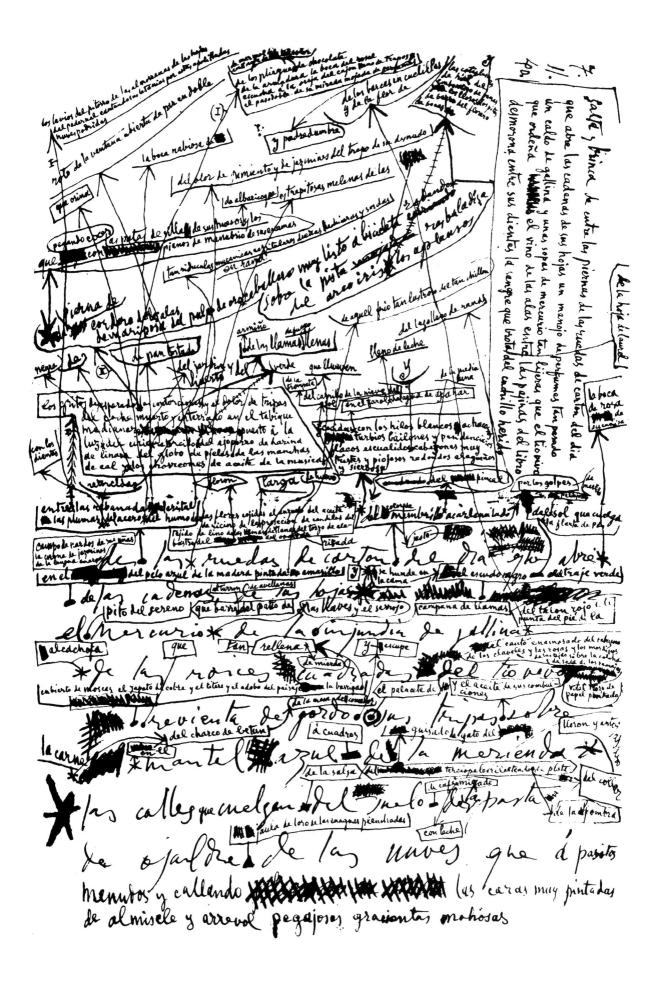

What marks out Picasso the painter is the place he gives in the text to colour, providing it with more prominence than any other element. Colour takes on a material, anthropomorphic existence: colour becomes flashy, garish and intense, exploding the limits of its objectivity. Manuscript pages 16 and 17 record the antics of colours (following the editors of *Picasso: écrits*, italics highlight the main body of the text on the lower manuscript page 17.):

marinade of cock's feet [crow's feet] and crest [of a bird or animal's head] of mortar with onion and pepper *of the trumpets* partly opened *of acid lemon* and garish *that* stubbornly *drips* from the border *of tiles* billing and cooing mauves [also mallows] *of the* handful of blue pink infra *pale* very chubby pleasant and showing off and discreet in love fiancé *of the blue* tender faithful and accomplished putting its foot in the puddle of light stuffed in the coloured cape of the gnawed bone of fishing rods figs very black and full to the brim of the violin tune of the jealous furious colour green pale vermilion of the contrite lover of the colour distributed so parsimoniously on the iron scaffolding and the guitars of *velvet* of the open hand of *bottle green* drawing and measuring with a lovely *flourish of the cape* of the snail wild and smiling true light-hearted fearful and very pleasant man *of the orangey green juice* and devoted servant *of the green* yellow *reddish* very mister green and horrible *green* angry with the *blue* pure and pale and *blue* black and *gold of the gilt* of gold and *silver* the very mischievous *apple green of the almond green that….*[25]

In the page-long quotation from "7.11.40", Picasso writes about colour in a joking manner that disguises his serious aesthetic concerns about form and representation. The page includes one of Picasso's famous 'recipes' for a "marinade" ("salmuera") which combines spicy and earthy tastes, music and intense colour and involves all of the senses. The "trumpets", either a flower or musical instrument, are "acid lemon", a colour that combines the idea of sharpness, referring equally to taste and sound. Picasso frees colour from things: colour itself becomes the subject and the object. The painter's palette—"vermilion", "bottle green", "acid lemon", "almond green", "gilt", "green yellow reddish" and "blue black"—is what matters here, rather than 'natural' colours. In the opening of the passage, colours exist independently of a viewer and freed from any 'support'. Further along, the colour "blue" is associated with "the puddle of light" and the word "colour", with "the iron scaffolding". The first refers to what makes colour visible to the eye; the second to what gives form or structure to colour.

Another stratum of the text returns to the rotten sun and its association with anality. The sun itself need not appear in the text, as the mention of one of the images we know to be associated with the rotten sun suffices to indicate that a cataclysm is imminent:

"7.11.40", Parchment Notebook (*Carnet parchemin*), pages 12-13, 7 November 1940

sweets of whitish squeaking *liquid* from the gauze of the plaster moistening *of the wall stuck to the* filthy *scab of* the dirty arsehole of the sky....[26]

The words bring to mind tastes, textures, sounds—evocations of Picasso's childhood perhaps. The "whitish squeaking liquid" suggests the transformation of syrup into brittle crunchy "sweets" which are in turn associated with scabby wounds, sticking plasters, a wall and "the dirty arsehole of the sky". Often in "7.11.40" Picasso refers to home remedies: "mustard plaster" ("paño de mostaza"), "poultices of ice of the swelling of veins" ("cataplasmas de hielo del embarazo de venas"), "gauze of the sticking plaster" ("gasa del emplastro") and the "avid licks" ("lametones") of "the tongues of San Roque's dog" ("las lenguas del perro de San Roque" [the dog that licked plague wounds]). The liquid running from the gauze of the plaster moistens "the wall stuck to the filthy scab of the dirty arsehole of the sky". The wound, the site where form collapses in Picasso's aesthetic, has become a hardened scab stuck to a bit of gauze in need of moistening to remove it. The "filthy scab" of a wound, the orifice of the greatest importance for Picasso, collapses into the "dirty arsehole of the sky". The anal rim, the scab and the sun are conflated in a single orifice that evokes the impossibility of form and of the artist's difficulty in producing a work of art. Within the extreme dissociation of "7.11.40" the sun explodes, detonating its yellow colour, giving the sense of a violent shift in vision:

the light crushed thrashed on top of the monstrous stage curtain of the eye nailed to the split in the sun *that is dragged* inside *the black purse of the poppy* greenish blue exploding in the bottle full of howls the crackling of broken cane from the heavy and dense load of *yellow* yellow *to the limit of* its yellowness and *flashy intensity*....[27]

The sun appears to disintegrate on top of the eyelid, "the monstrous stage curtain of the eye", as the eye and the sun collapse. The eye is 'crucified', "nailed to the split in the sun", and "dragged inside the black purse of the poppy", like the bull's carcass in the bullring (the word *arrastra* refers to the 'dragging off' phase of the bullfight). The "poppy", a flower associated with the goddess Demeter and therefore with death and oblivion, explodes its "greenish blue" inside the "bottle full of howls". The sun cracks up under the burden of its "yellowness" and, Picasso adds, its "flashy intensity". The word "pinturera", which means "flashy", comes from the Spanish *pintura*, or painting. The various debasements in "7.11.40" lead to the deposing of the most elevated symbol, the sun, in the parodic form of a straw basket.

 The story of the sun does not end here. Towards the close of "7.11.40", Picasso cites another motif that includes the symbolic image of the horse's guts, the sun, the ear and the "arsehole":

the guts of the wounded horse on its back caress the ear and arsehole of *the light that is crushed on the straw basket of the sun stretched out full length sleeping on the beach* of sand and stardust....[28]

Picasso returns to the bullring scene of spilled guts under a bright sun: the guts "caress the ear and arsehole of the light". We learn of the fate of the sun, a crushed straw basket sleeping peacefully "stretched out full length" ("a pata larga") on the beach. The whole episode of the sun and eye exploding describes, after all, the intense light just before sunset, as the sun appears low on the horizon. Such is Picasso's motif of the collapse of the visual in 1940. The calm stillness of this scene and the humour that deflates the intensity of the apocalyptic event that has just occurred may indicate that this is the dénouement of metaphysical terror and that Picasso is about to move on.

PORTRAIT D L'AUTEUR

The Banquet

Desire Caught by the Tail, 1941

The six-act play *Desire Caught by the Tail* (*Le désir attrapé par la queue*), 1941, and its subject of desire gives us a new point of focus.[1] For the first time Picasso produces a manuscript with speaking parts and scenes, although we are in no sense spectators of this unperformable, dada-style play.[2] Why, then, does Picasso present his ideas in dialogue form? Writing in the month of January, he convenes a cast of bohemian characters to a New Year's Eve banquet and various other gatherings. Their conversation, inspired by Plato's *Symposium*, proves a liberating mechanism that encourages philosophical thought, as well as displays of vulgarity and impropriety, especially when the subject concerned is sex (eros, or love).[3] And no less than in the play's title: the word "queue" is the French slang for "penis". However, whereas Plato allows for a temporary relaxing of propriety, Picasso, in the guise of a Dada provocateur, borrows the symposium genre to challenge the notions of Art, Truth and Beauty.

Desire, a concept evoked in philosophical and psychoanalytic treatises from Plato to Lacan, sets the frame of reference for the play, which has the relationship of the artist Big Foot and his model The Tart at its heart. The Occupation—"these somewhat long years of black night" ("ces quelques longues années de nuit noire"), in the words of Big Foot—remains very much in the background, as the artist and his coterie distract themselves from wartime privations with parlour games, dancing and the lottery. Their gatherings at Big Foot's studio, Sordid's Hotel and Anxiety Villa usually result in a comic disaster. Gravediggers interrupt a picnic ("déjeuner sur l'herbe") and carry the cast off in coffins, and a lottery draw ends abruptly when smoke from a burning chip pan (in the promptor's box) suffocates everyone in the room.

What is really at issue here is the disruption, in a fallen, material world, of desire, the force of eros, that which brings the sexes together. What happens to the phallus when it becomes a material thing, and to the model when she is viewed as a real woman? Picasso examines the possibility of this materialisation in Big Foot's long-winded, baroque soliloquies (the main focus of analysis) with hilarious results, particularly in the reversal of gendered desire. The very identity of the artist is at risk, as Picasso reviews the category of the 'castrated' male, Oedipus, Samson or Endymion. Picasso, like Plato in the *Symposium*, takes physical love as a point of departure in order to transcend it, but with a very different result. Big Foot, Picasso's alter-ego, tries to analyse visual form, but the contemplation of absolute beauty, Plato's ultimate goal, constantly eludes him. Bringing the weight of his classical knowledge to bear on modern ideas, Picasso stages a confrontation between classical art and the 'philosophy of existence' that precedes a dramatic 'fall' from the idealistic Big Foot's studio to the sewer that is Anxiety Villa. The absurdity is predicated on a world in which form and the classical view of art have collapsed. For Picasso the fall leads, not to collapse, but to a new focus on man.

Picasso might well have turned his thoughts to desire on the night of Tuesday 14 January 1941, sitting alone in his studio, confined by the curfew and frozen with cold. During that first winter of occupation, probably not yet into a new rhythm of work and under the Nazi ban on exhibiting, he continued with writing. Picasso's friend and biographer, Roland Penrose, referred to the restrictions on movement and the food shortages of that time that made many artists temporarily passive.[4] The situation inspired Picasso's treatment of ordinary life in wartime Paris of an artist like himself, a model like his companion Dora Maar and their friends, people like the Leirises and the Zervoses. The studio-bound artist of the play turns to writing and the ideal world of creation to distract himself from the distress and discomfort, much as Picasso did.

And so Picasso, following in the Platonic tradition, begins *Desire Caught by the Tail* with a New Year's Eve feast at which any claim on rationality is utterly cast aside:

Big Foot:

Onion, stop being funny; now we are well feasted and ready to tell the four primary truths to our cousin. Once and for all we must explain the causes of the consequences of our adulterous marriage; we must not hide its muddy soles and its wrinkles from the gentleman rider, however respectful he may be of propriety.[5]

Big Foot's frank speaking or, literally, his revelation of "the four primary truths" (the French phrase "dire les quatres verités premières" means to speak frankly and to utter banalities) announces the subject of the play—the revelation of the truth of desire, and, particularly, the nature of male sexual identity. As with Plato, Picasso's exploration of this important aspect of artistic creation is both serious and comic. Big Foot expounds nonsense about our "adulterous" marriage (the French text uses the word "adultérin", which means "spurious"). Is this relationship a facetious reference to a homosexual liaison (as in Socrates' male coterie in the *Symposium*) between Big Foot and Onion, his rival for the affection of the model Tart?[6] Right from the outset, the male artist is dethroned.

At the dinner party, all the characters compete verbally and, on face value, spout inanities. The table talk veers from incoherent, staccato, Dada-like interjections to a banal discussion about renting a furnished villa (a possible reference to Picasso's search for an apartment to rent for Marie-Thérèse and Maya, whom he brought to Paris from Royan in the spring of 1941):

Round Piece:

Just a moment, just a moment.

Big Foot:

No good, no good.

The Tart:

Enough, that's enough, quiet down and let me talk.

Big Foot:

Well.

Round Piece:

Well, well.

The Two Toutous:

Gua, gua.

Big Foot:

I wanted to say that if we want to come to an understanding at last concerning the price of furniture and the letting of the villa, we must, and absolutely with one accord, strip Silence immediately of his suit and put him naked in the soup which in parenthesis is beginning to cool off at a frantic pace.

Fat Anxiety:

I ask for permission to speak.

Thin Anxiety:

Me too, me too.

Silence:

Will you shut up.[7]

The conversation continues into the early hours with talk about a rendezvous at a hotel and problems with the heating. This seemingly senseless chatter is not without purpose. The radical and anti-hierarchical *Symposium* tradition encourages a competition of ideas through the dialogue of the characters. One by one, Picasso's characters are shown to represent types of counter-classical thought. Sitting at the table with Big Foot is his friend Round Piece, whose name, we might speculate, alludes to the hermaphrodite, the original, spherical human, described in Aristophanes's *Symposium* speech:

> The hermaphrodite was a distinct sex in form as well as in name, with the characteristics of both male and female… each human being was a rounded whole, with double back and flanks forming a complete circle….[8]

Desire Caught By the Tail,

(*Le désir attrapé par la queue*),

Act 1, Scene 1, 1941, private

collection

Personnages — Le gros piéé
l'oignon
la tarte
sa cousine
le bout rond

les deux
toutous

le silence

l'angoisse grasse

l'angoisse maigre

les rideaux

ACTE I er

scène I

le gros pied — L'oignon trève de plaisanteries nous voili bien reveillonnés et à point
le dire les quatre verités premiers à notre cousine. Il faudrait ne expli
une fois pour toutes les usages ou les conséquences de notre mariage adultère
Il ne faut pas cacher un seul les verités y ser ridi ni justement rider
il espectacune soit t'il des convenances.

le bout rond — un moment un moment

le gros pied — inutile inutile

la tarte — mais en fin
mais en fin un
peu de clme et
l'oignon moi parler

le gros pied — bien

le bout rond — bien bien

les deux toutous — gnà-gnà

le gros pied — je voulai dire que si vous voulons nous entendre en fin une soyez du pied des meubles et de la locacion de
la villa il faudrait et d'un absolue parfait acord le chantiler tout le suite le silence le son complet et le metre nu
dans la soupe qui entre penetrea comme à reposition d'une vitre pâle

l'angoise grasse — je demande la parole — l'angoise maigre — moi aussi moi aussi — le silence voulez vous
nous taire

The comic, often obscene playwright centres his praise of Love on the genitals, reviewing every sexual pairing—heterosexual, homosexual, lesbian—following the bisection of the hermaphrodite. Plato's reference to bisection or cutting brings in the act of castration, a notion which may well be at the origin of the spherical, 'castrated' image of man at the end of *Desire*.[9]

And what of Big Foot, whose name recalls the tragic figure of Oedipus? We can be reasonably assured that Picasso's Oedipus has little to do with Freud. Perhaps it is the anti-authoritarian Oedipus, who defied the gods and the sacred mysteries, that is of importance to Picasso.[10] The centrality of man as a rational subject was instituted with Sophocles' Oedipus, while in *Desire*, rationality is unequivocally overturned. Picasso prepares the ground for the emergence of modern existential man, as we will see in the finale of the play. Big Foot is so named, we might gather, because he is a philosophical painter, a seeker after truth through love and beauty. Or maybe, for Picasso, Oedipus's renowned swollen foot was a double for another swollen part of the artist's anatomy. The reference to Oedipus, blinded through auto-mutilation, returns us to the issue of blindness and vision, of knowledge and especially self-knowledge, with the rotten sun as a guiding principle.

The Two Toutous, a pair of dogs played by a single actor, who barks, licks and makes strange utterances, recall the 'dog philosophers', a familiar name for the Cynics, mid fourth century BC philosophers of the Socratic tradition, whose philosophy had a political, as well as an ethical and social dimension.[11] They emphasised the natural, animalistic side of man and mocked social convention. The phrase "desire caught by the tail", with its message of direct satisfaction of desire and of "self-mastery", could have been penned by a Cynic.

As for the sisters Fat Anxiety and Thin Anxiety—names appropriate to a pair of Carnival figures—they live a filthy and utterly nihilistic existence in the sewer-hole of Anxiety Villa and thus embody the philosophical malaise of existence identified by Heidegger and Sartre. Picasso's ironic depiction of the 'philosophy of existence' and the oppressive mood of anxiety associated with it owes much to the Spanish carnival tradition.

And what of Dada, the influence that presides over Picasso's play? As he began *Desire*, Picasso must have recollected the Dada manifestations in 1920 where he used to meet his friend Tristan Tzara, Dada's founder, and the high society "Cacodylic New Year's Eve" party organised by Francis Picabia, which Tzara and Picasso attended on 31 December 1921.[12] Picasso's drawing of the stage set for the opening scene of *Desire* depicts a flaming heart inside an old stove similar to the antique stove in his studio, as well as a possible tribute to Tzara's play *The Gas-Burning Heart* (*Le Coeur à gaz*), 1921.[13] Automatist language is one of the competing voices in Picasso's play, and the disembodied pairs of feet that complain of chillblains in the corridor of Sordid's Hotel may well be modelled on the characters Eyebrow, Mouth, Eye, Ear, Nose, Neck in *The Gas-Burning Heart*.[14]

The only source that Picasso actually claimed for *Desire* was Alfred Jarry's *Ubu cocu*, a play filled with black humour, Rabelaisian scatology and sexual impropriety, and the artist produced Jarry's original manuscript to prove it.[15] As we have seen, anarchy reigns at the New Year's Eve banquet, as Picasso throws down his provocation to classical art.

With the breakdown in order complete, the scene is set for the confrontation between desire—the driving force of classical art—and existence, and the complex of artistic values associated with the rotten sun. The classical conception of art predicated on the male artist and the female model goes awry from the moment Big Foot intones his first soliloquy on the model. He delivers the following humorously grotesque word-portrait of his cook, "an hispano-mauresque Slav slave", who shares characteristics with his companion, Dora Maar. Humour, however, is mitigated by mourning; the stage is draped in black:

Big Foot:

When you think it over, nothing is as good as mutton stew. But I am more partial, on a wonderful day when it is snowing hard, to having it boiled or well done à la bourguignon by the meticulous and jealous care of my cook, the Hispano-mauresque Slav slave, my albuminous servant and mistress, melting into the fragrant architecture of the kitchen. Apart from the pitch and glue of her attentions, nothing can equal her allure and her chopped flesh on the dead calm of her regal movements. Her sprightly jokes, her warmth and her chill stuffed with hatred are nothing more, in the middle of a meal, than the goad of desire larded with gentleness.[16]

Big Foot's description of his cook is both ontological and erotic. He mockingly refers to the quality of her being—her attentions stick to him like "pitch" ("poix") and "glue" ("glu")—in words that alert us to the presence of the "slimy". He portrays her as diseased: she is "albuminous" ("albuminurique"), which is to say she has albumin in the urine, a symptom of kidney infection. And her sensuous body, like the meat for her delicious stews, resembles "chopped flesh"("chairs hachées"). A vulgar description of her genitals returns us to the image of the slit as wound: "the searing fire of her lips, frozen on the straw of the open dungeon removes nothing of its character from the scar of the wound".[17] With her beauty unveiled—"the chemise lifted from beauty" ("la chemise relevée de la beauté")—the cook becomes part of the real world of "the sink, stinking of laundry" ("l'évier puant des linges").

The cook, now described as a physical painting, steps out of the frame: "the canvas jumps the barrier [the frame] and falls panting on the bed" ("la toile saute l'obstacle et tombe haletante sur le lit"). Big Foot is a victim of the portrait's aggressive advances: "I have such marks on my body" ("Je porte sur mon corps ces marques"). We learn from Roland Penrose of the connection between the cook's portrait and Dora Maar. When Picasso writes, "The roses of her fingers smell of turpentine" ("Les roses de ses doigts sentent de térébenthine"), he refers to Dora, a painter in her own right, wiping the ends of her fingers with turpentine.[18] Big Foot's final accolade to his fragrant cook again refers to Dora: "… I light the candles of sin with the match of her charms. The electric cooker can take the blame"("j'allume les cierges du péché à l'allumette de ses appels. La cuisinière électrique a bon dos"). When Dora cooked a good meal, her friends said jokingly that her electric cooker should have the credit.[19]

Taking up the idea of gender reversal in a subsequent scene, Picasso turns Big Foot, asleep in his studio, snoring loudly, into an Endymion, subjected to

the gaze of his four female friends.[20] They express their love for him, each in a different way. Thin Anxiety makes a long-winded and flowery speech; Fat Anxiety puts her desire more crudely; and the sentimental Tart gushes her love:

Thin Anxiety (looking at Big Foot):

He is as beautiful as a star. He is a dream repainted in water colour on a pearl. His hair has the complicated arabesques of the halls in the palace of the Alhambra and his complexion has the silver sound of the bell that rings the evening tango in my ears so full of love. His whole body is full of the light of a thousand shining electric lamps. His trousers are swollen with all the perfumes of Arabia. His hands are transparent mirrors made of peaches and pistachios. The oysters of his eyes enclose hanging gardens gaping at the words of his glances, and the garlic mayonnaise colour which encircles him sheds such a gentle light on his breast that the song of birds that is heard sticks to it like a squid to the mast of a fishing smack which, in the swell of my blood, navigates according to his image.

Fat Anxiety:

I would like to have a go at him without his knowing.

The Tart (with tears in her eyes):

I love him.[21]

Each of the women takes out a pair of scissors and, like Delilah, cuts off his hair so that he resembles a "tête de mort" ("death's head"), also the name in French of Gouda cheese. Big Foot's cheesy skull suggests fermentation, a reminder of the artist's mortality. One of Picasso's most famous sculptures, *Death's Head* (*Tête de mort*), 1943, conveys the process of human decay in bronze. The enormous head, its eye sockets and nose cavity hollowed out and its ghoulish mouth grimacing, shows the disintegration of the flesh rather than the contours of the skull.[22] Like the model, Big Foot, too, is subject to the negative effect of existence on art. The reference to the death's head is prescient, as the subject is one of Picasso's first ideas for his return to sculpture, a medium he had been forced to abandon since he lost Boisgeloup to Olga in 1937.

As though a consequence of the artist's emasculation, the rotten sun appears. The sun's rays penetrate the slats of the shutters and beat The Tart, The Cousin and the Anxiety sisters. They scream "aye aye aye aye aye" and make nonsense sounds interspersed with words dissociated from their professions of love. The Cousin cries: "Oh isn't he beautiful! Aye aye aye… who aye… oh! who aye aye is aye aye aye aye aye… bo bo." The Tart repeats similarly: "Aye aye I love him Aye aye love bo bo aye aye aye love him aye aye bo bo bo bo." When the sun attacks the women, they become incoherent and repeat glossolalia, while Big Foot sleeps on. Covered in blood, the women faint, punished by the sun.

And so the rotten sun and its constellation of negative values—blindness, madness, emasculation and death—enters the analysis of desire. The artist's identification with Endymion and Samson and their emasculation adds to his already complex persona as Oedipus and Socrates, the moderator and speaker in chief of Plato's *Symposium* debate.

Desire Caught By the Tail,
(*Le désir attrapé par la queue*),
Act II, 1941, private collection

l'oignon — Le choix de cet Hôtel comme lieu de rendez-vous et place publique de champclos à faire de ... cette
entroit n'est pas encore fait et nous devons examiner au microscope d'abord
parcelle à parcelle les pieds foller du ... encore bien ...

ACTE II

le gros pied — ne vous cachez pas
si adroitement derrière le derrière de l'histoire
que tout nous ... et nous ...
le choix des témoins est fait et
bien fait nous d'une ...
si nous tous ... échapper la ... sur l'ombre portée intempte à régler au propriétaire

le silence — enlevant ses habits — qu'il fait chaud nom de dieu

SORDID S'HOTEL

→ II^e acte

la ... — je ... déjà
... de charbon tout
à l'heure mais ça ne
chauffe pas c'est
...

l'oignon — il ...
... cette
... lumière
elle ...

l'oignon — il ...
préférable ...
l'année prochaine
une ... et ... plusieurs
... plus de ... ni
...

la tarte — moi je ... mieux le chauffage central c'est plus propre

l'angoisse ... — dire que je m'ennuie

l'angoisse ... — ... on est en visite

le bout ... — au dodo au dodo savez-vous l'heure il est 2 Hs — 1/4

Scène II

une véritable

(... de lumière)
(lumière d'orage) — les ... s'agitent — quel orage quel nuit ...
certainement ... nuit de ... nuit pestilencielle ... en porcelaine de chine
(riant et pétant) ... (musique du ... danse
macabre) (les pieds la scène commence à tomber sur le plancher et les
feux follets courent sur l'scène)

Picasso penetrates the heart of the subject of desire, and lowers the tone of the play even further, in the artist's studio. Here, according to The Cousin, Big Foot carries on his lewd relationship with The Tart—she has been "dragged into the gutter of <u>Big Foot's Artistic Studio</u>" ("traîné dans l'égout [the French for "sewer"] du *Studio artistique de Gros Pied*"). Classical art, predicated on the binary of male artist/female model, is degraded, and the gender roles are reversed. Who is the subject and who, the object in the artist/model pairing, and what is the status of the artist? In the studio scene Big Foot deconstructs classical art, while existence continues to encroach on his ideal world.

What is Picasso's meaning in the studio scene, in which he parodies, in essence, Socrates' *Symposium* speech on love, desire, Eros, immortality and absolute beauty?[23] Socrates conveys these concepts in a dialogue between himself and the sorceress Diotima, his instructress in love, and we should take note of his recourse to the female dimension on such matters. First, we should establish what Socrates says about love, or rather, desire. For when Socrates speaks, he shifts the debate from the subject of love to the subject of desire. He establishes that: "one desires what one lacks or rather one does not desire what one does not lack".[24] Socrates uncovers the great contradiction (aporia) of desire, one that Picasso exploits in the relationship between Big Foot and The Tart. The artist loves the model when he idealises her in his art; when he possesses her, he no longer desires her and is, in fact, impotent. The act of possession also brings with it mortality and death: only at his peril will Big Foot have a sexual relationship with the model.[25] And it is the notion of mortality that Picasso lingers over in *Desire*.

We must work hard to match Socrates' ideas with Picasso's, for Picasso picks and chooses certain elements of the dialogue, particularly the desire for procreation, both carnal and spiritual, and immortality, an oblique reference to the dimension of death. Picasso also parodies the interruption of the symposium by the drunken Alcibiades, Socrates' former lover, who overturns the orderly progression of speeches in praise of love to make a speech in praise of Socrates. And this he does in fairly crude terms, lowering the level of the debate from the metaphysical to the physical realm. Picasso adapts the change in tone of the *Symposium* debate to his analysis of desire and art, introducing the existential dimension, as he understands it in 1941, at the very moment of the perceived death of classical art.

As the studio scene begins, Big Foot, stretched out on a camp bed—that is, in the prone position of the model—is working on a novel idealising The Tart. We should note that he is writing rather than painting. Big Foot reads aloud his 'love letter', a portrait of The Tart and an account of her creation, shot through with base images:

Big Foot (half stretched out on a camp bed, writing):

Fear of the uneven temper of love and tempers of the leaping goat of madness. Covering laid over azure released from the seaweed that covers the dress starched with rich scraps of flesh brought to life by the presence of puddles of pus from the woman who has suddenly appeared reclining on my bed. Gargle of the molten metal from her hair shouting with pain all her joy of being possessed....[26]

Love is capricious and a form of madness, Big Foot begins, describing the ideal female and erotic possession. As in a creation myth, the model is formed between "azure" and "seaweed"—'above' and 'below'—but mortality and disintegration are already present in this ideal nude, a "dress starched with rich scraps of flesh brought to life by the presence of puddles of pus".

Big Foot describes the process by which the model's image is formed, with respect to traditional gender roles:

Big Foot:

…The blackness of ink envelops the rays of the sun's saliva hitting on the anvil the lines of the drawing, bought at the price of gold develop, in the needle-point of the desire to take her in his arms, his acquired strength and his illicit powers to win her….[27]

Picasso's extended simile of the forge relates the shaping of the model's image on the anvil by the hammer—the active and passive elements of the creative act. The simile makes sense if we think of the analogy between forging metal on an anvil and etching on a copper plate. The model's hair, we might recall, is "molten metal". Forging, in its negative sense, has to do with fabricating a false image, recalling the associations of the god of the forge, either Hephaistos or Vulcan, with the infernal world. A demonic figure, he vies with the true creator on high.

In Picasso's text the etching process falls under the negative influence of the liquefying sun—that which inhibits the image: "The blackness of ink envelops the rays of the sun's saliva". The ink's blackness and the sun's saliva combine like fire and water in an alchemical transformation to produce the drawing by beating the lines on the anvil. The image derives from saliva, a wet, semen-like fluid—in mythic tradition saliva and semen equally have the virtue of engendering. The liquid property of things also has feminine sexual associations. The artistic world that Big Foot inhabits is fluid, and the liquid matter, either male or female, confuses the gender dimension of the creative process. The simile ends as the desiring artist etches the model's image with the "needle point", which doubles as an erect phallus. The inky saliva on the point "develops… his acquired strength and his illicit powers to win her". Big Foot, in a position of weakness, only possesses the model "illicitly", in representation, without her knowing, for in reality the artist and the model fail to consummate their affair.

We are about to progress further into the terrain of role reversal, interrupted desire and the problem of existence. A seduction scene takes place with The Tart as seductress, similar to Alcibiades' attempt to lure Socrates, as he confesses in his speech, making Socrates the beloved and Alcibiades the lover. Just as Big Foot finishes reading his text, The Tart enters the studio naked: "I bring you an orgy". In 'real life' the subject and the object of desire are reversed. The Tart orders Big Foot to make tea and to kiss her all over. They embrace and fall on the floor. She immediately gets up and accuses him: "You're smart enough at giving and taking…" ("Vous avez de belles façons de recevoir et de prendre…"). The stage directions indicate the extent to which the model herself is debased:

The Tart:
(She squats in front of the prompter's box, and facing the audience, pisses and pisses scalding hot for a good ten minutes.)

Oof! That's better now!

(She farts, she farts again, she tidies her hair, sits down on the floor and begins a clever demolition of her toes.)[28]

The Tart uses the prompter's box, the hole in the stage, as a toilet (an idea borrowed from Alfred Jarry's *Ubu cocu*), a farcical image of the collapse of the two holes at the centre of creation.[29] As their lovemaking is so abruptly interrupted, Big Foot produces his novel, which he refers to as "this great sausage" ("un gros saucisson") and a substitute for water, tea, sugar, bread and jam. The association of Big Foot's art with a large sausage, the phallus as a material thing, is equivalent to the model using her 'hole' for urination. The male and female elements necessary to the artistic process have been turned away from their creative purpose.

Instead of resuming their lovemaking, Big Foot reads his novel aloud to The Tart, beginning with the passage establishing the 'author's' tenuous identity:

Big Foot (he reads):

The acrid stench spread around the concrete fact of the narrative, established a priori, does not pledge the person destined to this task to the slightest modesty. In the presence of his wife and before a public notary, we, the only responsible person established known and honourably recognised as author, I pledge my entire responsibility only in the specific case when unbounded anxiety may become fanatical and murderous for the limited view of the subject at table, expatiating at full capacity, on the plumb-line of the complex machine for establishing at any price the exact data of this case already experimented by others, contrary to the light cast by points of view on how to support the weight of these interior precisions.[30]

We, of course, laugh at Picasso's contradictory and legalistic rhetoric (is an accurate translation even possible?), an ironic attempt to ground the work in logic. How can the "concrete fact [of the narrative]", a Sartrean concept, as has been said, be established "a priori", that is, without the aid of experience, or observation?[31] Picasso plays on the subject position of the "narrative", as the 'author's' identity shifts: first, the author is referred to in the third person singular as the "person" and with the possessive "his wife", then as "we" and "I" in the same sentence, and finally, as "the subject at table", recalling the drawing of the author on the frontispiece of *Desire*. The author is an artist with a philosophical bent who wavers between subjectivity and objectivity, the accurate and the false, the rational and the mad.

As Big Foot, in full flow, continues reading his novel to the still naked Tart, The Cousin and The Onion happen by the studio to the annoyance of Big Foot, who tells them that he and The Tart "are having a quiet fuck" ("on est en train d'en foutre un coup"). Their unexpected visit to bring an absurd gift of shrimp serves as a device to disrupt the relationship between the artist and model, just as Alcibiades disrupts the symposium at the moment Socrates finishes his discourse on 'platonic' love and the contemplation of absolute beauty. Alcibiades speaks in praise of Socrates and tells the 'truth' about love in a realistic, if vulgar register. He compares the physically ugly Socrates to a satyr,

which belies the attraction of his beguiling way of speaking and his intelligence. Alcibides praises Socrates:

> I propose to praise Socrates, gentlemen, by using similes....
> I declare that he bears a strong resemblance to those figures of
> Silenus in statuaries' shops, represented holding pipes or flutes;
> they are hollow inside, and when they are taken apart you see that
> they contain little figures of gods. I declare that he is like Marsyas
> the satyr. You can't deny yourself, Socrates, that you have a striking
> physical likeness to both of these....[32]

Big Foot is confused by the contrast between The Tart's unkempt appearance and her allure just as Alcibiades is with Socrates. When The Tart disappears into the bathroom to tidy herself, Big Foot complains about The Tart to The Cousin:

Big Foot:

That girl is mad and is trying to impress us with her affected tricks like a princess. I love her, of course, and she pleases me. But between that and making her my wife, my muse or my Venus, there is still a long and difficult path to reconnoitre. If her beauty excites me and I am mad about her stench, her table manners, her way of dressing and her affectations are a pain in the arse. Now, tell me frankly what you are thinking. I am listening. You, Cousin, what do you think?[33]

Alcibiades, continuing his comparison of Socrates to the Silenus figure, relates the nature of the philosopher's sexual attraction:

> The Socrates whom you see has a tendency to fall in love with good-
> looking young men, and is always in their society and in an ecstasy
> about them. (Besides, he is to all appearances, universally ignorant
> and knows nothing.) But this is exactly the point in which he
> resembles Silenus; he wears these characteristics superficially,
> like the carved figure, but once you see beneath the surface you
> will discover a degree of self-control of which you can hardly form
> a notion, gentlemen.... He spends his whole life pretending and
> playing with people, and I doubt whether anyone has ever seen
> the treasures which are revealed when he grows serious and
> exposes what he keeps inside. However, I once saw them, and
> found them so divine and precious and beautiful and marvellous
> that, to put the matter briefly, I had no choice but to do whatever
> Socrates bade me.[34]

We are left in no doubt that Alcibiades, when speaking of Socrates' "treasures", is referring to the philosopher's penis. And he follows the above passage with a description of his repeated attempts to seduce Socrates, to no avail. The Cousin, recalling the schoolgirl Tart, reiterates the same contradiction between the model's physical appearance and her essence:

The Cousin:

Very dirty in her person, untidy hair, stinking of a thousand nasty smells and sleepy. In her short black apron, her heavy slippers and her knitted jacket, all the men— old workmen, young men and gentry, we could see clearly the fires and the candles lighted before her devastating image that they carried away, the pure diamond of the fountain of youth burning in hands hidden in their trouser pockets.[35]

The Cousin's depiction of the young Tart smacks of paedophilia, and we might note the similarity to the young Marie-Thérèse, who was 17 when she first met Picasso outside the Galeries Lafayette in January 1927.[36] The Tart's dirty and untidy appearance masks her allure, or, to put it more blatantly, sex appeal, judging from the effect she has on her male admirers. Men succumb to her charms, which are hidden like the votive figures inside the Silenus statue. This brings to mind Jacques Lacan's famous reading of Plato's *Symposium* and his discussion of the Silenus and its contents, the Greek word for which is *agalma*.[37] Lacan proposes a number of variations on the meaning, drawing on the popular literary use of the word in antiquity: jewellery or any precious ornament, a fetish or an idol and, as such, an image or an icon and therefore a reproduction, and even the breast. *Agalma*, for Lacan, will always remain the object of desire.

The model's essence, her indefinable allure, cannot be grasped, except in representation—her glorious image leaves an imprint on the palms of her male worshippers. As Picasso implies, the men masturbate with the "devastating image" "burning in hands hidden in their trouser pockets", eradicating the distance between the male subject and the female ideal. The discussion between The Cousin and Big Foot ends without resolution, but what is most striking is the model's imprint, an image, votive figure or icon, and its translation to the outside world in a reproducible form. Picasso emphasises this transformation of the image once again in The Tart's parting words to Big Foot:

The Tart:

Now that I am really a virgin, I am off straight away to put up the luminous signs of my breasts within reach of everybody, and feather my love-nest in the all night city market.[38]

The model's breasts, a form of the *agalma*, will be visible to all through her own agency, in advertisements, a humorous acknowledgement of Dora's independence as a woman and her success as a photographer. The Tart's luminous signs could refer to Dora's use of the 'photogram' or 'rayograph' (photographs produced by placing objects on sensitised paper and exposing them to light), invented by Man Ray and his assistant Lee Miller.[39] Picasso testifies here to the power of the image in its seductive capacity, just as Lacan interprets it with reference to Socrates and his hidden object of desire.[40] We must hang on to this notion of the *agalma* as image and keep in mind its mimetic quality, its ability to replicate without the artist's intervention, without the consummation of his desire. No wonder The Tart can claim "now that I am really a virgin", as though this state has been restored to her. The model, who has already broken through the confines of the frame, now makes a direct appeal to her public, undermining the role of the (male) artist.

After The Tart's departure for Les Halles, Big Foot composes the following passage: "I carry in my worn-out pocket the candy sugar umbrella with outspread angles of the black light of the sun."[41] While The Tart seeks love in the street, Big Foot, again reclining on his bed, satisfies his own desire through the hole in his pocket—"desire caught by the tail". His erection, hard as candy, is like an umbrella, an object that has phallic associations. The open umbrella forms a black circle that represents "the black light of the sun" ("la lumière noir du soleil")—*soleil noir* being the symbol of melancholic poets.

Anxiety Villa: The Fall into the Sewer

And so we experience a dramatic change of perspective: "The scene takes place in the main sewer bedroom kitchen and bathroom of the villa of the Anxieties" ("La scène se passe dans l'égout chambre à couché cuisine et salle de bains de la villa des Angoisses").[42] The sewer—a description previously applied to Big Foot's studio and literally, a latrine for The Tart—becomes central to the final act. The sisters prepare a feast of sorts, returning to the idea of the banquet at the beginning of *Desire*. At the Anxietys' feast dining is hardly the point: the tablecloth is covered with blood and excrement, while the farcical menu includes melon soup, stuffed turkey smelling of "terrors" and "frights", sturgeon, porridge and mussels "dying of fear". In this sordid, dismal atmosphere, desire remains forever interrupted and the artist and the model meet their fate. The fall to abjection disrupts the connection between 'inside' and 'outside' and 'above' and 'below'—images of frames and windows are significant in this respect—abolishing the classical view of the world.

Thin Anxiety delivers her soliloquy inside the sewer of her bed:

Thin Anxiety

I am nothing but a congealed soul, stuck to the window-panes of the fire. I beat my portrait against my brow and cry the merchandise of my pain, at windows, closed to all mercy.[43]

Thin Anxiety, in tears, conveys her angst in terms of existential philosophy—her life as purgatory on earth from which there is no escape—as well as in terms of idealist art: she "beats her portrait against her brow". Her represented self has no more of an existence inside the frame.

Her equally anxious, though more earthy sister Fat Anxiety elaborates their suffering:

Fat Anxiety

When I left this morning from the sewer of our house, immediately, just outside the gate, I took off my heavy pair of hob-nailed shoes from my wings and, plunging into the icy pond of my sorrows, I let myself drift in the waves far from shore. Lying on my back, I stretched myself out on the filth of that water and for a long time I held my mouth open to catch my tears.[44]

Fat Anxiety, floating on her filthy, watery hell, has no control over her existence. Her "hob-nail shoes" keep her heavy and earth-bound.

Just as the sisters begin their meal, The Tart drops by unexpectedly and joins in the feasting and conversation. The sisters tell her about The Onion's demise, with a spear through his head and his body "in pieces". The Tart, in turn, gives them news about her failed relationship with Big Foot, in a parody of Plato's *Symposium*:

The Tart:

You know, I have found love. He has all the skin worn off his knees and goes begging from door to door. He hasn't got a farthing, and is looking for a job as a suburban bus conductor. It is sad, but go to his help… he'll turn on you and sting you. Big Foot wanted to have me and it is he who is caught in the trap.[45]

We can compare The Tart's portrayal of Love to the passage in Socrates' speech that describes the god's nature and parentage:

> Again, having Contrivance for his father and Poverty for his mother,
> he bears the following character. He is always poor, and, far from
> being sensitive and beautiful, as most people imagine, he is hard
> and weather-beaten, shoeless and homeless, always sleeping out for
> want of a bed, on the ground, on doorsteps, and in the street. So far
> he takes after his mother and lives in want.[46]

According to Socrates, Love desires beauty and wisdom, because he lacks these qualities. Far from being divine, his low status condemns him to mediate the physical world and the world of forms. Picasso's Love suffers a more dramatic loss of status. In the contemporary world of existence, Love is unable to bring the sexes together or bridge the gap between reality and the metaphysical realm. Unemployed, he is forced to seek a lowly, mundane job as a bus conductor.

The oppositions 'above' and 'below' and 'male' and 'female' are overturned in the post-metaphysical world, making the model's position, too, untenable. The Tart, burned by the sun, leaps to her death:

The Tart:

Look! I have been out in the sun too long, I am covered in blisters…. Love. Love…. Goodbye.

(She lifts up her skirts, shows her behind and laughing, jumps with one bound through the window breaking all the panes.)[47]

Her mock suicide allows her to escape her ideal image by jumping through the window into the 'real' world, breaking out of the 'frame' or prison of representation.

The sisters sound a bugle for the cast to assemble and they host a party at which they play an absurd guessing game and dance. Big Foot speaks the final words of the play, as he leads his friends in resistance to the war:

Desire Caught By the Tail,
(*Le désir attrapé par la queue*),
Act IV, 1941, private collection

113

Light all the lanterns. Throw flights of doves with all our strength against the bullets and lock securely the houses demolished by bombs.[48]

The play closes with a scene of illumination, as described in the stage directions that are the final words of *Desire*:

(All the characters come to a stop on either side of the stage. By the window at the end of the room bursting it open suddenly, enters a golden ball the size of a man which lights up the whole room and blinds the characters, who take out handkerchiefs from their pockets and blindfold themselves and, stretching up their right arms, point at each other, shouting all together and many times.)

All:

You! You! You!
(On the golden ball appear the letters of the word: 'Nobody'.)[49]

And so the examination of desire comes to a conclusion with a fall to existence rather than an ascent to the world of forms. We might think of the "golden ball the size of a man" as yet another image of the rotten sun. As though playing another light-hearted parlour game, a kind of blind-man's buff, the friends blindfold their eyes (*se bandent les yeux*).[50] They point and shout together "You! You! You!", an indication of the other. This notion of otherness, which Plato introduces, albeit in a different way, at the end of *The Symposium* replaces, for Picasso, the pairing of the artist and model.[51] The experience of otherness, discussed in the writings of Sartre (*Being and Nothingness*, 1943), Maurice Merleau-Ponty (*Phenomenology of Perception*, 1962), and Alberto Giacometti (*Écrits*, 1990), a friend of Picasso, who had remained in Paris at the beginning of the Occupation, was integral to existential philosophy.[52]

At this point *Desire* changes tone, as Picasso introduces the subject of blindness and illumination, presumably a return to the Oedipus allusion. We have seen the model in her death leap, but the finale of *Desire* reveals the fate of the artist, and this we must deduce from the stage directions that end the play. Picasso ends with the image of "the huge golden ball the size of a man" on which appears the letters of the word "nobody". Picasso writes the word "personne", a contradictory expression that means "someone" and "no-one"—an ambivalent, existential ending. The word "personne" is neutral, neither male nor female.

The image recalls the unnamed "portrait of the author" on the frontispiece of *Desire*, but the space designated for the author is empty. Picasso's "golden ball the size of a man" would seem to announce a falling away from form, and from Plato's world of forms. The play marks a shift in Picasso's thinking, from the metaphysical terror expressed in his previous writings to a new focus on human life. This new direction is evident in his art from 1941, particularly in his return to sculpture, when he began to model the "death's heads" and the large *Death's Head*, cast in bronze in 1943.[53]

When Picasso wrote *Desire Caught by the Tail* in an atmosphere of pessimism, he could not have imagined the more positive circumstances of the play's 'première' three years later, at the instigation of Michel Leiris, on 19 March 1944 at the Leiris's Grands-Augustins apartment, close to Picasso's. A large number of guests filled the Leiris's apartment. Brassaï's photograph commemorates the symbolic encounter between the surrealists, the old luminaries of the Left Bank, and the young generation of intellectuals, Sartre, de Beauvoir, Camus and Jacques Lacan, with Picasso standing among them.[54]

Death's Head (*Tête de mort*), 1943, sculpture photographed by Brassaï, Musée Picasso, Paris

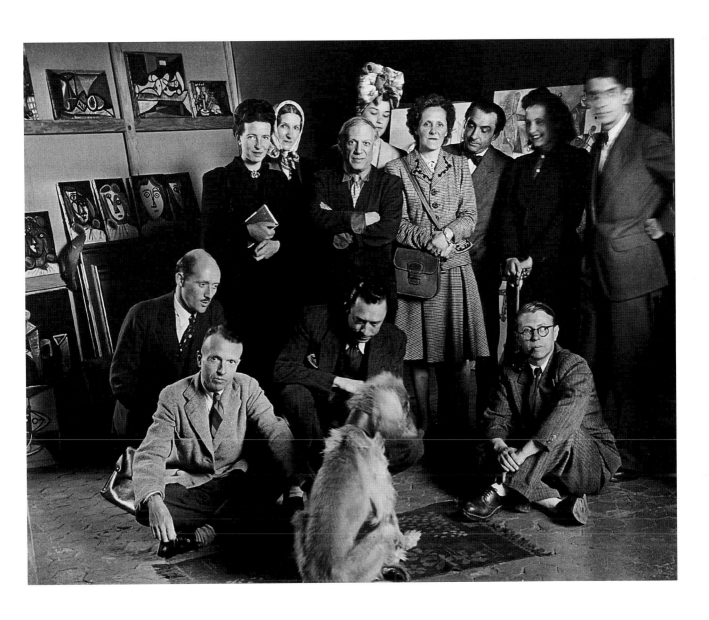

Halasz Gyula Brassaï, **Gathering of Actors for Desire Caught By the Tail** (*Groupe de lecture de la pièce de Picasso Le désir attrapé par la queue*), 19 March 1944, Musée Picasso, Paris

Photograph taken by Brassaï in Picasso's painting studio at 7 rue des Grands-Augustins of the cast and guests who had attended the première. The cast, chosen by Michel Leiris: Michel Leiris (Big Foot), the novelist Raymond Queneau (The Onion), the actress Zanie de Campan (The Tart), Simone de Beauvoir (The Cousin), Jean-Paul Sartre (Round Piece), the poet Georges Hugnet (Fat Anxiety), Dora Maar (Thin Anxiety), Louise Leiris (The Two Toutous), Jacques-Laurent Bost (Silence), the publisher Jean Aubier (The Curtains) and Albert Camus, the director. According to Brassaï, Camus announced the characters and read the stage directions, tapping the floor three times with a cane to indicate the scene changes. For a later version of the play by Jean-Jacques Lebel, see the Appendix.[55]

Al rededor del
circulo quadrado
del tiempo

The Dialectic

The Four Little Girls,
1947-1948

The Four Little Girls

(*Les quatre petites filles*), page I,
24 November 1947-13 August
1948, Musée Picasso, Paris

118

I Golfe-Juan 24.11.47.

La scène — Un jardin potager
~~tracé~~ presque au milieu
un petit

4 petites filles chantant

nous n'irons plus au bois
les lauriers sont coupés
la belle que voilà ira les ramasser
entrons dans la danse voilà comme
on danse dansez chantez embrassez qui
vous voudrez.

petite fille I — faisons toutes les roses
avec nos ongles et faisons saigner leur
parfums sur les rides de feu des jours
de nos chansons et de nos tables jaune
azur et pourpre - jouons à nous faire mal
et embrassons nous avec rage en poussant
des cris affreux.

The Four Little Girls
(*Les quatre petites filles*),
page LXXXIII, 24 November 1947-
13 August 1948, Musée Picasso,
Paris

"Around the square circle of time" ("Alrededor del círculo quadrado del tiempo"), Picasso writes, giving the co-ordinates for the construction of a new world. The intriguing phrase is inscribed in Spanish on the frontispiece of *The Four Little Girls,* 1947-1948, a work of metaphysics disguised as a child's fairy-tale.[1] It had been three years since Picasso produced poetic texts, but in 1947, in a new phase of Mediterranean verve, he began to write the play that features the four characters known as First Little Girl, Second Little Girl, Third Little Girl and Fourth Little Girl. After the long period of confinement in Paris, he had resumed his usual trips to the south of France. In 1946 Picasso had taken up the offer of Romuald Dor de la Suchère, the director of the historical museum in the Château Grimaldi at Antibes, to use the upper floor of the *château* as a studio. The following year, during one of France's most dystopic periods, Picasso, an official member of the French Communist Party (joined October 1944) and a high profile peace campaigner, exited Paris to reside permanently on the Golfe-Juan, accompanied by his companion Françoise Gilot and their first child Claude (born May 1947).[2] He left behind the Party's ideological battles and ignored the diktats promoting Socialist Realism and condemning abstraction. In August 1947 Picasso began to work at the Madoura ceramic factory, where in a couple of months he produced some 2,000 pieces based on mythological figures and Mediterranean flora and fauna similar to his painting of the time.[3] References to his ceramic art, as well as to etching, then his other important medium, are numerous in the play.

Manuscript page I of *The Four Little Girls* bears the date and place of the beginning of writing, "Golfe Juan 24.11.47", and page LXXXV, the date and place of completion, "Vendredi 13 Août 48 à Vallauris". For the first time there are long, undated gaps within a single piece of writing. The only other date, 17 May 1948, appears in Act IV in a passage spoken by Fourth Little Girl, who describes an event in Picasso's life on that day and claims him as her 'father':

Fourth Little Girl

To-day the seventeenth day of the month of May in the year nineteen-forty-eight, our father has taken his first bath and yesterday, a fine Sunday, he went to Nîmes to see a bullfight with some friends, ate a dish of rice à l'espagnole and drank an oenological wine in a test tube.[4]

There is very little plot in *The Four Little Girls*, but the girls are constantly in motion, their games the focus of the action. The girls squabble, dance and sing in a lush orchard garden on their summer holiday from school. They speak in rhymes and riddles and declaim at length esoteric poetry about life, death and art. At times their play is ritualistic: they perform animal sacrifice, for example, recalling Picasso's previous aesthetic. Images of the rotten sun figure in the girls' speech: "Black mouth of the sun full of cinders".[5] However, in the play the sun is also portrayed as beneficent. First Little Girl: "There, a great sun slowly rolls across the stage to our feet where it stretches out full length and licks our hands".[6] Eyes rain on the girls and light is restored:

Seated Tanagra, 1947

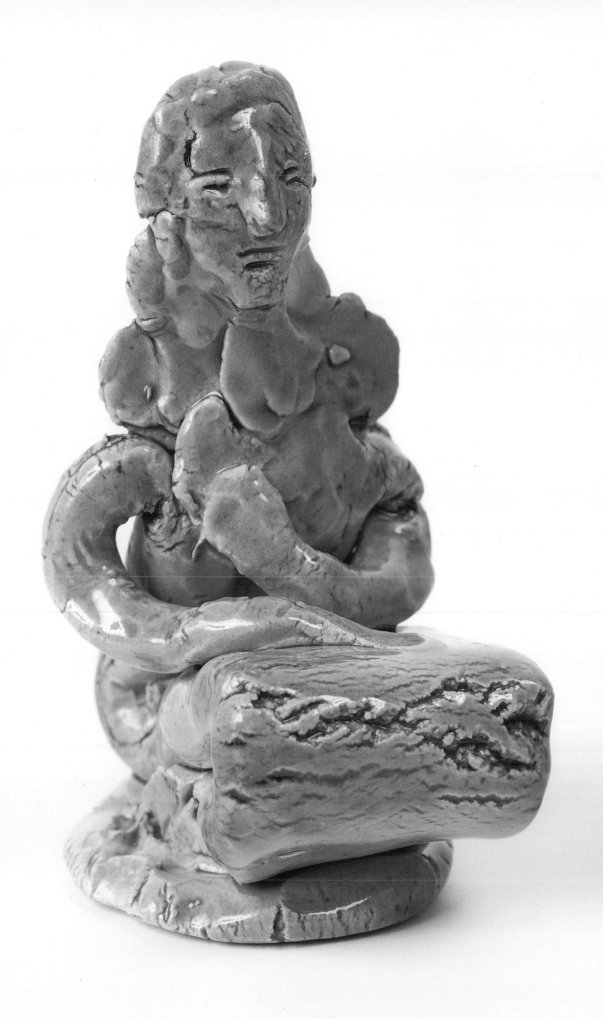

Second Little Girl:

We are covered with light

Fourth Little Girl:

We are dirty with light.

Second Little Girl:

I am burnt.

First Little Girl:

I am frozen with light.[7]

In the late 1940s a new impetus for art presents itself, as rationality is re-asserted. It may not be too overstated to claim that there are the beginnings of a rational direction in *The Four Little Girls*, a precondition, as we will see, for the return to structure and the fixing of the image.

Key to an understanding of *The Four Little Girls* are the words and images on the frontispiece of the manuscript: the phrase "around the square circle of time" (written in Spanish, it should be noted, in a play in French) and the imprints of leaves, like water-stains, which accompany it. The leaves (the French word "feuille" means both "leaf" and "sheet of paper") signify the transformation of nature into art, a dialectic of nature and culture. These words and images indicate the philosophical tenor of the play and the promise of a return to concrete space by means of rational thinking.

Picasso's phrase "around the square circle of time" condenses a whole tradition of philosophy and aesthetics, beginning with Aristotle's concept of time.[8] In order to conceive time and space, Picasso must overcome the previous state of incoherence and dissolution represented by the rotten sun. The way back to the world of rationality lies in the dialectic. And so, in dialectical fashion, Picasso's play moves from the ideal to the real world, to the orchard garden, a sensual, though no less conceptual space. Picasso seems to draw on several types of dialectical thinking—the philosophical, the aesthetic and the political—a mental construct that, although false, is necessary in order to think about the world. Thus Picasso's return to structure in *The Four Little Girls*, in his typical attitude of irony and parody, is founded on paradoxes and hypotheses.

As the phrase "around the square circle of time" implies, Picasso's return to structure depends on aesthetics as much as on logic. We might discern a connection between Picasso's square circle and Leonardo da Vinci's illustration of Vitruvius's theories of proportion, in which a man with arms and legs extended fits into the two 'perfect' geometrical forms, the circle and the square. This idealistic notion—the foundation of Renaissance aesthetics—attempts to synthesise the dialectic—the sensual and the intellectual, the organic and the geometric.[9] Picasso's "square circle", then, implies a resolution as much as a beginning. Translating this dialectic he must synthesise his aesthetic of the abject (rotten sun) and the aesthetic based on structure, incompatible types of thinking. As the play progresses and reaches synthesis, there is a return to a negative position before contradiction is resolved. For example, at the end of Act IV, there is a leap forwards as the elements required to represent the world rationally—the letters of the alphabet and numbers—appear with a big yellow sun on the backdrop of the stage. However, Act V begins with a return to negativity as the girls "in holocaust" recite images of abjection: "stinking baggage" ("grosse pouffiasse"), "fat turd" ("large étron"), "exquisite sewage" ("ordure bien filée"), and "sandwich gilded with shit" ("tartine dorée de

merde").[10] We might be right in supposing a Hegelian and therefore Marxist logic in *The Four Little Girls*, no doubt an ironic gesture by Picasso, a prominent member of the French Communist Party at this time. In the final act, the little girls are instrumental in founding a new rational world: the four girls metamorphose into four white leaves, which in turn become the four pillars of a white cube, an ideal, symbolic structure.

The Ronde and the Dialectic

The play begins *in medias res*: we are in the natural world fully formed. "The scene: an orchard garden, almost in the middle a well" ("La scène: un jardin potager, presque au milieu un puits"), Picasso writes. We have no knowledge of what came before: the garden is already an abundant earthly paradise. Right from the start Picasso elaborates the notions embedded in the phrase "around the square circle of time". Picasso proceeds from the construct of the "square circle" to the projection of time and space. For Picasso, as for the classical philosophers, time and space are categories of nature, and it is in nature, in an edenic garden, that he sets the scene of art's return to form.

A *ronde*, a fertility dance evoking the cycle of birth and death, is performed by the four little girls. With a spinning motion the new world begins: the *ronde* is at the origin of time and space, setting up a tension between stability and motion. There are four girls, a geometric formation. They dance a *ronde*, together forming a circle, and with their circular movement, they mark out space. When Third Little Girl hides from her sisters and the four girls become three (the symbol of circularity), instability results, perpetuating the cycle of sacrifice. In their wild, Dionysian play, the girls use their fingernails to make the roses "bleed their perfumes", a foretaste of blood sacrifice:

First Little Girl

Make the best you can, make the best you can of life. As for me, I wrap the chalk of my desires in a cloak, torn and covered with black-ink stains that drip full-throated from blind hands searching for the mouth of the wound.[11]

The words of First Little Girl recall Picasso's artistic traumas of the 1930s: the act of sacrifice engenders art, as black ink stains "drip full-throated" like blood from a wound and "blind hands"—blindness rather than vision, hands rather than eyes—seek "the mouth of the wound".

Sexuality is an essential component of the return to form. While they dance, the girls sing the traditional song "The laurel trees are cut down" ("Les lauriers sont coupés"):

Four Little Girls, singing.

We won't go to the woods
The laurels all are cut
That honey there
Will go and pick them up
Let's go to the dance
This is how they dance
Dancing, singing, kissing whoever you will[12]

This licentious song tells of the loss of innocence and sexual awakening of the pubescent girls (Picasso's daughter Maya was 12 at the time).[13] The laurel trees recall the myth of Daphne, the huntress who is turned into a laurel tree in order to preserve her virginity. *The Four Little Girls* presents us with a similar metamorphosis: at the end of the play the girls, like the goddess, are turned into leaves; blood emanates from them, causing a cataclysmic flood that results in the transubstantiation of nature into art. The girls provide the female element that, for Picasso, is central to the coming-to-be of art.

We might wonder who the little girls are and why there are four of them, dressed alike, often in assorted primary colours. The girls symbolise the four elements, the cornerstones of the constructed world. Third Little Girl represents the element of fire, the attribute of artists. Her sisters call to Third Little Girl, hiding behind the well: "Tidy your hair, it is in flames and is going to set fire to the chain of curtsies scratched in the tousled wig of bells licked by the mistral".[14] This strong identification of Third Little Girl with Picasso marks her out from the other three.

She calls out intermittently to her sisters from inside the well or off-stage, "Coming, coming, coming!" ("Ça y est, ça y est, ça y est!"), as they plead with her to come back and play. A *double entendre*, her cry highlights the tension that is released as art comes into being. The mysterious Third Little Girl, a kind of fairy or spirit, also shows a sinister side, as she shouts from her hiding place inside the well: "You won't get me alive and you can't see me. I am dead".[15] Throughout the play, she retains a ghostly presence:

P Manciet, **Picasso at the pottery wheel** (*Picasso travaillant la céramique*), 1947

124

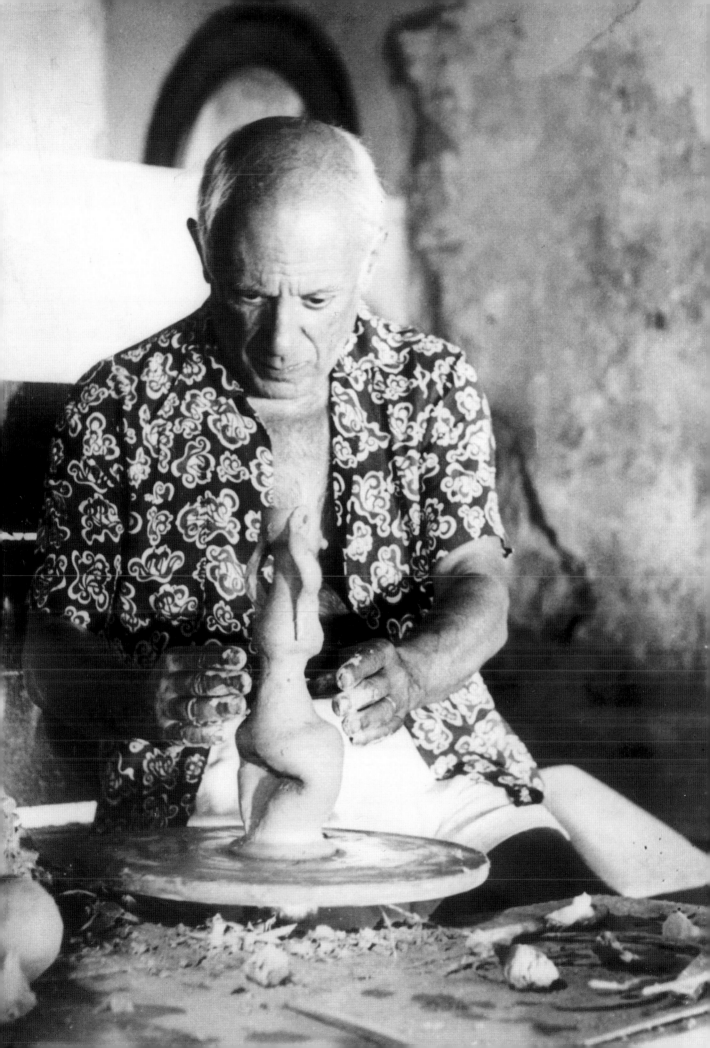

Second Little Girl

You won't make me believe—and if I say believe I exaggerate—that her departure and the synthetic projection of her image, even diluted in the imaginary broth of this afternoon, is subject to the following dazzling revelations and audacious cursory discussions.[16]

The phrase "synthetic projection of her image" has a striking contemporary resonance, giving the sense of the cinematic. (In 1948 Picasso was filmed at work in his studios at Vallauris and Antibes by the Belgian director Paul Haesaerts.) Third Little Girl is a projection that has no physical substance, her image "diluted in the imaginary broth of this afternoon", a disembodied figure, a simulacrum or false image that strains the credulity of Second Little Girl. Due to the synthetic projection of her image, Third Little Girl is paradoxically both present and absent, an ironic reference, perhaps, to Picasso's position as an artist at the time.

Soon after the opening *ronde*, Picasso brings in the dialectic: an opposition arises between the 'natural' and the represented world, between nature and culture. For example, Second Little Girl is herself a force of nature—she grabs fruit and eats greedily—while her cheeses are subject to quality control. (The term "agrée" [accepted], given on food labels, certifies the quality of a product):

Second Little Girl

I gather grapefruit, I eat them, I spit out the pips, I wipe my lips with the back of my hand and I light up the festoons of lanterns with my laugh, incomparable cheeses, I ask you to accept yours sincerely at your feet and I sign.[17]

Throughout the play the natural and the artificial are in opposition. Three surfaces—a cloth, sheet and dress—serve as supports for the stuff of nature transformed into art:

Fourth Little Girl

yawning jaws of the sun crushed on the embroidered cloth like almonds in a plate of rice

Sheet from the bed folded diagonally festooned with carnations and irises

silk dress... bordered with branches of mimosa, heliotrope, narcissi, carnations, ears of corn[18]

Picasso also combines signs and the natural things they represent nonsensically and with no apparent strategy or purpose in the poetic dialogue. There is an awareness, nonetheless, of a world differently represented, as nature becomes increasingly artificial or synthetic. And this in-built drive of art towards the synthetic is the linear trajectory of the artistic narrative of *The Four Little Girls*.

How will the transformation of nature into art be brought about? Referring once again to the title page of *The Four Little Girls*, we will recall the faint imprints of four leaves—a barely perceptible residue of matter in a state of potentiality, the memory or ghost of a form. Out of prime matter, form arises. Will the transformation occur through outside intervention, or will it be internal to nature itself—the 'scientific' approach?[19] Picasso presents us with both eventualities. In the first scenario, there is a mediator, a role that falls to Third Little Girl. The artistic sister and a bit of a show-off, she distinguishes herself from her siblings by moving through the trees and grass "unrolling her arabesques in curves and colours and gossamer threads" ("déroulant ses arabesques en courbes et couleurs et en fils de la Vièrge"). Her acrobatics create shape and colour out of the natural world.

When Third Little Girl goes away, the sun goes in and it starts to rain "for ten centuries". Her sister refers to her antedeluvian art and past reputation:

First Little Girl

The rain which rises little by little lasts ten centuries already and composes meticulously the page painted so minutely with little signs and squiggles coming undone and gordian knots and anthropometric pegs, all responsibilities and consequences of the game imposed by the other side of the river—that's where she has given us so much pleasure[20]

A rain of ink creates a drawing according to the rules of a bygone era—"the other side of the river" [the other shore would be a better translation], bearing in mind that, not long before, Third Little Girl claimed, "I am dead". The "deluge" marks a division between two eras. Is Picasso bemoaning the loss of the classical tradition or preparing the way for a new venture in 1947?

In another scenario the elements of art have an inner momentum. How does the stuff of the natural world—"floods" ("flots"), "puddles" ("flaques"), "washes" ("laves"), "drool" or "foam" ("baves"), "spit" ("crachat") and "splashes" ("éclaboussures")—take shape? In the passage from the end of Act I below, the transformation of matter into form occurs as colours and geometric shapes come together of their own accord:

Second Little Girl:

Spirals of lemon yellows, great white square of oranges, lozenges in lemon yellow, perfect ovals, exasperated circles of lilac roses, of tomatoes sung, whispered by the olives of the violet hidden in the blueberry syrup.[21]

However, the passage from matter to form is not a smooth transition, and art continues to be associated with sacrifice. Colour and form coalesce as Third Little Girl sacrifices a goat at the beginning of Act II:

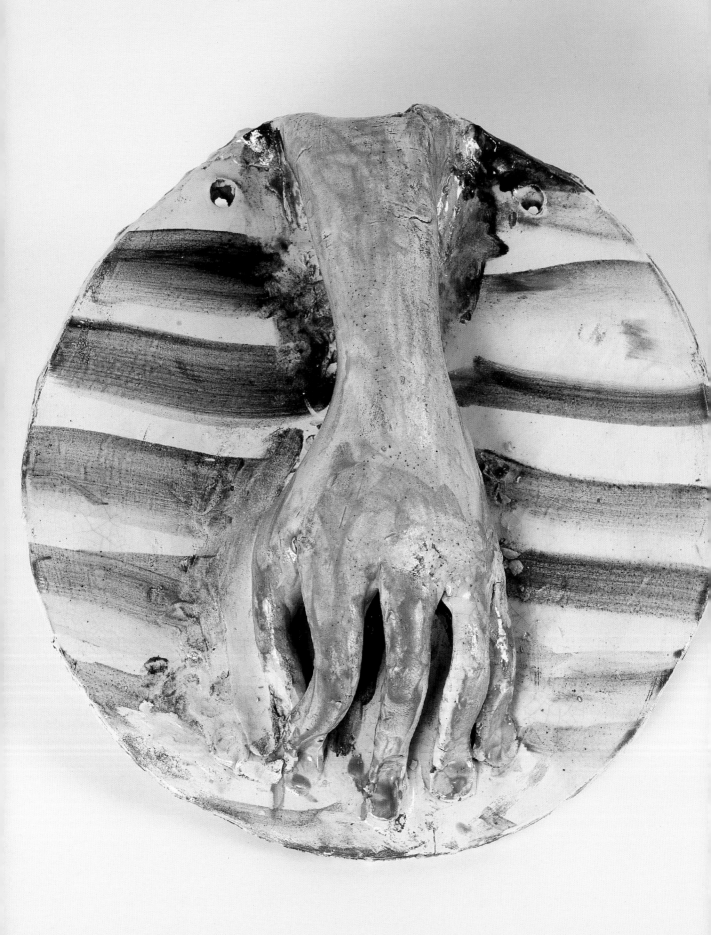

Third Little Girl, she goes down the steps of the house, holding a doll larger than herself tied with chains of garlands of flowers and leaves; a yellow apron.

White bird with amaranth blue and lemon blue checks, perpendicular line of sky blue, irritating average of white spread on the lilac stain in great spoonfuls of broad lemon yellow, spread body and soul on the closed ogive of the sparkling centre of a great circle, closed and double-locked with lacquers, emerald silence hidden between the folds of an egg laid by the goat.

(She arranges her doll, chained with garlands of flowers, in the boat and ties it to the mast, lies on her back on the ground and sucks and caresses the goat.)

Handsome young man, good-looking sweetheart, my lover, my sun, my passion, my centurion, my furious horse, my falsehood, my hands like spirals of butter, delicious ascent and descent attached to the chains of the merry-go-round at the fair, lemon squashed in the mouth closed with nitric acid of a tender dove that opens like a fan at the centre of the smoky furnace of a tar-barrel.

(She gets up, unties the goat and cuts its throat, takes it in her arms and dances.)[22]

Picasso is describing his work at the potter's wheel—the "merry-go-round": the application of glazes that run into defined geometric areas—squares, semi-circles, and circles; and the firing of the piece: "a tender dove that opens up like a fan at the centre of the smoky furnace". Art continues to be associated with formlessness, as we are reminded by the shaping of wet clay on a turning wheel: "my hands like spirals of butter, delicious ascent and descent attached to the chains of the merry-go-round at the fair".

We can see the close relationship of Picasso's ceramic art to the aesthetic content of *The Four Little Girls*: the wheel's turning motion—like the circle of time and the girls' *ronde*—is at the origin of the creation of form and the renewal of art in 1947. As with so many passages in the play, the colours and geometric shapes described in the quotation above allude to the transformation of the flora and fauna of the natural world into art. This transformation proves to be conceptual as well as plastic, as Picasso, in the guise of Third Little Girl, makes the transition from formlessness to form. Pottery making, which employs earth, fire and water in an alchemical process, is one of man's oldest activities, a coming-to-form through a return to archaism.

Hand on Striped Tablecloth,
1947-1948

Hand on Striped Tablecloth, 1947-1948, a white earthenware plaque with a flesh-coloured hand against a background of blue and white stripes— a possible allusion to Picasso's signature Breton t-shirt—shows the artist grappling with his new medium. The sculpted feminised hand works the viscous clay, a primordial *pâte*. Interestingly, Picasso takes up ceramic art as Jean Dubuffet creates his *hautes pâtes* or "raised pastes" and as the philosopher Gaston Bachelard lectures on his philosophy of *pâte* at the Sorbonne in 1947.[23] In contrast to Picasso's typically masculine representations of his hand in plaster, 1930s, and bronze, 1950, the feminised hand is associated with unformed matter, softness and malleability. With *Seated Tanagra,* 1947, one of his first ceramic pieces, Picasso returns to early Mediterranean art. The rough, lumpy, deeply fissured female figure has been fired in a state of near collapse and expresses the fine line between form dissolving and coming-to-be.

After she cuts the goat's throat, Third Little Girl cradles the animal and dances a *ronde,* surrounded by the other three girls, dressed up in wings and false moustaches. After the sacrifice, Third Little Girl disappears from the scene again, but we continue to hear her litany—"Coming, coming, coming"— from off-stage, until her dramatic return at the end of Act IV.

Fullness and Void

The notion of fullness and void evokes another paradox, another dialectic. For Picasso, the void is what comes before representation, before the blank page. Aristotle comments in the *Physics* that according to the first philosophers (alluding to Anaximander), the void, or infinity, is a first principle or is thought to have an existence in its own right, like the four elements.[24] Aristotle recognises the void as a paradox for, if it were a principle like the four elements, then it would have a limit, an impossibility, given that the infinite is limitless. The void as silence is a powerful image in the play, one that has a continual presence. Silence precedes the emergence of art, as we see in this passage following the goat sacrifice:

Fourth Little Girl

Here the page is white, empty, snuffed out. Silence wraps its feet in ashes, a great soft white pool deposits its spit with pale fingers on the edge of [the] sheet stretched over the corpse. (Act II)[25]

There is the sense of a return to the void in the play, however much progress is made towards the restoration of form. The blank page will provide the material support for art, but, before the beginning, there is only silence, "its feet in ashes", a reminder of the rotten sun and the destruction by fire of the old world. There is no form as yet: the page is a "soft white pool" and a "sheet" that covers the goat's dead carcass.

According to the dialectic, the little girls' poetry leads from emptiness to life, laughter and, eventually, art:

Fourth Little Girl

Silence stripped of the crowds of fiery silver lamps fanned into daylight, the dance that falls on the flower that drowns makes notes of its laughs in the palm of its hand while loosening the buckle of its sandal. (Act IV)[26]

Third Little Girl

Emptiness puts out its claws and bites into the veil hung in front of the image. (Act V)[27]

First Little Girl

Silence stretches its limbs on the soap-bubble of the dream, buried in antics spilt from palms, beaten hard enough to draw blood. (Act V)[28]

First Little Girl

Window open to the immaculate white of a page marked in the centre in bees' honey with the word 'laugh'. (Act V)[29]

The Four Little Girls, reading a book.

the open door of oblivion hitting its stinking ponds against the sky. (Act VI)[30]

Silence, void, immaculate whiteness, oblivion: we are witness to the coming-to-be of the represented world through the sudden movement of a fan; through tearing claws and bites; the stretching of limbs; the drawing of blood; the first mark on a white page; a door hitting against the sky. An unexpected movement separates infinity from the finite, creating the dialectic of void and representation. The veil, the shroud, the window and the door create a division between the represented world, both as writing (the girls read the final line above from "a book") and as "the image", and the emptiness that preceded it. It is no longer sacrifice that engenders art, but the dialectic.

The sun rises from its ashes and brings a new dawn for the image, or rather a dialectic of darkness and dawn, but there are many false dawns in *The Four Little Girls*. The first imprint appears, without human intervention, on the page that will become the support for the ink and eventually the image:

Fourth Little Girl

The shadow of dawn marks with its nail its bouquet of anemones on the corner of the page. (Act III)[31]

Representation begins in the shadow of dawn, at the origin of drawing: the fingernail of dawn scratches the corner of the blank page, leaving a barely perceptible imprint. It deposits a "bouquet of anemones", in Ovid's *Metamorphoses* the blood red flower associated with Adonis (Venus changes him into an anemone) and the symbol of the ephemeral. The image has not yet emerged from the darkness; it remains in a state of possibility. The movement of the dialectic continues as Fourth Little Girl delivers a long soliloquy sitting in the moonlit garden:

Fourth Little Girl

The morning soaks its allusions and its blond wagons with bitter acid-drops, rampant stars with the black paws of axle-trees, full stops and commas fixed at the unhooked casement window howling because of so much ochre and pale festoons unravelled in the cracks of dust, and streaks oiling the step to the well thrown on the fire, taming the sparkling grey, providing a gourd taken from the trap, its splashes of illusion and its deceitful allusion on the hidden wings of the curtains [32]

Fourth Little Girl imagines morning, with its dampness and pale yellow light as sharp as acid drops. The pale carts that bear the early morning light have wheels like "rampant stars with the black paws of axle-trees", an image of night ushering in the dawn. The text shifts from the stars to an open casement window fixed with "full stops and commas". Representation in the form of punctuation marks, the logic of written language, begins with a fall into the world, mediated by the open window. The unfastened window howls at the abundance of "ochre" and "pale festoons". The "gourd taken from the trap" splatters its ripe contents on the "curtains". (The gourd was one of the archaic pottery shapes decorated by Picasso at Madoura, associated here with a theatre curtain.)

 The coming of daylight is an active, ongoing process, indicated by the repetition of the gerund in the opening sentence: "howling" ("hurlante"), "oiling" ("huilant"), "taming" ("apprivoisant"), "providing" ("pourvoyant"), "shivering" ("frissonant"), "burning" ("brûlant"), "intervening" ("intervenant"), "uncovering" ("découvrant"). As her soliloquy continues Fourth Little Girl uses the verb "unfurl" or "unfold" in close succession to emphasise the sense of nature unfurling, opening out, spreading: "all sails set" ("toute voile déployée"); "the open cage opens its fan" ("la cage ouverte déploye son éventail"); "the spread of azure diluted in all the milk spilt" ("l'azur déployé diluée dans tout le lait répandu"). Matter—the unformed clay and liquid

colour—is flowing, flooding and spreading. As the stuff of the natural world comes to life, the voice of Third Little Girl can be heard crying, "Coming, coming, coming".

At the end of the act the sun, or a simulacrum of the sun, appears together with the letters of the alphabet and numbers painted in bright colours on a white backdrop:

CHANGE OF SCENE: the stage is painted white; back-cloth, wings, flies are covered with all the letters of the alphabet and large numbers painted in all colours. The floor is also painted in the same way. In the middle, a bed where the three little girls—FIRST, SECOND AND FOURTH—are lying. Some enormous Winged Dogs wander round the stage by the bed. (Act IV)[33]

The artificial sunrise brings with it elements of a rudimentary, child-like language, both linguistic and mathematical, which appears all of a sudden after a quick change of scene. The artificiality of the moment of synthesis is repeated in the stage directions that follow and which include a description of the dramatic return of Third Little Girl:

The little girls jump out of the bed, naked. They lay on the ground a large blue lake surrounded with flowers and bathe in it. From the middle of the lake the Third Little Girl emerges, also naked; her hair is covered with flowers and her neck, wrists, ankles and waist are encircled with flowers; she dances in the middle, holding the doll in her arms and the goat on a lead. The Winged Dogs fly away. A crowd of photographer-reporters enter and photograph the scene from every side. The curtain falls.[34]

The girls create a simulated form of nature—a kind of cartoon animation that replaces painting and that bears directly on the future of image making (*Snow White*, the first Disney animated film, came out in 1939). The blitz of news photographers is a scene that could be drawn from Picasso's own experience of media celebrity, particularly in the American press, in the months after the Liberation of Paris, when he was besieged in his Grands-Augustins studio by friends, GIs and reporters.[35]

Picasso relates in dense poetic language the arising of consciousness and the beginning of perception with the movement that marks out space on a blank surface, a *tabula rasa*, a phrase Picasso uses in the text.[36] He refers throughout *The Four Little Girls* to the return of the image through the reinstating of drawing, either with chalk or, in the case of etching, with the burin and acid:

Second Little Girl

Ashes thrown as food to the eagles of the hen-run melt the bronze wings of the horse that draws the plough to a diamond song and chains the melodies of the point of the burin, scratching the honey of the copper, to the lanterns. (Act II)[37]

Second Little Girl

Scribbles, scribbles, scribbles wiping the sponge soaked in chalk over the air and the song…. (Act III)[38]

First Little Girl

Here is the bill: three packets of white cotton for sewing and darning dead centre the catastrophic image revealed by the acid, the knee lighting up the road of the scars at each step (Act IV)[39]

This is a moment of ambivalence, of groundlessness, of drawing on air, always on the verge of the first mark: a furrow—the mark of the plough, a scratch, scribble, stitch, acid burn or cut. The surface—honey, air, water—is still too liquid or too vapid to receive the first mark. Music—words and melodies— is also important as a kind of aural surface that has structure of a kind, but no visual form. The act of "sewing and darning dead centre the catastrophic image" or of burning the image into the surface with "acid" recalls Artaud's aggressive sewing, stitching and burning of the "subjectile", the support for the image, which becomes confused with the artist's own body.[40] The use of acid to produce the image—a reference to Picasso's etching—is born out of "catastrophe", the sudden violation of the integrity of the surface, without human intervention.[41] The emergence of the image is an aggressive and difficult process that involves a kind of penance like walking on cut knees— "the road of the scars" [a more accurate translation would be "the way of flayed flesh" ('écorchures')].

Second Little Girl speaks of "a screen and tabula rasa" ("un écran et table rase" [Penrose's translatation of "table rase" as "clean sweep" fails to convey the full meaning of the phrase]):

Second Little Girl

The rose of the carnation laughs the story with all its teeth. It listens and reflects already on the final consequences of threads plaited so finely to make a screen and a clean sweep [tabula rasa] of all smothered rage at the dawns so long awaited.[42]

The phrase *tabula rasa* is a philosophical concept, a metaphor both for the pre-conscious mind and the world. As Penrose translates the phrase, the "table rase" is a "clean sweep", a new dawn. The *tabula rasa* recalls Picasso's image of the "square circle", the projection of time and space in its geometric form. The first mark on the *tabula rasa* indicates space that sets time in motion; the first mark also indicates the moment of the constitution of consciousness.[43] Picasso expresses the mediation of mind and world on the written surface: "Salted anchovies of the wide road of memories, chopped small on the marble covered with graffiti from so many dawns" (Act V).[44] The metaphor combines brain matter, salty chopped anchovies, consciousness, "the wide road of memories", the blank surface, "marble", and writing, "graffiti", in the act of representation.

Picasso's *tabula rasa* provides a support for the image, whether as marble covered with graffiti or, as in the passage quoted at the beginning of the section, a kind of textile—the "threads plaited so finely"—that mediates the world and representation by creating a 'screen' between the two. The notion of the *tabula rasa* is a contentious philosophical issue, whether for Plato and Aristotle or Kant, Husserl, or even Freud, one that raises questions about the supposed simultaneous origin of time, space and consciousness.[45] Which comes first, the argument goes, the sensual or the intellectual, the physical mark or the retention of the mark in consciousness? What is the *tabula*, is it active or passive? For Plato the *tabula* is a block of wax that has the capacity to retain form (as script), while for Aristotle, it is the blank page.[46] The *tabula* is also defined by Plato as *chora*, a reference to the wax block as a kind of matrix that has the capacity to be both intellect and world.[47] This property of the *tabula* would mediate or overturn the dialectic. For Freud the *tabula* is his grandson's Mystic Writing Pad ("Note upon the Mystic Writing-Pad", 1925), a two-layered apparatus that, according to Freud, functions like the unconscious in its ability to erase a mark while leaving a trace in the layer underneath.[48]

For Picasso, the tightly plaited threads serve as both 'screen' and *tabula rasa*—a group of images that link writing to the arising of consciousness, to perception and to the fully visible image. The plaited threads as screen also suggest that the textile-like apparatus both facilitates and hinders vision. Could not the woven threads that form the screen and *tabula rasa* refer to Picasso's dense script, which becomes an actual textile-like surface—both writing and support? For Picasso, too, the *tabula* as script seems to be a mediating apparatus that performs the functions of creating and recording the lines ("threads") at the same time. On Picasso's *tabula rasa* writing precedes or takes the place of the visual image not yet emerged.

The *tabula rasa* precedes the transformation of nature into art through an alchemical process:

The night falls. Some stars, the moon. All the stars. Some crickets. Some frogs. Some toads. Some cicadas. Some nightingales. Some fireflies. An intense perfume of jasmine fills the theatre and a dog is heard barking in the distance. Later, the whole garden lights up, each leaf is a candle-flame, each flower is a lamp of its own colour, each fruit is a torch and the ribbons of the branches of the trees are lights of separate flames. Shooting-stars fall like harpoons from the sky and plant their swords which open like roses and cups of fire. (The four little girls play at leap-frog and laugh; laugh and sing).[49]

As though an ordinary night, the stars come out, frogs croak, a dog barks and insects buzz. But in an instant—without outside intervention—a fiery transformation occurs: the garden lights up and becomes an artificial, 'represented' world. A leaf becomes a candle flame, flowers turn into coloured lanterns, and pieces of fruit burn like torches. The sky is lit by a firework display in the shape of "harpoons", "swords", "roses" [also "rosettes"] and "cups of fire".

In the following passage, the metamorphosis of the four little girls takes place in a great flood of blood (the little girls' menstrual blood?) that fertilises the garden:

They lie down on the ground and go to sleep. Some trees, flowers, fruits, everywhere blood is flowing, it makes pools and inundates the stage. Four big white leaves, forming a square, grow from the earth and shut in the four little girls. While turning, there appears by transparency, written successively on each leaf: 'FIRST LITTLE GIRL'; 'SECOND LITTLE GIRL'; 'THIRD LITTLE GIRL'; 'FOURTH LITTLE GIRL'.[50]

In a metamorphosis worthy of Ovid, the quintessential poet of matter and its continually changing form, the four little girls turn into "white leaves" or "white pages" (feuilles blanches), in a return to the imprints of leaves on the frontispiece of the play. The three girls have become four, creating stability and ending the cycle of sacrifice. In a further transformation—from darkness to light—the four leaves are changed into the pillars of a white temple, a structure traditionally associated with the constructed, material world and with wisdom, truth and moral perfection. With a throw of the switch, the blacked-out stage is lighted to reveal the abstract scene:

Complete Black-out. The stage, after lighting returns: the interior of a cube painted white all over fills it completely. In the middle, on the ground, a glass full of red wine.[51]

The girls, representing the four elements, provide the foundation of a cubic structure, form in its purest state. The pure white structure serves as an altar on which is displayed a glass of red wine, symbolic of the transubstantiation of sacrificial blood and the overcoming of sacrifice. Thus is the return to form consecrated in the new artistic order.

The play ends as it began, with an abstract concept which refers to the synthesis of the sensual and the intellectual. With the white cube, the rational overcomes the former incoherence and madness as the circle is squared. But what does this cube represent in 1948? Picasso's cube places before us a type of visual field at the origin of abstract art—a kind of art Picasso vehemently rejected—which suppresses the formless, impure or abject.[52] Françoise Gilot recalls a more prosaic meaning of the white cube. She describes the kitchen in Picasso's Grands-Augustins apartment as a large white cube, a place that inspired Picasso's two versions of the cubist-style painting, *The Kitchen*, November 1948 .[53] This abstract painting is an anomaly in Picasso's art, similar only to his 1924 Juan-les-Pins dot and line drawings. Picasso conceived the kitchen on more than one level. As described in his writings, the kitchen is a place of sacrifice. *The Charnel House*, 1945, one of his most important post-war paintings and the mirror image of *Guernica*, depicts a heap of dead bodies underneath a table laden with food. The nearly abstract *The Kitchen*, made "out of nothing", Picasso said, becomes an idealistic space, a place of reconciliation.

The Four Little Girls ends with an idealistic desire for peace and hope for the future, a Hegelian cancellation of contradictions. On 25 August 1948, twelve days after he completed *The Four Little Girls*, Picasso travelled to the Cracow Peace Conference, one of several such engagements between 1948 and 1950. In a moment of idealism peace overcomes war.

The Kitchen (*La Cuisine*),
1948, Musée Picasso, Paris

"So, essentially, the kitchen was an empty white cube, with only the birds and the three Spanish plates to stand out from the whiteness. One day Pablo said, 'I'm going to make a canvas out of that—that is, out of nothing'."
Françoise Gilot, **Life with Picasso**, p. 210

EL ENTIERRO del CONDE de Picasso OGAZ

23.4.69.

The Phantom

The Burial of the Count of Orgaz, 1957-1959

So what exactly are these Meninas whose glorious existence we would be ashamed to call into question? What if not phantoms of maids of honour and the phantom of Velázquez, or, more faithfully, phantoms of phantoms, since even when the artist and his models, the maids of honour, were alive, the Velázquez and the maids of honour of the painting were no more than effigies, among other effigies projected on to the white of his canvas by the man whose name was "Velázquez" and who, like the maids of honour, no longer has in our twentieth century any traceable existence other than that of a phantom lying in wait in one of the innumerable corridors of the palace of history.

Michel Leiris, "Picasso and *Las Meninas* by Velázquez", 1959

"Circus figures: the parade," II (*"Personnages de cirque: la parade"*, *II*), 17 April 1967, Museu Picasso, Barcelona

"In the theatre: the Cocu brandishing Zeus's 'thunderbolt'" (*"Au théâtre: le Cocu brandissant la 'Foudre de Zeus'"*), 3 December 1966, Museu Picasso, Barcelona

And so the image continues to haunt Picasso. In the 1950s, with the whole tradition of painting behind him, Picasso begins a dialogue with artists of the past. He thinks against his time, questioning the linear development of art. "You have to kill modern art," he says, "for modern, once again, no longer exists."[1] In 1957 Picasso, now 75 years of age, lives at the villa La Californie at Cannes, isolated from the Parisian *avant-gardes*, an anachronism, it was thought, in his own lifetime. He continues to paint, taking as his subject Old Master works, producing inspired 'copies', mainly from reproductions but also from memory. Picasso's 1950s aesthetic, however, is very modern, related to the construction of new realities through language and the image. To his long engagement with the technology of image making, using photography both for documentary purposes and as an artistic resource, he adds his collaboration with the cinema.[2]

Technology and artistic inheritance are important concerns for Picasso, haunted by the phantoms of artists long dead, as he composes the *Burial of the Count of Orgaz*, 1957-1959.[3] Picasso uses the technology of image making in a concrete sense, but he also has a more abstract and complex relationship to technology, which has to do with his own body, as will be seen below.[4] He is inspired by Old Master works—they comprise his artistic inheritance—but not in the sense of a return to the past, as his technique and his interpretation of reality are influenced by contemporary ideas.[5] What does Picasso actually inherit and by what means? What relevance does his copying have for modern art?

The Burial begins as a bizarre kind of play that develops into a work of epic proportions.[6] Picasso parodies in words El Greco's famous altarpiece of an interment, turning the events depicted in the painting into a series of salacious stories and malevolent gossip about people in a remote Spanish village. The etchings included in the 1969 Gustavo Gili edition of the text portray some of the village characters, together with a miscellany of others: Picasso himself, a self-mocking portrait of the artist as an old, naked Dionysus; his kneeling assistant, Sabartès; a nineteenth century gentleman dressed like the composite figure of Goya and Courbet described in the *Burial*; Cupid and Psyche; circus figures and musketeers.[7] These rude, satirical images reflect the carnivalesque structure of the play and Picasso's tendency, particularly evident in the late etchings, to bring all forms of representation—painting, theatre (including the audience), circus and carnival—and different historical periods—the seventeenth, eighteenth and nineteenth centuries and the 'present'—on to the same level.[8]

Picasso produced the 14 texts of *The Burial* in fits and starts over a period of three years. Ten of the texts are in Spanish and two, in French. The dates of composition serve as titles: "6.1.57 Cannes A.M."; "12.1.57"; "27.1.57"; "14.8.57"; "2.12.57"; "16.1.58"; "17.1.58"; "8.6.58"; "19.6.58"; "21.7.58"; "5.8.58"; "8.8.58"; "Second Part" "9.8.58" and "20.8.59", the second half of which bears the heading "Third Piece". Picasso returned to the work after long intervals, following the cyclical rhythm of the Spanish year: 6 January is Three Kings Day and 14 August, the eve of the Feast of the Assumption. It is no coincidence that these dates are holidays, days that enforced a break with routine. But it is St John's Eve on 24 June that is most closely associated with *The Burial*. St John's Eve, the night of fire (traditionally bonfires are lit), is a time of the waking dream, when the force of the erotic is unleashed.

The content of the texts is absurd, consisting of tales about priests with whoring daughters, the village idiot, the postman, oversexed women, grandmothers in bikinis, people vomiting, pissing and dying of laughter. They follow one after the other in random fashion like a shaggy dog story. This is representation from below in a language and picaresque tone characteristic of Spain's Golden Age (Renaissance) literature.[9] Such passages alternate with passages of pure gongoresque-style poetry that bear no relationship to the stories. Freeing language from any constraint, Picasso turns writing into a material thing "in which the machine mashes nothing even seemingly solid…" in the words of Michel Leiris.[10] The two sides of representation—literary language and gossip—fail to match, and neither seems to have any connection to the other or to outside reality. Picasso, at his most absurd and humorous, is also at his most esoteric, playing his intellectual games with tongue in cheek.

The first manuscript page includes the title "El entierro del conde de Orgaz" and the date and place of composition of the opening text, "6.1.57 Cannes A.M."[11] The irrational text offers no clues as to why Picasso borrows the title of El Greco's masterpiece. The grandiosity of the gesture, furthermore, is at odds with the look of the manuscript page, with its scribbled phrases. The content of "6.1.57", at once serious and absurd, reflects the events of the holiday on which it was written, Three Kings Day, or Epiphany, a great festival with processions, the lottery and gift giving. Like all Spanish festivals, it is a time for gender and social inversions and the mocking of authority. Picasso's viewpoint from below, from the popular level, ridicules 'high art'.

The text divides into passages that alternate among the speaking parts "0", "1" and "2"—characters whose impersonal names would appear to be a facetious reference to a mathematical code of communication. The late 1950s was the time when linguistic theories and universal codes of communication were being developed. The visual aspect of numbers fascinated Picasso, a poor student of mathematics, he claimed.[12] The voices in the quotation below each form a part of a larger unknowable puzzle that is *The Burial of the Count of Orgaz*:

El Greco, **The Burial of the Count
of Orgaz**, 1586-1588, Toledo,
S. Tomé, Spain

A group of nobles dressed in
seventeenth century costume
stand in a group behind the body
of the fourteenth century Count of
Orgaz who, cradled by St Thomas
and St Augustine, is about to be
re-interred. Among the nobles on
the far right is El Greco, the figure
looking outwards, while his young
son, the kneeling figure in the
foreground on the far left, also
looks outwards as he points to the
body. Above, in contrast to this
scene, an extravagant swathe
of flowing material supports the
angels, heavenly hosts, St Peter,
St Mary and, at the apex, John the
Baptist and Christ, their figures of
different sizes.

<u>1</u>

here there is only oil and old clothes.

<u>2</u>

son of a whore whore crafty and again crafty gash wolf rheumatism and one-eyed owl

<u>0</u>

boy of flowers winking and gossip on top of the make-up box of the twisted nail opened by the point of the knife.

<u>2</u>

weasel Pérez dressed like a priest spreading the skin of the suit of shadows.

<u>1</u>

after having received the envelope open and without a stamp it might be eaten by the postman or his grandmother without having to account to anyone about it so happy about that.[13]

The running joke in *The Burial* about a primitive postal system, a postman, a roving letter and empty envelope begins here. Throughout the *Burial* the letter doubles as Picasso's rambling epistolary work—"the open envelope without a stamp" ("el sobre abierto y sin sello")—and the stories it contains, a form of communication that is both private and public: "the girls from downstairs put themselves in an envelope and put a stamp on it and posted it" ("las chicas de abajo se metieron en un sobre le pusieron un sello y lo echaron en el correo"), "16.1.58". The names "Don Juan", "Minuni" and "Paco Reina" appear, but we never learn who they are. The voices talk nonsense, gossip and speak in seemingly logical sentences none of which makes sense:

<u>2</u>

I'm not saying that what I'm not saying I'm not saying in order to say that I'm not saying it.

<u>1</u>

a heap of I'm saying a heap of tell me a heap of saying of not saying like a heap of chestnuts praying their tapers and their slowly fried eggs.[14]

Voice 2 utters a series of negations, negating itself. Voice 1 creates a false equivalence between "a heap of I'm saying", drawing on the colloquialism "I have loads to tell you", and "a heap of chestnuts", an actual 'heap'. A carnival atmosphere reigns and the voices refer to carnival activities—the lottery and bullfights—the wearing of masks and a celebratory "binge" ("juerga"). Picasso revels in the sound of the repetitive voices—either the first person singular "I", the familiar second person singular "you" or the impersonal "one"—which have no existence outside the text.

1

one knows what one knows one knows what is known what is no longer known is known and forgotten what is known and not lived what is seen what is glimpsed what is never seen and what is wished to see and seen in a stain of wine on the table top under the empty glass beside a knife and some crumbs of bread.

2

that's how I've always believed again the light goes out if you light it the light doesn't need light to see clearly

1

don't say silly things dance and sing and don't tell me stories[15]

Picasso also celebrates a more tangible form of reality, describing, for example, the "empty glass", "knife" and "crumbs" on the table. Thus, the passages also deal with such philosophical subjects as reality, belief, seeing and knowing in a parodic manner. Such passages could be compared to works by Picasso's literary contemporaries, such as the _nouveau roman_ novelist and theorist Alain Robbe-Grillet.[16] Picasso applies similar techniques, exposing his procedures and promoting experimentation, techniques he will transfer to painting.[17] Such fictional techniques would already have been familiar to Picasso from Cervantes, considered the first European novelist.[18] At the end of "6.1.57" speaking voice 1 admits that it's all just stories (cuentos Cachupino).

Picasso continues the quasi-theatrical structure of the _Burial_ in two short, mainly French texts written later in January, which allude to an actual stage and dehumanised characters and include stage directions, as well as a list of live forms of representation:

12.1.57
The most complete emptiness on the stage
characters 0—00—
the most important completely beyond the question of conventional gestures
pica pica [itching powder] and _matasuegras_ [reed pipe].[19]

27.1.57
appearance of the old imbecile and search in the dustbins for the poverty and the excess of reality of the _quain quain_ [malevolent gossip]
national holiday fireworks balls military parades and ecclesiatical illuminations[20]

The characteristics of the theatre Picasso describes here—the emptiness of the stage, the tramp as character, the nonsense language, the non-conventional gestures, the search for reality "in the dustbins"—bear a striking similarity to Beckett's Theatre of the Absurd.[21] Again, Picasso seems to refer to a 1950s avant-garde theatre that expresses the new reality: "being there", on the stage, is the only reality.[22] Picasso adds "the poverty of the excess of reality", recalling the title of André Breton's essay on the surrealist object, "Introduction to the Discourse on the Poverty of Reality" ("Introduction au discours sur le peu de réalité"), 1925. Are "reality" and the concrete, then, the subject at the heart of

El entierro del conde 6.1.5t.
de Orgaz

1 aquí no hay mas que aceite y ropa vieja,

2 hijo de puta puta calvo y manco

0 tojo rueño de lobo ~~???~~ buo cojo
niño de flores postraneros y rosillo sino
del carton de afeites del clavo trunco
abierto por la punta del cuchillo.

2 ratoncito perez tirada la carn
rogando la piel) del traje de tinieblas

1 a fin de que habiendo recibido el
sobre abierto y sin sello se lo pueda
orinar el cartero ó su abuela sin
temer que darle cuentas á nadie
tan contento.

2 pero alto que lo que hay que hacer
es aquí sentar de liar el lio
al ovillo y desplumar el verso
de la vela.

Picasso's *Burial*? Is this the characteristic of the 1950s that he wants to engage with, however ironically, in his art? At this point Picasso suspends work on the texts for seven months.

14.8.57: "the burial of the Count of Orgaz continues"

At the head of "14.8.57" Picasso writes the date of the eve of the Feast of the Assumption (St Mary's Day) and the phrase "the burial of the Count of Orgaz continues". This, the third section of *The Burial,* is the only text that mentions the painting by El Greco. "14.8.57", like the 1966-1967 illustrations, provides a site where diverse elements can be brought together: El Greco, "the four little girls", Prosper Merimée's *Carmen*, Velázquez and *Las Meninas*, as well as live forms of representation and gossip.[23]

In "14.8.57" Picasso loosely follows the two-tiered structure of El Greco's painting, which depicts the burial scene in words 'below' and heaven 'above'. He opens with the nobles around the grave and goes on to focus on the swathe of material, which takes on an anthropomorphic quality. References to heaven appear in the second half of the text. Between these two sections are passages of pure poetry, seemingly meaningless. At the mid-way point, a story tells of the outrageous behaviour of some of the village types. "14.8.57", and Picasso's *Burial* as a whole, unfolds as in a dream, a "summer dream" ("sueño de verano"), as time, place and characters become confused. The text begins:

Don Diego Firme [Staunch] Don Ramón Don Pedro Don Gonzalo Don Juez [Judge] Don Peregrino [Pilgrim] Don Flavio and Don Gustavo and Don Rico [Rich] Don Clavel [Carnation] Don Morcilla [Blood Sausage] and Don Rato [Rat] Don Ricardo Don Rugido [Wind] Don Gozo [Pleasure] Don Rubio [Fair-Haired] Don Moreno [Dark-Haired] Don Cano [Grey-Haired] around the open grave eat the silk that rains from the spout that getting drunk at the top of their voice the gold threads of the banquet of owls the fringe of needles placed face downwards on top of the table full of silver coins on top to the left of the fan of refreshments placed in the window that overlooks the port full of jasmine pieces of tinder of the chasubles and the cock's feet [also crow's feet] of the flock make sausages of the keys of the feathers of oil of the songs and cracklings that cook between the fingers of the wings of the goat[24]

The roll call of nobles with humorous names standing around the open grave brings to mind Picasso's art school caricature of his teachers, which he produced after seeing El Greco's painting on a school trip to Toledo.[25] The silk drapery, with its rich gold threads and fringe, unexpectedly turns into a cover for a table laden with fiesta refreshments, cooling off on a window ledge overlooking the Bay of Cannes, the view from Picasso's studio window. The Magi, who had failed to appear on 6 January, arrive drunk, and a celebration like "Nochebuena" ("Christmas Eve") and the "catorce de julio" ("Bastille Day") begins. The first section of "14.8.57" ends with the word "kitchen" ("cocina"), the place where Picasso often did his writing.

Picasso draws a line under the first part of the text, creating a link between the burial of Orgaz and the uproarious festivities of 14 August with the phrase: "And here the story ends and the banquet. Not even the madman

knows what happened then." ("Y aquí termina el cuento y el festín. Lo que pasó ya ni el loco lo sabe.") Illogically, "14.8.57" continues with an intrigue about a town where everyone knows everyone and everyone is related by blood or by marriage—the postman, his wife, the sister of his sister-in-law and so on:

The postman's wife went to the bullfights with her cousin, the postman ran off with the sister of his sister-in-law Amalia and the nephew didn't find out what he did all afternoon nor at what time he came home. It wasn't that night or the following day when they got into trouble but on Aunt Regüeldo's saint's day in the middle of the banquet when the *merengue* [row] suddenly began. Perdaguino's daughter, the one with the blouse, let off a fart and taking her tits out of her blouse raised her skirts and showed us her pussy. Imagine the face of the priest and the grimace of the little nephew the goat-herder's daughters the little whores opposite and the nuns were crossing themselves and dying of laughter at so much lightning and thunder[26]

On the feast day of the Virgin everyone behaves badly. The village gives itself over to the living theatre of carnival, as representation takes place from below, from the level of the people. Such passages as the story cited here, of which there are many in subsequent texts of *The Burial*, may have a tenuous link with reality. It can be deduced from the mountain terrain and other details described in *The Burial* that the work is set in the Pyrenees, an area Picasso knew well. The characters may be caricatures of people he met in Gósol, a village in a remote part of the Pyrenees, in the summer of 1906 and in Horta de Ebro, also in the Pyrenees, in the spring and summer of 1909. Gósol, known mainly for hunting and smuggling, offered little in the way of entertainment, apart from religious festivals, and particularly the bonfires, celebration of the Mass, processions, games and dancing of St John's Eve.[27] Picasso's Gósol paintings, *Woman with Loaves,* for example, *Still Life* and *Head of Josep Fontdevila*, and sketchbooks like the *Catalan Notebook* (*Carnet Catalan*) depict dancing couples, peasant girls and other locals.[28] The portrait photographs Picasso took in Horta include such village types as a guitar-player and women and children, although his sitters are more sedate than their ribald counterparts in *The Burial*.[29]

The subject of the interment returns with the phrase "the four girls in their beds burying the Count of Orgaz" ("las cuatro niñas en sus camas enterrando al Conde de Orgaz"). The phrase appears at the top of the manuscript page, creating another division in the text. The section that follows corresponds to 'heaven', although what appears there has nothing whatever to do with the divine. According to the dream logic of "14.8.57", the heaven of Picasso's *Burial* involves Velázquez and the studio where he painted *Las Meninas*, but Goya, Courbet and the figure of Picasso himself are present there too. These figures mingle in Picasso's narrative account of Velázquez's studio, and they become confused with the subjects of his royal portraits like those of Picasso's *Meninas* series. Also included in this fantasy narrative of artists in Velázquez's studio are Pyrenean village types, bullfighters and civil guards. Picasso writes:

in their beds the Meninas play at burying the Count of Orgaz

the boy playing the piano hanging tied by his neck mounted on a horse dressed like a chef in his (mourning) hat holding in his left hand a frying pan like a shield— (the horse with black and silver trappings) <u>this has nothing to do with the Meninas</u>

a ham and sausages hanging from the two hooks in the ceiling

Modesto Castilla natural son of D. Ramón Pérez Cortales

D. of S. and V. placing his <u>palette-mirror</u> in front of the mirror nailed to the wall at the back of the room

the figure in the doorway is Goya painting making a portrait of himself with his hat [like a] chef's toque and his striped trousers like Courbet and myself—using a frying pan as a palette

the fourth little girl starting from the left mounted on a horse covered in black trappings and silver ornaments
decked out like a *picador*

on top of the painting an owl that came one night to kill pigeons in the room where I'm painting

all the pigeons

on the piano keys a cigarette end burning
and the two civil guards behind the Meninas

in the heaven of the burial of the C. of Orgaz Pepeillo—Gallito and Manolete

in their beds the Meninas play at burying the Count of Orgaz[30]

In the opening passage of the text quoted above, Picasso, in the spirit of carnivalesque mockery, describes a "boy", a character equivalent to the jester in Velázquez's *Las Meninas,* mounted on a horse in the manner of an equestrian royal portrait, wearing a chef's toque and holding a frying pan. The final underlined words of the passage confirm facetiously, "<u>this has nothing to do with the Meninas</u>". The boy playing the piano is the subject of a 'surrealistic' painting, as Picasso describes *The Piano*, 17 October 1957, from his *Meninas* series in the quotation below. One of the anomalies of the *Meninas* series,

The Piano (*Le Piano*),
17 October 1957,
Museu Picasso, Barcelona

The Studio: The Pigeons

(*L'atelier: Les pigeons*),

11 September 1957,

Museu Picasso, Barcelona

The Piano includes Picasso's basset-hound Lump, who replaces the noble court dog under the jester's foot in the painting by Velázquez. Roland Penrose describes the origin of the comic image:

> As he pokes the good-tempered dog with his foot the boy's hands seem to flutter nervously. This tempted Picasso to think that he might be playing an invisible piano, and to paint a study of him seated at a piano well lit with candles. He also noticed in the original a little black line in the panelling that rises from the nape of the boy's neck. This in turn suggested to him a cord by which the young pianist was hanged like a helpless tinkering marionette. 'I saw the little boy with a piano', he said to me. 'The piano came into my head and I had to put it somewhere. For me he was hanged so I made him hang. Such images come to me and I put them in. They are part of the reality of the subject. The surrealists in that way were right.'[31]

However, Picasso mocks what we know he reveres—the tradition of painting and the artists whom he felt to be with him in the studio, looking over his shoulder while he worked.[32] He continues the mockery with the phrase "a ham and sausages hanging from the two hooks"—the hooks being a reference to the empty chandelier hooks visible on the ceiling in Velázquez's painting. Picasso then describes Velázquez's self-portrait in *Las Meninas*: "D. of S. and V. [Diego de Silva y Velázquez] placing his palette-mirror in front of the mirror nailed to the wall at the back of the room". In the text a mirror, like the one Velázquez depicts, doubles as the artist's palette. In the following passage Goya appears "in the doorway", recalling Velázquez's brother in the background of *Las Meninas*. Goya is painting his self-portrait, using a frying pan as a palette and dressed in a chef's toque and striped trousers "like Courbet and myself" ("como Courbet y yo"). The ludicrous portraits of Goya and Courbet in the text match Picasso's depiction of two figures in his 1966-1967 etchings wearing top hats and striped trousers. Picasso also includes a musketeer in the same etching. Returning to the text, "the fourth little girl", too, is the subject of a royal equestrian portrait, in which she is dressed like a *picador*, a figure from another of Picasso's store of subjects.

Picasso's allusion to the owl (mochuelo) and doves (palomas) is a reference to his own studio where "I am painting". The image recalls an incident that happened while Picasso was painting the *Meninas* series in his studio at La Californie, as Roland Penrose recounts:

> He tells how recently, while he was painting one night, a large bird of the same race [an owl] flew in at the window and after battering itself against the glass, perched on top of the canvas on which he was at work. It had come, he thought, to prey on his pigeons that fly at liberty from the terrace outside the window during the day.[33]

By the time he was writing "14.8.57", Picasso must have moved to the top floor studio, as Penrose describes:

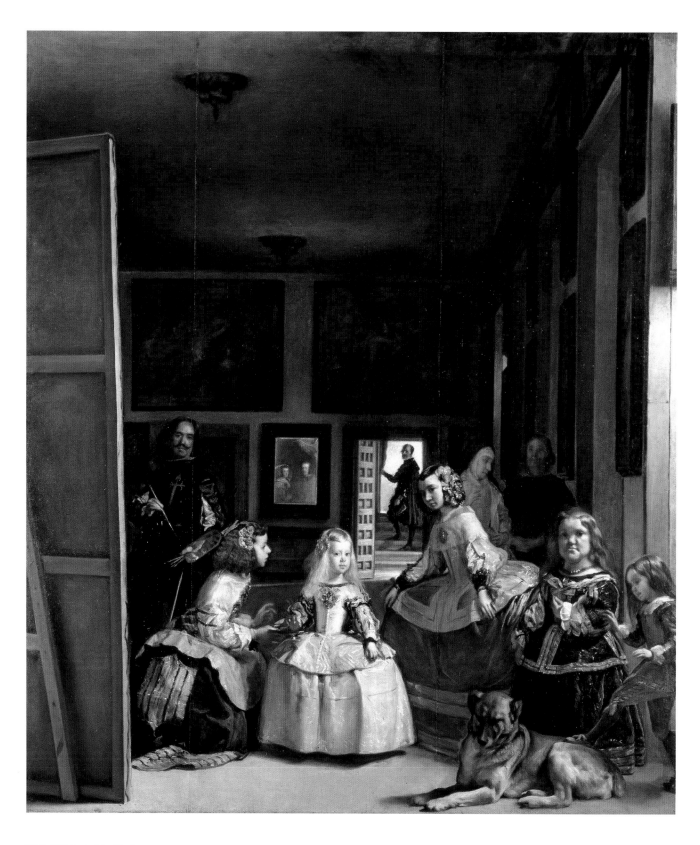

Diego Velázquez, **Las Meninas**,
1656, Museo National del Prado,
Madrid

Since midsummer the work in progress has taken place on the top floor, hitherto uninhabited except by the tame pigeons. [...] The pigeon house, looking not unlike a cubist construction, was built by him on the balcony of one of the largest of the empty rooms that he has now invaded. There is nothing to distract him but his doves and the view over the palm and eucalyptus trees towards the Lerins Islands that lie just below the horizon. Here he can work isolated and undisturbed by day or late into the night.

None of the treasures from the rich haphazard assortment below has yet been elevated to this level, nothing breaks the bleak severity of torn and faded wallpaper and the marble mantelpieces of abandoned luxury. He works at night by the light of a high-powered electric bulb hung from the middle of the ceiling. 'What does it matter,' Picasso says, 'if it looks good by that light it will look good at any time.'[34]

Penrose's account explains why Picasso includes nine paintings of doves on a balcony overlooking the Bay of Cannes in the *Meninas* series, 6-12 September 1957. The pigeon house described in the quotation above had a moveable metal grille cover, a prominent feature in the paintings of the balcony, which focus on the border between the interior and the exterior of the studio, where, as with Velázquez in his studio, Picasso paints *Las Meninas*.

In "14.8.57" Picasso refers to the Old Master painters with whom he identifies specifically: El Greco, Velázquez, Goya (the young Picasso was dubbed "le petit Goya") and Courbet. In 1950 he painted copies of El Greco's *Portrait of a Painter* and Courbet's *Young Women on the Banks of the Seine*.[35] These artists are also famous for their self-portraits in the studio: Velázquez's *Las Meninas*, Courbet's *The Studio* and Goya's numerous self-portraits.[36] Picasso's *Burial* is also a kind of self-portrait in which he depicts himself, "yo" ("myself"), as heir to the legacy of the great painters. He evokes the great Spanish artistic tradition and Courbet, the favoured painter of the French Communist Party, with whom he exists on the same level, at the same moment in time.

"In the heaven of the burial of the C. of Orgaz Pepeillo—Gallito and Manolete", Picasso writes. Pepeillo, a bullfighter, was the author of the classic work on the bullfight, *Tauromaquia o el arte de torear*, an edition of which was illustrated by Goya, 1816, and by Picasso, Gustavo Gili edition, 1959. The renowned Gallito and Manolete represent two generations of twentieth century bullfighters. Thus, Picasso's humorous portraits of Old Master artists in "14.8.57", in which he includes himself, contain the elements of his new aesthetic—the idea of repetition, of the copy or simulacrum and of the artist as phantom—as he resurrects the tradition of painting from the dead. There is laughter rather than mourning at the burial of the Count of Orgaz.

Las Meninas

After 14 August Picasso breaks off writing about Velázquez's *Las Meninas* to paint it. Sabartès compares Picasso's project of copying *Las Meninas* to a "dissection", an "autopsy" and a "laboratory experiment", for which the artist draws on different aspects of his cubist experiments.[37] He varies the size and colour of the series of works inspired by the painting, focusing either on the

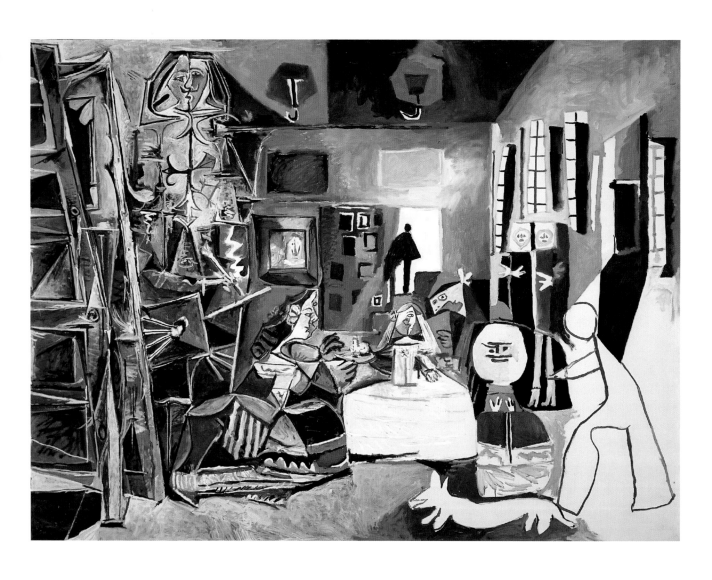

Las Meninas, 17 August 1957,
Museu Picasso, Barcelona

image as a whole or on the figures, especially that of the Infanta. During the first month he produces a series of small canvases of the two central female protagonists, their heads, torsos and full-length figures. Next comes the group of nine paintings of doves on the balcony, while the larger treatments of the painting as a whole appear in succession in mid September. Picasso returns to the female figures, both singly and as part of a group, in October and November, and he produces one last *Meninas* on 30 December 1957. Tangential to the series are *The Piano,* the three landscapes dated 2 December 1957 (Velázquez reproduced well-known landscape paintings in *Las Meninas*) and the portrait of Jacqueline, 3 December 1957.

What does *Las Meninas* represent in 1957 for Picasso as a modern artist, bearing in mind that Picasso's modernity is at issue here? Velázquez's *Meninas* is the painting par excellence about mimesis, or the representation of reality.[38] With its complex perspective and mirror effect, however, the painting draws no simple correlation between representation and reality, but rather portrays the feints and subterfuges involved in the construction of 'reality'. For Picasso, who couched his ironic remarks on art according to the Aristotelian paradox that "art is a lie that makes us realise truth", *Las Meninas*, a perenially modern work, proved the ultimate challenge.[39] In his *Meninas* Picasso explores the paradox of representation for painting in the 1950s.

The origin of Picasso's *Meninas* project precedes his actual painting of the work by a number of years. Jaime Sabartès cites a comment Picasso made in 1949 or 1950 about copying *Las Meninas* in his own way:

Let's suppose you want to copy Las Meninas pure and simple. A moment would come, if I were to undertake that task, when I would say to myself: what would happen if I put that figure there a bit more to the right or a bit more to the left? And I would try to do it, in my own way, without concerning myself with Velázquez. That attempt would surely lead me to change the light or to place it differently, due to the fact that I would have moved a figure.[40]

Picasso carries out his idea seven years later, relying on his memory of the painting he had last seen on visits to Madrid in August 1934 and to Switzerland in 1937, when the Prado paintings were held there for safe keeping. Picasso must also have referred to a reproduction, as Sabartès suggests. He begins the work of deconstruction with a large format "copy" of the painting as a whole, in a brash, pseudo-cubist style *Las Meninas*, 17 August 1957, a parody of modernist painting, masks the seriousness of Picasso's project and sets the tone for the rest of the series. Through humour Picasso, no mere copyist, lays claim to *Las Meninas*, as he dusts off Velázquez's masterpiece, letting in light and air.[41] Velázquez's exceptionally large canvas measures 318 x 276 cm, while Picasso's is 260 x 194 cm. Picasso widens the format to open out the painting and suggests the daylight streaming through the window and the doorway with a bold theatrical illumination. The light outside the doorway, a strange presence that does not cross the threshold in Velázquez's *Las Meninas*, looks, in Picasso's version, like a blind spot or a non-space: there is nothing outside the canvas. Picasso conceives the image in tones of grey; line and volume, rather than colour, are what matter here. The picture surface is broken up into crude squares, rectangles and curves of varying sizes, and the major features of the painting are put in place: the caricatural figures, including Picasso's dog Lump,

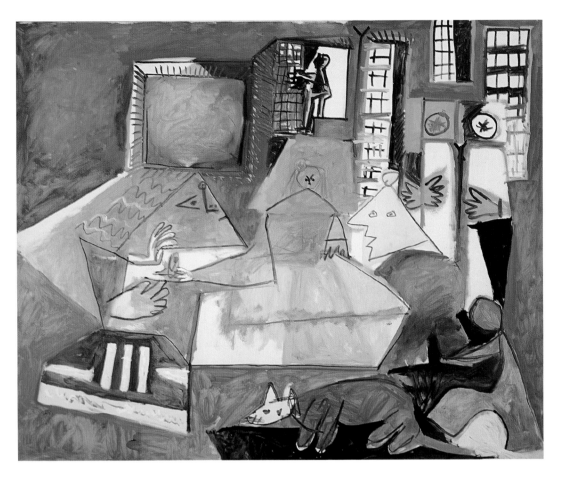

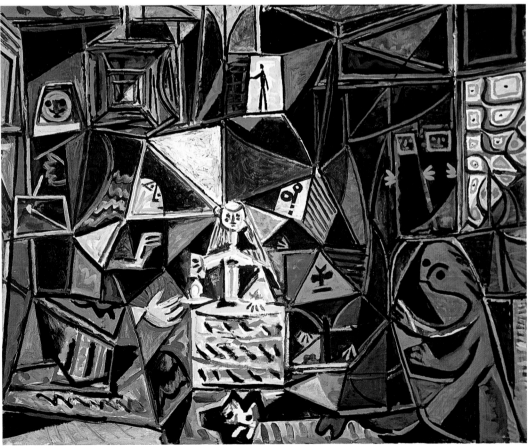

the reciprocal elements of representation (easel, paintings, mirror, doorway, windows) and the light source. The doorway appears to recede into the distance, as in Velázquez's *Las Meninas*, and the figure in silhouette appears very far away. However, what looks convincingly real in Velázquez's *Las Meninas* is made to look false in Picasso's painting.

In this first painting of the *Meninas* series Picasso reserves his greatest ridicule for the figure of Velázquez: he enlarges the artist—his head touches the ceiling—who towers over the schematic figures on the right, mere outlined white shapes bathed in light. He mocks Velázquez's artistic persona and the high status he actively sought and finally achieved, for his art and for himself. Philip IV, the royal figure reflected in the mirror together with the queen, ordered the Cross of Santiago, the highest order of knighthood, to be painted on Velázquez's self-portrait in *Las Meninas* after the artist's death.[42] The acceptance of painting as a liberal art, based on Velázquez's dazzling display of perspective, and the social status of the painter, no longer a lowly craftsman, are an important part of the meaning of the seventeenth century painting.[43] In Picasso's series as a whole the artist is almost always absent or reduced to a cypher, a reflection of the twentieth century deflation of the subjective in the arts and science in favour of objectivity.[44]

Three treatments of *Las Meninas*, painted in succession as part of the group of six, 15 September-3 October 1957, are coloured variations on the manipulation of space. In *Las Meninas*, 15 September 1957, the figures are made of three-dimensional geometric shapes that nonetheless appear as flat as *papiers collés* (pasted paper) against the loosely painted, solid blue and green ground. The Infanta's skirt, the subject of a small study of the previous day, is, roughly, a parallelepiped. The light coming in through the grid-like windows, moved to the background, is dispersed as solid white blocks. The enlarged mirror to the left of the doorway appears blank, reflecting nothing, and the image of the king and queen is eradicated. The two figures on the extreme right, Velázquez's courtiers, are long narrow rectangles with circles for heads, each with a web-like hand. The jester and the dog retain their same curved shapes.

In *Las Meninas*, 18 September 1957, the surface of the painting is criss-crossed by a web of multi-coloured shapes or black and white spaces that represent planes and recesses. Picasso creates a complex spatial arrangement that is claustrophobic, disorientating and sinister. The art nouveau window frame, in reality a feature of the ground floor of La Californie, is merely a decorative panel that lets in very little light. The mirror on the back wall, a series of frames within frames, demonstrates the *mise-en-abyme* effect as it recedes into deep space. The dresses of the Infanta and Doña Isabel de Velasco are flat geometric shapes with patterning, the rich texture of the material conveyed with diagonal or script-like lines painted in thick impasto. Elements of the costume and hair ornaments of these figures are taken up in five small studies of 9 and 10 October and a further five of 17 November 1957. As Picasso extracts the minute detail from the whole, the discrete image, he treats *Las Meninas* as if it were a photograph, a notion that will be returned to below.

A more severe, dramatic treatment of *Las Meninas,* 19 September 1957, has a matt black and red background that resembles a theatrical space, recalling the equivalence of theatre and painting for Picasso, as for Velázquez.[45] The narrow, high space, arranged like a two-tiered backdrop, is compressed in the centre. The easel, designated by two red and two white lines against a black background, resembles the outlines of an upright coffin, which leaves

caption
Las Meninas, 15 September 1957, Museu Picasso, Barcelona

Las Meninas, 18 September 1957, Museu Picasso, Barcelona

Las Meninas, 19 September 1957, Museu Picasso, Barcelona

a void in the space for the artist. The central group appears as paper cut-out shapes painted red, blue, yellow, green and white.

In his *Meninas* paintings Picasso leads the viewer or, more appropriately, the reader—for linguistics and language, rather than perception are what seem to matter here—into a series of games with reality. Picasso concerns himself with the way reality is produced, not the reality that matches the world outside, but that of the surface of the work. In 1966 Michel Foucault provided a detailed description of Velázquez's *Las Meninas*, the painting that inaugurated the Classical Age, the era when, according to Foucault, representation becomes the basis for understanding the world.[46] In meticulous detail Foucault analyses every aspect of the painting: the reciprocal gazes; the artist and the models, or subject and object; the spectator; interior and exterior; material and immaterial (the actual painting and the mirror image).

Foucault's linguistic analysis illuminates Picasso's approach to *Las Meninas*. The task of reproducing *Las Meninas* becomes an exercise in geometry, tracing the lines of the reciprocal gazes, the dynamics between the positions of the figures and the replication of the various substitutes for representation: the back of the canvas, the mirror, the windows, the doorway and the paintings on the walls. The artist's canvas becomes a "monotonous rectangle" and the painter's gaze "commands a virtual triangle" that unites his eyes, the model and the figure on the canvas. The reader is not sure who or

what Foucault is describing; he eschews the naming of the individual subjects for objective description, which sets language and vision one against the other:

> it is in vain that we say what we see; what we see never resides in what we say. And it is in vain that we attempt to show, by the use of images, metaphors, or similes, what we are saying; the space where they achieve their splendour is not that deployed by our eyes but that defined by the sequential elements of syntax.[47]

To begin with, Foucault speaks in abstractions—'the painter', 'the characters', 'the models', 'the spectators', 'the images'—instead of disclosing the identities of the figures—Velázquez; the Infanta Margarita; Doña Maria Agustina Sarmiento, one of the *meninas*, or ladies-in-waiting; Nicolaso Pertusato, the jester; Philip IV and the queen, Mariana, and so on.[48] Foucault uncovers the meaning of *Las Meninas*, not by naming the figures, but by describing them as part of the syntax of the language of representation. For Foucault, the function of the painting, the demonstration of the paradoxes of representation, is more important than the apparent subject, the visit of the Infanta and her retinue to the apartment where Velázquez is painting a royal portrait. Velázquez captures the royal party as the king and queen enter, or so it is supposed from the position of the heads of the other figures.[49] He implies the royal presence before him as a sign of his ascendant social status, so that *Las Meninas* is actually the self-portrait of the painter. Decorum, however, forbids such a representation, obliging Velázquez to depict the reflection of the king and queen in the mirror.[50] Foucault, for his part, puts aside the interpretation of *Las Meninas* as Velázquez's self-portrait, for in the modern era subjectivity is denied.[51]

In his *Meninas* Picasso, too, plays with artistic identity. Having jokingly inflated the importance of Velázquez in the first painting of the series, he then all but eradicates him from the others. Picasso treats the elements of *Las Meninas*, including the figures, as part of the syntax of the whole, carrying out his spatial manipulations as a geometric exercise. On display are the tricks involved in the construction of painting and of representation. Picasso breaks the illusion of reality that Velázquez maintains. Instead of alluding to the space outside the painting, Picasso portrays space folding in on or replicating itself. Picasso makes obvious what is implicit in the ambiguities of *Las Meninas*: the structure of replication and the surface of the work as the only reality. Picasso's 'imitation' of *Las Meninas* provokes a number of questions. What exactly is imitated? What is the referent? And what of the temporal dimension of Picasso's act of painting the series?

When Picasso's *Meninas* series was first exhibited at the Louise Leiris Gallery in 1959, Michel Leiris recognised the modern concerns of the project.[52] On the issue of authenticity Leiris is certain that no one doubts the existence of the work or its importance, even if they only know of it from hearsay or from a reproduction. Leiris creates what might be called a *mise-en-abyme* of the image: the real or historical Velázquez and the people he painted; the artist's painting of himself and the figures in *Las Meninas*; the photographic reproduction of *Las Meninas*, by which such a famous work is known in the modern day; and *Las Meninas* by Picasso. The possibility of endless replication removes all reality from the work and the figures represented there. Following on from the quotation at the heading of this chapter, Leiris writes: "Effigies of phantoms or phantoms of phantoms, this is what *Las Meninas* became, after

first being mere effigies or phantoms."[53] According to the mirror logic Leiris describes, Picasso's *Meninas* series represents:

> *Meninas* as it were raised to the power of two, which are to the old masterpiece what the *Meninas* of the Prado in Madrid were to the maids of honour of the Spanish court and who are neither the *Meninas* by Velázquez, nor those by Picasso, but Las Meninas by Velázquez by Picasso, a work with a false base, which—when we examine it—leads us to discover that the object to which it applies also has a false base, so that these Meninas displaced by three centuries are revealed finally as an object with three bases, or even an indefinite number of bases.[54]

Leiris eradicates the 300 years between Picasso's *Meninas* and that of Velázquez, as the artists' names and their paintings of *Las Meninas* become interchangeable. "*Las Meninas* by Velázquez" becomes "Picasso's *Las Meninas by Velázquez*" becomes "*Picasso* by the Meninas of Velázquez" and its antithesis, "*Velázquez* by the Meninas of Picasso".[55] The two *Meninas* are two interchangeable 'self-portraits' that are constructed by *Las Meninas* as much as the two artists are constructors of the work. More important than the autobiographical dimension for Leiris, as for Foucault and for Picasso himself, is the 'pictorial advance' instigated by Velázquez, then challenged and taken forward by Picasso. The paradox of representation, however, the reciprocity of inside and outside, leaving open the possibility of endless replication, remains. Before returning to the structure of the phantom and of replication, which seems to haunt Picasso's *Meninas* and his other work of the 1950s and 60s, we return to the *Burial*, just as Picasso does, to complete our understanding of his painting projects.

"8.8.58"

In December 1957, with the *Meninas* series virtually complete, Picasso again takes up the *Burial*.[56] As he changes medium from the highly formalised paintings of the *Meninas* series to the dissociation of the *Burial*, we strain to find any sense of continuity. What remains at issue, however, both in the text and in his painting, is the altered relationship between representation and the world. The text, lacking a unified authorial voice, displays the failure of the descriptive function of language. A recurring motif in the *Burial* is the figure of the postman, whose presence highlights the lack of connection between the remote town and the outside world. The recurring image of the letter that has no content and no destination (the open envelope without a stamp) mocks expectations that the *Burial* leads to a rational conclusion—a humorous metaphor, then, for the problem of language and meaning. A case in point is "8.8.58", a multi-dimensional text which sustains a pseudo-narrative of outrageous carnivalesque behaviour, veering off into nonsense poetry and ending with a memory of St John's Eve:

"2.12.57", "16.1.58",

The Burial of the Count of Orgaz
(*El Entierro del Conde de Orgaz*),
2 December 1957, 16 January
1958, Musée Picasso, Paris

2.12.57.

Una a una y la otra sigue la
la riata el camino y el arrollo
labando y tendiendo y en el romero
sus recuerdos hay angelitos que lloran
y otros que ~~van~~ ~~por~~ el agua riendo
~~duerme~~ niño chiquito que viene
el coco y se lleva los niños que
duermen poco

16.1.58.

las chicas de abajo se metieron
en un sobre le pusieron un sello
y se lecharon al correo y ni
visto ni pisto. y allí se fueron
al paralelo a ver correr las
girls "las carcajadas" hacer
sus estripdips dormidas en
sus cunas al abrigo del sol y
de la luna tan contentas

but at this time the girls from downstairs and even Aunt Juana already all drunk and scratching their thing and naked as though for a joyous celebration they weren't doing anything except looking at the clock and fanning their pussies with the desire they all had to fornicate with the first postman to arrive at the town hall with his donkey on his back and his wife inside its belly to kick up a hell of a row with the boys from the port here there was no other way to make cold what is hot and hot what is cold and to light up the little lamps and Bengal flares and to fry *buñuelos* [doughnuts] and *churros* [pastries] in the frying pan of tears rolling their sugar cane through the wheat fields and there was quite a scuffle when Filomena got up on top of the table and began to piss herself and to tie knots in the *banderillas* [darts used to goad the bull in the bullfight] made into mourning with noodles the ugliest and the finest telling and retelling their suffering she was singing the *copla* [ancient song] with her fingers under the table with her cousin but that big idiot Uncle Gumersindo pretending he couldn't see went up to the mountain quickly running he put nets in the bushes and without a call or a goldfinch he set off the decoy and his mischief and then to cap it all without a shot or a sigh the girl wasn't made for dramas or comedies and the never-ending story was already dry and rancid and the froth that enamelled it smelled of jasmine and carnations and tuberose for the cold that shattered the naked body of the saint cracked and crushed the flesh of the bag full of water that went through the rear arch of the heap of broken tiles thrown on the seashore of rocks of blue charcoal of your very naughty gaze for that's how the priest likes his fried eggs and potatoes

first chapter raw owl's eye here the novel follows and links up this time not very clever or stupid and not very exemplary since the letter arrived and put the same day in the letter box without a stamp or a fanfare was like the olive branch and the dove like someone who swallows a bone and sucks the bottom of his foot like an idiot and what a shame that after so much shouting and rowing the young daughters of the priest could show off their charms and their skills in the camp bed of bedbugs when they wore a hole right in the middle not even the cleverest could have done better in spite of everything being turned upside down on top of everyone in the bed—poster announcing the bullfight at night-time the green wheat fields and the gilded blue frame make their intrigue behind the veil of the open shutter the closed door of your black eyes but very much earlier in the smoking light the velvet target that eats away the edge of the razor trembles and goes around the flame of the oil lamp on the half of the hand placed on its back on the bit of carpet of the silk of your arm stretched out all along the stream of the pen drawing with the colour of your memory your voice of rainbow and the perfume of fried suns and the odour of fish and watermelon and the Havana cigar-laden air and clams and basil later at two thirty or three in the morning beside the beach in Barcelona on the Barceloneta one St John's Eve wrapped up in pieces of tissue paper[57]

The text divides into two parts, intersected by a bogus reference to a literary work that never develops: "chapter one raw owl's eye here follows and links up the novel" ("capítulo primero ojo de búho crudo aquí sigue y enchufa la novela"). The random and trivial nature of the narrative is striking. The motiveless stories and empty characters appear to be pieces of a larger fiction that we can never grasp.[58] Written incongruously in a high-flown style, the texts of the *Burial* as a whole are pure literary creations which luxuriate in rich language that has no power to describe the world, while the visual dimension of language is utterly denied.

The first scenario of "8.8.58" describes an isolated town whose only link to the world is an antiquated postal system. A group of sexually voracious girls and a character called Aunt Juana wait at the town hall to fornicate with the postman, who is about to arrive in this upside-down world "with his donkey on his back" (the subject of a Goya etching). Communication between the village and the outside world appears primitive and erratic. The narrative is obviously a spoof: "the never-ending story" ("el cuento de nunca acabar") of Uncle Gumersindo and his bird-catching activities, one of several such accounts, has no point. Typical of carnivalesque satire are inversions of all kinds and the ridicule of authority: girls flaunt their "pussies" and someone called Filomena pisses in public without shame, while the priest's daughters are prostitutes, and active ones at that. Passages of pure poetry complete the text: "green wheat fields and the gilded blue frame make their intrigue behind the veil of the open shutter". The desire of a scene of nature to create a boundary around itself with a gilt frame is the origin of a work of art. The drawing of the model's body remains an erotic mental image: "your arm stretched out all along the stream of the pen drawing with the colour of your memory". The phrase describes the confluence between the artist's watery mental world, the image and the work of art that never materialises. Where is the site of the work: the mind or the world? The reference to the tastes and scents of "St John's Eve wrapped up in tissue paper" appears in the closing lines of "8.8.58". The memory of the famous festival, particularly associated with the north of Spain, has the sound of authenticity, as Barcelona was Picasso's second home.

A year later Picasso, in the same carnival spirit writes the final part of the *Burial*, "20.8.59", "Third Piece", and the tedium of the jumble of characters and hyperbolic language finally takes hold. In the finale he creates a pseudo-genealogy of a renowned family of brothers and sisters: "the youngest got married at eighty something and gave birth at the end of a month to a donkey the other married a lame *espartero* [shoes made of esparto grass] maker and gave her husband ten blind rabbits and a partridge." After listing many crazy exploits of these people we learn:

This family is an example and even today many things are told about them whether true or false you have to take into account in order to make a description of the revelry of that primitive postcard humanity.[59]

We realise that we have been duped by the invented description of stereotypical characters on a postcard, not forgetting that Picasso had preserved the photographs he took of the people he met on his Pyrenean visits.

In the final words of the last text, "20.9.59", Picasso sums up his literary work in the most elegant language: "an onion unfolds its chords within the sugary awakening of the moon—the silvered lace that the doves raise up they coo their suffering" ("una cebolla desarrolla sus cuerdas dentro del acaramelado despertar de la luna—el encaje plateado que levantan las palomas ríen sus penas"). As the *Burial* unfolds, driven by the series of empty envelopes and letters, the levels of signification are peeled away like the layers of an onion to reveal an absence of meaning.[60] In August 1959, at the Château de Vauvenargues, situated at the foot of Cézanne's Mont Saint-Victoire, Picasso completes the *Burial* and starts his new project of deconstructing *Le Déjeuner sur l'herbe, after Manet*.[61]

Picasso: Technology and the Image

In the 1950s and 60s Picasso relates, not to the modernity of art, but to the modernity of the image. While Velázquez employs the techniques of the seventeenth century to achieve the illusionist duplication of reality, Picasso reproduces reality in a modern way, simulating the technology of image making. Picasso perceives discretely: he breaks down the invisible planes of *Las Meninas*, cropping the image or treating it in sections, as though he were altering a photograph.[62] This type of seeing as a "montage of discrete elements" is referred to in this section as 'discretisation', or the decomposition of the image—which, although relevant to digital technology, can be seen to derive from the technique of alphabetic writing.[63] Picasso's experience of seeing is itself technological, as though his vision was enhanced by a camera.[64] This technological vision recalls Picasso's cubist techniques of facetting, the grid and *papiers collés*, which he devised, as was learned after the artist's death, with the aid of a camera.[65] Thus, he must have developed his sophisticated way of understanding how the visual operates from his early use of the camera as part of his art practice. He applies these anti-illusionist techniques to *Las Meninas*, the manual of illusionism. Each of the individual works of the *Meninas* series forms a discrete part of the whole, while a single painting, for example, *Las Meninas, 18 September 1957* becomes a surface of segments. In the interest of a more complete expression of reality, Picasso takes *Las Meninas* apart to examine how it functions. This treatment requires the viewer to create a synthesis of Picasso's analysis of Velázquez's painting (the series is installed as a unit in the Picasso Museum in Barcelona).

Picasso—a "living camera", as Man Ray called him—records the effect of technology on painting itself, as painting, in the end, is what appears to matter the most to him.[66] Picasso's 'discrete' way of seeing is evident in Henri Clouzot's film, *Le Mystère Picasso*, 1955, in which the camera films the evolution of a Picasso work (*The Beach of La Garoupe*). The image forms in ink on transparent paper, seemingly without the artist's mediation—Picasso is intentionally obscured by the easel—to create a work of cinema-painting using "time, the infinitely decomposed movement of images and sound".[67]

The technique of discretisation is relevant to Picasso's studies for his series based on Manet's *Dejeuner sur l'herbe*. In a development from the *Meninas* series Picasso elaborates the idea of movement, especially of an erotic nature, in his painting, inspired, according to Rosalind Krauss, by the television screen.[68] Remaining in thrall to the electronic pulse of the television, like the subliminal pulse of the "optical unconscious", he fills sketchbooks with

variations on Manet's *Dejeuner*, the successive images giving the impression of a form of mechanical reproduction like an animation film or a flipbook.[69]

In the winter of 1962-1963 at Mougins, Picasso becomes obsessed with Poussin's *Massacre of the Innocents* and its grand theme, which provides the inspiration for a series of paintings, also based on David, entitled *The Rape of the Sabines*, 24 October 1962-7 February 1963.[70] Hélène Parmelin writes that "Picasso once again is seen to be the prey of an *idée fixe*, a haunting, a theme eclipsing everything."[71] At night his vast studio at the Château de Vauvenargues becomes a theatre in which he projects slides of paintings by Poussin, as well as other artists, ten times life-size, onto the wall and large windows.[72] Projecting the slides on an enormous scale, he studies the works in detail, "as though under a microscope", Parmelin observes.[73]

The technology of the image summons phantoms: as soon as there is representation—whether in a painting, photograph or film—death and the phantom come into play.[74] Writing on Picasso and *Las Meninas*, Leiris is aware of the effect of the phantom, the perpetuation of existence after death through the image, and its implications for Picasso's *Meninas* project. It is worth recalling Leiris's order of representation based on Velázquez's *Las Meninas*, from reality to irreality. First, there is Velázquez himself and the *meninas*; second, the image he painted of himself and the *meninas*; third, the reproduction, the means by which most people know the painting; and finally Picasso's *Las Meninas by Velázquez*, "*The Meninas* to the power of two". In addition to the exponential replication of *Las Meninas*, there is also the reciprocal structure of the painting: the multiple gazes, the mirror, the doorway, the windows and the paintings hanging on the wall. Then there is the interchangeability of the artists, 'Velázquez' and 'Picasso'. As a consequence of the reversals, returns and reiterations, it becomes questionable which comes first: Picasso creates Velázquez just as Velázquez forms Picasso. Picasso does not simply take what he inherits from Velázquez, his system of representation, and repeat it: he varies, he radically alters *Las Meninas* to give a completely different, twentieth century work.[75] And for this he needs to think technologically and to remain open to the future. Space, time, the referent and the artist: every aspect of representation is beset by instability. Yet Picasso thrives on that instability, as he has shown in his *Meninas*: he demonstrates that space is non-space; that time is a-temporal and that the artist oscillates between existence and non-existence. Painting, still, can be the conduit for modern ideas. Picasso's *The Burial of the Count of Orgaz* and *Meninas* series, which takes shape within *The Burial*, deal with a series of paradoxes that haunted Picasso and that continue to haunt us wherever representation and the image are found.

Picasso rewrites Picasso: he begins with the "rotten sun"—the interiorising of the visual—and brings his writing to a conclusion with a burial. After 20 August 1959 not another word was produced by Picasso. *The Burial of the Count of Orgaz*, however, is not about finality, but about return and remembrance. After his repudiation of conventional image-making at the beginning of writing, his 'aesthetic breakdown', Picasso arrives at a new understanding of the visual in the 1950s and 60s, after the trauma of war and its aftermath. This trajectory of the image is seen in terms of the artist's own life, in which artistic inquiry is combined with autobiographical reflection. At every stage of this linear trajectory, Picasso involves himself in a series of paradoxes—elevation and fall, desire and lack, space and time, presence and absence—in which it is easy to become entrapped. As Picasso negotiates the impediment to representation that these paradoxes present, he applies his creative power to language, inventing imagery so rich and provocative that it can be said that he is as great a writer as he is an artist.

From the first text, *Boisgeloup 18 avril XXXV*, language is associated with eroticised trauma in an act of rending which opens the space of writing. Language is also associated with madness: Picasso's writing is a random torrent of words that is redundant to meaning. Humour is very important in Picasso's writing, as he mocks the abject and thereby mitigates the terror the abject induces. *Guernica*, one of the most important twentieth century paintings, irrupts from his writing, as a reminder of the power and reach of the visual. Writing, however, does not oppose the visual: language and images are involved in a complex interplay that uncouples them from their usual binary dependency.

Picasso Rewriting Picasso, then, condenses the meaning of Picasso's art, for which modernism does not provide a reference point. Speaking against the notion of progress in art, Picasso describes the image of the artist:

When I hear people speak of the evolution of an artist, it seems to me that they are considering him standing between two mirrors that face each other and reproduce his image an infinite number of times, and that they contemplate the successive images of one mirror as his past, and the images of the other mirror as his future, while his real image is his present. They do not consider that they are all the same images in different planes.[76]

Unpredictably Picasso finds the future in the past, while living in an eternal present of continual variation, allied to technology as a projection of the human. Picasso's writing, like his art, is subject to variation; for 25 years writing was Picasso's medium of the heterogeneous, which suppresses the image as something seen. Writing is the medium in which Picasso explores the image in its inchoate, nascent state. Writing also enabled him to retrieve structure and form. Throughout his period of writing Picasso falls in and out of the image, as he responds to the changing views of reality in contemporary culture. When he stops writing, Picasso finds a new role for the image. In the final phase of his career, at a time when painting ceases to have any validity as a medium, as Picasso laments, he assumes the mantle of the Old Masters. Picasso's works based on these artists are, nevertheless, conceived by means of a new structure of the visual based on technology that perpetuates the image. Representation and repetition join forces through technology, the hope and possibility of the image.

Self-portrait in the studio of the villa Les Voiliers

(*Auto portrait dans l'atelier de la villa "Les Voiliers"*), c1939-1940, Musée Picasso, Paris

Christina García Rodero,
Saint John's Day: Bonfires,
Alicante, 23 June 1989

Picasso's *Desire Caught by the Tail*, a work of automatic poetry and humorous erotic content, exists primarily on a mental level. The artist himself premièred the play as a reading. Picasso only ever granted the rights to produce *Desire* to Jean-Jacques Lebel, the artistic and political provocateur who introduced the 'Happening' to France. He had early links to André Breton and the surrealists and to such figures as the Situationist Guy Debord, the philosopher Gilles Deleuze and the psychoanalyst Félix Guattari. Lebel's multiple roles as poet, artist, performer and activist, place him within the same tradition as the Picasso of *Desire Caught by the Tail* and his Dadaist antecedents.

Lebel's *Desire* was performed within the context of the IVth Festival of Free Expression (Festival de la Libre Expression) at Saint Tropez in July 1967. Lebel's is the only production that carried out all of the stage directions, thus fulfilling Picasso's intentions. In Lebel's version, The Tart performed her urination and farting scene naked, to the accompaniment of an appropriate sound track. In fact, Lebel and his troupe were banned by the mayor of Saint Tropez and the production was forced to move to nearby Grissin. The performances of Lebel's *Desire* took place in the spirit of the Happening, to the accompaniment of music performed by the British avant-garde rock group, Soft Machine.

The props were conceived by Lebel and produced by MacDonald Prain, including a giant white resin bath large enough to accommodate eight, for the communal bath scene at Sordid's Hotel, and a rubber bed for ten couples, for the *Déjeuner sur l'herbe* scene. The face of Dora Maar in styrofoam, modelled on a Picasso portrait, served as a screen onto which was projected a video film of Lebel's lips speaking the lines, in the first use of that medium on stage. Ultra Violet, an actress from Andy Warhol's The Factory, played The Curtains, while holding up a shower rod with a clear plastic curtain. The cast was directed by Lebel himself.

I thank Jean-Jacques Lebel for the permission to cite his documentary material from the Lebel Archives and for his personal accounts of the event.

Desire Caught by the Tail
Chapiteau du Papagayo
IVth Festival of Free Expression
Saint Tropez
July 1967

Production: Victor Herbert
Direction: Jean-Jacques Lebel and Allan Zion
Sets: Roger Tallon, MacDonald Prain and René Richetin
Costumes: Emmanuelle Khan
Music: Soft Machine
Cast: Jacques Blot, Marnie Cabanetos, Bernadette Lafont, Michèle Lemonnier, Taylor Mead, Katherine Moreau, Dorte Oloé, Rita Renoir, Jacques Seiler, László Szábo, Ultra Violet

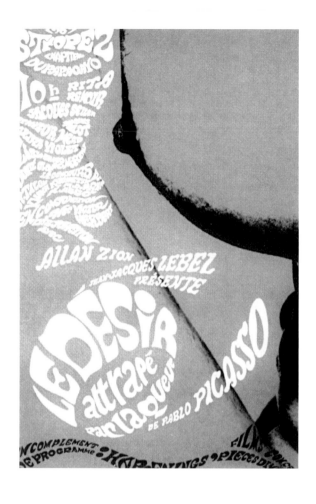

Clockwise from top left: Poster for
Jean-Jacques Lebel's 1967
production of **Desire Caught by
the Tail**

Members of the cast: Marnie
Cabaneto, The Tart, Jean-Jacques
Lebel, Director, and Victor Herbert,
Producer

Marnie Cabaneto, The Tart and
Jean-Jacques Lebel, Director

The stage set displaying one of
the props commissioned by Jean-
Jacques Lebel: the round red and
black disk is inspired by one of
Marcel Duchamp's roto-reliefs

Rita Renoir, Thin Anxiety and Taylor
Mead, the Two Toutous

Notes

Introduction

1 Picasso, Pablo, *Picasso: écrits*, Paris: Réunion des musées nationaux and Éditions Gallimard, 1989. Texts established, presented and annotated by Marie-Laure Bernadac, former curator at the Musée Picasso, Paris and Christine Piot. French translations of Spanish texts by Albert Bensoussan. Full documentation of texts in "Avertissement" and "Notices". Also included in the volume is a preface by Michel Leiris, the ethnographer and writer, entitled "Picasso écrivain ou la poésie hors de ses gonds". A dictionary of Picasso's poetic phrases, "La poésie de Picasso, Dictionnaire abrégé…", is compiled and introduced by Marie-Laure Bernadac. Christine Piot contributes a further essay on the poetry, "Picasso et la pratique de l'écriture". Most of the manuscripts are to be found in the collections of the Musée Picasso, Paris, under the number MP3663 or in private collections. There is an English version in the identical format to *Picasso: écrits*, with translations of the preliminary essays only. *Picasso: Collected Writings*, Carol Volk trans., New York: Abbeville Press, 1989.

2 For a discussion of the theme "soleil pourri" in Picasso's painting, see Ruth Kaufmann, "Picasso's *Crucifixion* of 1930", *The Burlington Magazine*, 111, 1969, pp. 553-561.

3 See Anne Baldassari, *Picasso and Photography: The Dark Mirror*, Deke Dusinberre trans., Paris: Flammarion, 1997.

Melancholia, Metaphysics, Measurement
Minotauromachia, 1935

1 See *Picasso Intime*, exh. cat., Geneva: Musée de l'Athénée and Sheibu Museum of Art (expanded version), 1981. See also Pierre Daix, *Picasso: Life and Art*, Olivia Emmet trans., London: Thames and Hudson, 1993, p. 234.

2 *Cahiers d'art*, vol. x, nos 7-10, Paris, 1936. The *Minotauromachia*, under the title "Gravure" or "L'Ile du Minotaure", appears as an example of Picasso's latest work, including his 1935 poetic texts, in this special Picasso issue of the review.

3 For the reference to Dürer in the *Minotauromachia*, see Sebastian Goeppert and Herma C Goeppert-Frank, *La Minotauromachie de Pablo Picasso*, Patrick Cramer ed., Geneva, 1987, pp. 36-37. See also Erwin Panofsky, *The Life and Art of Albrecht Dürer*, Princeton: Princeton University Press, 1955, pp. 130-138, 165, 168. For a discussion of the theme of melancholia in Italian and German painting between the two wars, see Jean Clair, "Sous le signe de Saturne", *Cahiers du Musée National d'Art Moderne*, 7/8, Paris: Centre Georges Pompidou, pp. 177-207.

4 Goeppert, *La Minotauromachie de Pablo Picasso*, pp. 94-100.

5 Picasso's statements of 1935 on art and the art world are recorded in an interview with Christian Zervos, "Conversation avec Picasso", *Cahiers d'art*, vol. x, nos 7-10, Paris, 1936, pp. 173-178.

6 The original manuscript of *Boisgeloup 18 avril XXXV* is kept in the archives of the Musée Picasso, Paris. Also reproduced in *Picasso: écrits*, Marie-Laure Bernadac and Christine Piot eds, Paris: Réunion des musées nationaux and Éditions Gallimard, 1989, pp. 1-13. Boisgeloup, Picasso's Norman château near Gisors (purchased 1930), housed his etching and sculpture studio.

7 See Rüdiger Safranski, *Martin Heidegger: Between Good and Evil*, Ewald Osers trans., Cambridge: Harvard University Press, 1998, pp. 177-178, 185. For an introduction to the French translation of "What Is Metaphysics?", see Alexandre Koyré, "Introduction", "Qu'est-ce que la métaphysique?", *Bifur*, 8, Paris, 1931, pp. 5-8. He speaks of Heidegger's work of "demolition", his "freeing and destructive catharsis", the end of all "false values, all conventions, all lies".

8 Heidegger, Martin, "What Is Metaphysics?", *Basic Writings*, David Farrell Krell ed., London: Routledge, 1993, p. 99. Heidegger writes: "Profound boredom, drifting here and there in the abysses of our existence like a muffling fog, removes all things and human beings and oneself along with them into a remarkable indifference".

9 Artaud, Antonin, "Production and Metaphysics" ("Mise en scène et la metaphysique", 1931), *The Theatre and Its Double*, Victor Corti trans., London: Calder Publications, 2001, pp. 23-26. Artaud takes a 'metaphysical' painting, *The Daughters of Lot*, 1609, by a little known seventeenth century primitive, Lucas van Leyden, for inspiration. The painting's spectacle of apocalypse (a black, laden sky with rockets and flares), fatality (a shipwreck), and sexual perversion (Lot's incestuous desire for his daughters parading before him) draws on a kind of 'metaphysical' imagery that had a profound effect on all the senses. In fact, Artaud originally thought to name his theatre, "The Metaphysical Theatre", before deciding on the word "cruelty".

The Rotten Sun
From *Boisgeloup* to the Civil War texts, 1935-1937

1 Kristeva, Julia, *Black Sun: Depression and Melancholia*, Leon S Roudiez trans., New York: Columbia University Press, 1989, pp. 6-9.

2 Picasso began to date all his work in 1928. See Brassaï, *Conversations avec Picasso*, Paris: Editions Gallimard, 1964, p. 123. Picasso explained to Brassaï that he dated his work in order to leave documentation for a future "science of man".

3 Bataille, Georges, "Rotten Sun" ("Soleil pourri"), *Documents*, "Hommage à Picasso", second year, 3, 1930, pp. 173-174. ("Rotten Sun", *Visions of Excess: Selected Writings, 1927-39*, introduction by Allan Stoekl ed., trans., Minneapolis: University of Minnesota Press, 1985, pp. 57-58.)

4 Bataille, "Rotten Sun", p. 57.

5 Bataille, "Rotten Sun", p. 58.

6 The two were acquainted at the time and Picasso knew Bataille's *Documents* collaborators, the poet Michel Leiris and the surrealist artist André Masson, through their close association with Picasso's dealer Daniel-Henry Kahnweiler. In any case, Bataille used Picasso, and not for the first time in *Documents*, as an inadvertent interpreter of his radical views. For the earlier reference to Picasso, see Bataille's essay on Dalí, "The Lugubrious Game" ("Le jeu lugubre"), *Documents*, 7, December 1929, pp. 297-302. (English trans. *Visions of Excess*, pp. 24-30.)

7 *Papier d'Arches* is a heavy type of artist's paper measuring 25.5 x 35 cm, which Picasso cut or folded to 17.5 cm.

8 See the description of the notebooks in *Picasso: écrits*, Marie-Laure Bernadac and Christine Piot, eds, Paris: Réunion des musées nationaux and Editions Gallimard, 1989, p. xxxviii.

9 Penrose, Roland, *Picasso: His Life and Work*, Gollancz: London, 1958, p. 366.

10 The study sheet relates to two female portraits (*Sleeping Woman with Shutters*, 25 avril XXXVI, and *Woman with a Watch*, 30 avril XXXVI) painted during Picasso's stay with Marie-Thérèse and Maya in Juan-les-Pins in April 1936.

11 *Picasso: écrits*, pp. 144, 147:
"I: portant noué à son cou en echarpe une baignoire remplie d'eau bouillante portant noué à son cou en echarpe une armoire à glace remplie de linge sale portant noué à son cou en echarpe la table de salle à manger servie pour le dejeuner la nappe en flames. II: dame de chevet colombe remplie d'eau claire au plumage liquide eclairée par une lampe de l'huile des ruches."

12 See Sigmund Freud, "Mourning and Melancholia", *On Metapsychology: The Theory of Psychoanalysis*, The Pelican Freud Library, 11, Harmondsworth: Penguin Books, 1984, pp. 262-268. The libidinal energy, or cathexes, drawn into the open wound of melancholia, as Freud describes it, is discharged and released for other purposes.

13 Picasso's construction of the subject—using the diary format and the first person 'authorial' voice—his patchwork of literary references and popular sayings and his parodic tone derive from the picaresque novel, an important Spanish literary genre which deals with the construction of fiction. One of the most famous picaresque novels, Francisco Quevedo's *El Buscón*, c1603-1604, published 1626, edition Lyon, 1662, as well as editions of Cervantes's *Don Quijote*, dated 1736, 1780, 1798, 1840, and *Novelas ejemplares*, 1613, edition dated 1739, appear on the inventory of Picasso's books kept in the library store of the Musée Picasso, Paris.

14 The phrase "hors de ses gonds" forms part of the title of Michel Leiris's essay on Picasso's writings. See "Picasso écrivain ou la poésie hors de ses gonds" ("Picasso the Writer or Poetry Unhinged"), *Picasso: écrits*, pp. vii-xi.

15 See Georges Bataille, "Sacrificial Mutilation and the Severed Ear of Vincent Van Gogh", 1930, *Visions of Excess*, pp. 61-71. In the essay Bataille wrote about the act of auto-mutilation, dictated by the sun and Van Gogh's madness and art. Picasso's 1901 self-portrait in the guise of the ear-less Van Gogh must also be significant.

16 *Boisgeloup 18 avril XXXV*, manuscript page I and *Picasso: écrits*, p. 1: "si yo fuera afuera las fieras vendrían a comer en mis manos y mi cuarto aparecería sino fuera de mí otros sueldos irían alrededor del mundo hecho trizas pero qué se ha de hacer hoy es jueves y todo está cerrado hace frío y el sol azota al que yo pude ser y no hay remedio tantas cosas han pasado hacer que al redondel tiren por los cabellos las raíces que los retratos marcan y no haciendo caso de los presentes del día hoy ha sido lo bueno y el cazador vuelve con las cuentas a pique que bueno está el año para adobos así y siempre están las cosas que dejando unas las lágrimas están que ríen sin hacer cuentos otra vez sino que alrededor del marco que han llegado noticias que esta vez la primavera no la veremos más que de noche y una araña pasa sobre el papel donde escribo que aquí está el regalo que otros se ponen de corbata el.día de fiesta y ya tenemos para tiempo...".

17 See Jacques Derrida, "White Mythology: Metaphor in the Text of Philosophy", *Margins of Philosophy*, Alan Bass trans., New York: Harvester Wheatsheaf, 1982, pp. 242-243. Derrida paraphrases from *The Republic* (VI-VII): "One looks at it directly on pain of blindness and death. Keeping itself beyond all that which is, it figures the Good of which the sensory sun is the son: the source of life and visibility, of seed and light." Aristotle compared the sun radiating flames to the sowing of seeds (*Poetics*, 1457b25-30); "sowing around a god-created flame".

18 Derrida, "White Mythology: Metaphor in the Text of Philosophy", pp. 242-244. Aristotle, who defined and categorised metaphor, giving it its proper place in the philosophical system, failed to analyse the flaw in the structure of metaphor, that is, the binary relationship between literal and allusive meanings. Derrida's strategy is to expose the flaw in the structure of metaphor, its "bottomless overdeterminability", the possibility that analogy, or the substitution of words, can be unending, creating an instability of meaning with serious implications for logic and truth.

19 For a similar series of metaphors of germs, seeds and semen, see Jacques Derrida, "Dissemination", (the final essay gives the title to the book) *Dissemination*, Barbara Johnson trans., Chicago: University of Chicago Press, 1981, p. 304. Dissemination, for Derrida, is a model of writing that breaks down the "mythical unity" of the text and allows for an infinite recombination of words, opening it up to a multiplicity of meanings and risking a breakdown of meaning. Derrida writes: "the shot/throw/blow [*le coup*] parts the seed as it projects it". A few lines below he adds, working, as he claims, on the false etymology of *seme* and *semen*: "Germination, dissemination. There is no first insemination. The semen is already swarming. The 'primal' insemination is dissemination."

20 See Pierre Cabanne, *Picasso: His Life and Times*, Harold J. Salemson trans., New York: William Morrow and Company Inc., 1977, p. 264.

21 *Boisgeloup 18 avril XXXV*, manuscript p. XIX and *Picasso: écrits*, pp. 6-7: "más de cien años que otra vez fueron haciendo blanco la espina que se ofrece al odio retorcido alrededor del hilo de la araña enternece tu voz recoge la sonrisa que te trajo el cartero y nace la portera bandera recogida y granada estallando en sus manos cien dedos que rebajan los años que recogen la voz guante que si seis diez y catorce hacen dos y medio al menos si me dicen que esto está listo y no hay más que hacer lo que ya he escrito pues no hay manera de salirse de aquí de otra manera con más garbo ole ole ole dale dale dale bueno anda anda anda ole ole y qué alegría que esto es lo bueno que de prisa se llega ole ole con castañuelas ole y un sol que parte estallando semillas y repicando a picotazos los besos y que ole y que ole que ahora está bien...".

22 *Boisgeloup 18 avril XXXV*, manuscript p. XXXIV and *Picasso: écrits*, p. 13: "el clarín se retuerce vestido de torero melancólico sol que escupe el agujero su vereda navaja de Albacete gusto de azúcar en la boca del jarro que queda detenida en el caño que se acuerda del oro que surce el codo de hilo de cáñamo y pisotea el color de su pelo capitán de cuadrilla de bandoleros silencio silencio silencio que nadie le mueva que nadie salga mira mira más lejos detrás de la hoja tira retira el bulto que no te vean corre sálvate que aún no es tarde que aún puedes recortar tu sombra canta a-a-a-a-a-a-a-a-a-i-a-i-a-i-a-i-a-a-a-a-a-a-a-a-a-a-a-a-a- en el verde oscuro hay otro verde más claro y otro más oscuro azulado otro más negro y uno más verde aún que el verde oscuro más tostado y otro más claro que el verde negro oscuro y otro más verde aún que el verde oscuro y otro más verde aún que todos peleándose verde verde que tocan las campanas a verde y aplaude tapa y pisotea la lista a-a-a-a-a-a-a-i-a-a-i-i-a-i-a-a-a-a-a-a-a-a-a-a-i-a-i-i-i-i-a-i que tapa y destapa el jarro pájaro que atraviesa de lado las manos acariciando su vuelo de dicha que deja caer un olor de violeta de la copa en la boca del árbol que recibe el presente muy reconocido a tantas amabilidades y esperando poder devolvérselas de la misma manera y dándole un millón de gracias se despide de usted afectísimo seguro servidor que sus pies besa y chafa en su mano el chinche más gorda y olorosa entre todas...".

23 Bataille's conflation of the anal and the excremental with the sun appears in a number of his 1920s and 30s writings, for example, "The Jesuve", 1927, "The Pineal Eye", c1927, "The Language of Flowers", "Rotten Sun", and *The Solar Anus*, 1931. For the English translation of these essays, see Bataille, *Visions of Excess*.

24 See Federico García Lorca, "Teoría y Juego del Duende" ("Theory and Structure of the Duende", 1931), *Obras Completas*, Madrid: Aguilar, S A, 1954, pp. 36-48. The word 'duende' gives its name to an aesthetic which, as García Lorca describes it, rejects structure and form.

25 *Lorca*, J L Gili, ed., Harmondsworth: Penguin Books, 1971, p. 36.

26 See the special Picasso issue of *Cahiers d'art*, vol. x, nos 7-10, Paris, 1936.

27 The texts were typed by Jaime Sabartés, Picasso's old friend from Barcelona days, whom he invited to manage his affairs in November 1935. Most of Picasso's writings were typed from his arrival until 1940.

28 See André Breton, "Picasso poète", *Cahiers d'art*, vol. x, nos 7-10, p. 188. Breton describes the work of translation and comments on the bilingual Picasso.

29 "24-28 noviembre XXXV", seventh state, *Picasso: écrits*, p. 46: "lengua de fuego abanica su cara en la flauta la copa que cantándole roe la puñalada del azul tan gracioso que sentado en el ojo del toro inscrito en su cabeza adornada con jazmines espera que hinche la vela el trozo de cristal que el viento envuelto en el embozo del mandoble chorreando caricias reparte el pan al ciego y a la paloma color de lilas y aprieta de toda su maldad contra los labios del limón ardiendo el cuerno retorcido que espanta con sus gestos de adiós la catedral que se desmaya en sus brazos sin un olé estallando en su mirada la radio amanecida que fotografiando en el beso una chinche de sol se come el aroma de la hora que cae y atraviesa la página que vuela deshace el ramillete que se lleva metido entre el ala que suspira y el miedo que sonríe el cuchillo que salta de contento dejándole aún hoy flotando como quiere y de cualquier manera al momento preciso y necesario en lo alto del pozo el grito del rosa que la mano le tira como una limosnita...". For an analysis of the Surrealist images in Picasso's poetry, including references to this suite, see Lydia Gasman, *Mystery, Magic and Love in Picasso, 1925-1938: Picasso and the Surrealist Poets*, PhD thesis, New York: Columbia University, 1981, pp. 50-100.

30 Breton, "Picasso poète", p. 188, endnote. "la voile tour à tour gonflée de sens comme d'intentions au delà du sens et vue en pleine fonte de profil, mais cette voile alors ne sera plus la voile blanche, ce sera vraiment celle du bateau-pirate—pour compléter l'illusion il bat ici, indifférement, pavillon français et espagnol—ce ne sera plus celle qui se prend pour une fin, qui s'éprend de son propre reflet, mais celle qui se rit de la tornade et se porte, dans la nuit profonde et magnifique de notre âge, au-devant de tout ce qui reste à conquérir".

31 Góngora's artificial, convoluted style, termed "culturanismo" (the style of the cultured) revolutionised poetic language in Golden Age Spain, c1550-1650. Unappreciated for 300 years, Góngora became a symbol of artistic and political freedom for the poets of the generation of 1927, led by Federico García Lorca. Picasso declared his affinity with Góngora in *Vingt poèmes de Góngora* (Paris: Les Grands Peintres Modernes et le Livre, 1948), a magnificent *livre d'artiste*, for which Picasso copied 20 of Góngora's poems in his own hand and provided 41 original drawings. In the 1890s, Mallarmé's poetry was compared to Góngora's.

32 Derrida, Jacques, "Mallarmé", *Acts of Literature*, Derek Attridge ed., London: Routledge, 1992, pp. 115-116.

33 *Picasso: écrits*, pp. 76-79: "nunca se ha visto lengua más mala que si el amigo cariñoso lame a la perrita de lanas [*perra de lanas* is a poodle; 'perrita' is a colloquial expression for 'lousy' or 'wretched', while 'perra' means 'bitch'] retorcidas por la paleta del pintor ceniciento vestido de color de huevo duro y armado de la espuma que le hace en su cama mil monerías cuando el tomate ya no se le calienta ni le importa un pito que el rocío que no sabe ni el número primero de la rifa que le pega el clavel a la jaca haciendo que su arroz con pollo en la sartén le diga la verdad y el saque de apuros le canta la zambomba y organiza en el amor carnal la noche con sus guantes de risas pero si alrededor del cuadro medio hecho de la línea sin vergüenza hija de puta insaciable nunca harta de lamer y comer cojones del interfecto...".

34 The *Roman de la Rose*, 1526, a bawdy fourteenth century tale about the absurdity of consummating love, appears on the inventory of Picasso's library, kept in the library store of the Musée Picasso, Paris.

35 Freud, Sigmund, "Three Essays on the Theory of Sexuality", 1905, *On Sexuality,* The Penguin Freud Library, vol. 7, James Strachey trans., Angela Richards ed., Harmondsworth: Penguin Books, 1991, pp. 61-76.

36 Picasso's daughter Maya was born to Marie-Thérèse Walter in Paris on 5 October 1935.

37 Picasso continues to abstain from painting at the beginning of 1936, while his art is being lauded, and that in a Republican context (under the auspices of Catalan modernist architect José-Luís Sert's ADLAN [Amigos de las Artes Nuevas, Friends of New Art]), in a touring retrospective in Spain (January to March 1936). Paul Eluard, the French surrealist poet, delivered a speech on Picasso ("Je parle de ce qui est bien" ["I speak of that which is good"]) and Jaime Sabartés gave a broadcast on Picasso's poetry on Barcelona radio for the ADLAN opening. Eluard's and Sabartés's speeches are published in the special Picasso issue of *Cahiers d'art*, 1936. The exhibition opened on 18 February 1936, a euphoric and politically volatile moment, as the Republicans made great gains in the general elections, though with serious consequences that led to civil war in July that same year.

38 For a description of baroque Spanish staging see N D Shergold, "The Court Theatre of Philip IV, 1622-40", *A History of the Spanish Stage, From Medieval Times Until the End of the Seventeenth Century*, Oxford: Clarendon Press, 1967, pp. 264-297. A sketch by Picasso at age 13 of the famous Andalusian actor Antonio Vico playing in Calderón's *The Mayor of Zalamea* at the Teatro Principal in La Coruña reveals that he was very much in thrall to Spanish Golden Age theatre even as a boy. See John Richardson, *A Life of Picasso*, vol. I, New York: Random House, 1991, p. 41.

39 Artaud, Antonin, "Production and Metaphysics'" ("Mise en scène et la metaphysique"), *The Theatre and Its Double*, Victor Corti trans., London: Calder Publications, 2001, pp. 23-26. Artaud records his experience of physical shattering, both aural and visual, while viewing *Lot and His Daughters*, and goes on to recreate the apocalyptic drama of the painting.

40 Artaud, Antonin, "The Theatre of Cruelty (First Manifesto)", *The Theatre and Its Double*, pp. 70-71.

41 "20 janvier XXXVI", *Picasso: écrits*, p. 97: "y al primer rempujón que le da el toro al caballo levanta el telón y se encienden todas las barcas llenas de candilejas al fuego artificial de las gavillas de cohetes que hacen su cosecha de luces espatarradas entre las sábanas de los colores que le hacen la cama y de los ramos de flores de la copa del vidrio banderillero [man who throws the banderillas, or barbed darts at the bull's neck] que clava su abanico que se enreda en la madeja deshecha del dibujo de las barcas y el toro con su llave busca el ojo de águila del pandero que resuena al golpe dado por el cuerno en el jolgorio de su vientre como el intencionado repique de la juerga...".

42 "20 janvier XXXVI", *Picasso: écrits*, p. 97: "convite fino y delicado de la muerte y abre de par en par la puerta de la baraja de la barriga a la yegua levanta las cortinas y descubre el festín y arregla la mesa y las sillas y recoge los trapos olvidados y limpia con su hocico las manteles manchados de la sangre recogida brota en las copas por los caminos y veredas de las tripas trenzándolas tan cuidadosamente y arreglándolas y atándolas a las costillas colgándoles farolitos y banderas su ojo rebañando el interior de los detalles descubre el fondo de la cueva en el hondo más profundo interior pegado al techo retorcido del árbol seco y esponja ahogándose de sangre el huevo duro del caballito blanco y azul...".

43 "20 janvier XXXVI", *Picasso: écrits*, p. 98: "la barca rota meneando sus patas y deshaciendo el lío de las cruentas intestinas bellezas que se enredan cada vez más al laberinto del palo mayor del dolor prisionero del juego de ajedrez que nada campeón entre las olas de oles...".

44 The drawing forms the basis for Picasso's drop-curtain (*The Remains of the Minotaur Dressed as Harlequin*, 28 May 1936) for Romain Rolland's *Quatorze Juillet*, performed during the Popular Front demonstrations in Paris. The arena, where a horse and nude female rider holding a javelin appear, looks like the Colosseum of Rome. By May 1936 Picasso has returned to his usual art practices and has become more overtly political. Sidra Stich discusses the historical context of this work and Picasso's participation in the Popular Front against fascism. See Sidra Stich, "Picasso's Art and Politics in 1936", *Arts*, October 1983, New York, pp. 113-118.

45 Freud, Sigmund, *The Interpretation of Dreams,* Penguin Freud Library, vol. 4, James Strachey, ed., trans., Harmondsworth: Penguin Books, 1991, pp. 381-382.

46 For an analysis of the hieroglyph, Freud and Artaud, see Jacques Derrida, "Freud and the Scene of Writing", *Writing and Difference*, Alan Bass trans., London: Routledge, 1993, pp. 218-221. In the same edition Derrida writes on Artaud and the hieroglyph in "La parole soufflée" (p. 192) and in "The Theatre of Cruelty and the Closure of Representation" (pp. 240-242).

47 "20 janvier XXXVI", *Picasso: écrits*, p. 98: "libro abierto espantado al sol que le abre la boca y le mira la garganta su lengua hablando ya verdad echando planos perspectivos y tirando lineas de huída vuelve su cabeza hacia atrás y dice mírame...". Following this, the text goes into a long incantation of the command "mírame" ("look at me"): "ya que me miras mírame que ya me miras mírame me que ya miras ya mírame que me miras si ya me ya miras que ya miras que si me miras y si la mira la si la la si la mi si si mi si la si".

48 See note 4. Bataille, "Sacrificial Mutilation and the Severed Ear of Vincent Van Gogh", *Visions of Excess*, pp. 61-72.

49 For a discussion of the visual (the hieroglyph or pictograph) versus the audible (glossolalia) and the breakdown of meaning within the context of Artaud's poetry, see Jacques Derrida, "To Unsense the Subjectile", *The Secret Art of Antonin Artaud*, pp. 80-87.

50 Musical notation and number, spoken like incantations, direct us towards Artaud's "cruel" language, the language "of dynamic expression" and language "in space", or the language of dreams (as opposed to the words conventionally spoken by actors). See Artaud, "The Theatre of Cruelty (First Manifesto)", pp. 68-72. And not forgetting that the physicality of language, the vibrating voice invokes "metaphysics" (in Artaud's particular sense of the term) in that it puts the intellect or the spirit in touch with the cosmic (see "Production and Metaphysics", p. 35).

51 "20 janvier XXXVI", *Picasso: écrits*, p. 98: "y que cada ricito del testuz tomando la forma de una letra combinada de una cierta manera que aquí está lo difícil formarían la página completa de la verdad de la historia pasada por el cedazo de las matemáticas de la poesía exacta de su ojo...".

52 "20.2.37", "25 janvier XXXVII-25 février XXXVII", *Picasso: écrits*, p. 156: "toothache in the eyes of the sun sting–sting sun madness of teeth with eyes– eyes with teeth sting of the sun of sun madness sting eyes with teeth of toothaches–sun sting of madness eyes". "20.2.37" is one of the texts of the suite written in Indian ink on *papier d'Arches* folded in two. Original manuscript held in the archives of the Musée Picasso, Paris.

53 Ontology, to give Sartre's definition: "The study of the structures of being of the existent taken as a totality." Jean-Paul Sartre, *Being and Nothingness*, Hazel E Barnes trans., New York: Routledge, 1989, p. 633. For Sartre, as for his mentor Heidegger, the ontological becomes the existential.

54 Picasso's artistic works of early 1937 include satirical etchings of Franco and his exploits (*The Dream and Lie of Franco*, 8, 9 January 1937, completed June 1937), monstrous female bathers, as well as numerous portraits of close female friends, some in the pose of Melancholia, head resting on hands, over an open book, January, February 1937. He also painted a large body of still lives (about 55 between 1936 and 1939). It was probably in January 1937 that Picasso accepted the official commission of the Spanish Republican government to fill the most prominent space in the Spanish pavilion at the Paris World's Fair, due to open the following May. Picasso must have struggled to find an appropriate theme and expression for the commissioned mural throughout the winter of 1937, as there is no evidence that he began the work before 18 April 1937.

55 *Picasso: écrits*, p. 159: "les dessins affectant l'indifférence aux mots propres désignant la gueule ouverte des choses se montrant dans toute leur colère en pleine crise de rage...".

56 See Julia Kristeva, *Powers of Horror: An Essay on Abjection*, Leon S Roudiez trans., New York: Columbia University Press, 1982, pp. 1-2.

57 For a political analysis of Picasso's drawing, see Stich, "Picasso's Art and Politics in 1936", pp. 113-118. Picasso's drawing, created during the euphoria of the anti-fascist Popular Front demonstrations in Paris, May 1936, depicts a slumped minotaur/harlequin and three mythical figures that relate, according to Stich, to the fascist imperialism of Mussolini (the eagle-headed figure) and Hitler.

58 "10 avril XXXVI", *Picasso: écrits*, pp. 118, 120: "sole sun toothache double the stakes and gilding on the feather of the gaze fix the point of the fall and stir her fingernails into the dance" ("seul soleil rage de dents double la mise et peint dorade sur la plume du regard fixe le point de chute et délaie ses ongles à la danse").

59 "20.2.37", *Picasso: écrits*, p. 159: "les couleurs numérotées par ordre hiérarchique vont mourant une à une en touchant à la réalité des objets qui les désignent comme la compagne destinée à démêler les fils du dessin emprisonnant les images des phantômes durcis sur le feu de la lumière...".

60 Sabartés, Jaime, *Picasso An Intimate Portrait*, London: W H Allen, 1949, p. 171.

61 Sartre, *Being and Nothingness*, p. 186.

62 Picasso often wrote at his dining room table and in the kitchen at rue la Boétie. He set many texts in a kitchen, which functions as a place of sacrifice, in which various types of fruit, vegetables or other items of food are the protagonists. The kitchen is equally a place of philosophical significance, where the 'author' of the text records himself writing in a defined, 'existential' space.

63 "20.2.37", *Picasso: écrits*, p. 159: "avec quel empressement et quelle joie et quels cris de plaisir et bonheur ne sachant pas où donner de la tête mettant son cul au vent et les voiles sur les yeux de chacune se laissant tomber du plafond au sol sur les seins rebondissant sur les vitres de la fenêtre les brisant se blessant se coupant tachant de leur sang les murs le parquet le plafond le feu de la cuisine le coupant en morceaux l'hachant menu la pressant de leurs poids…".

64 "20.2.37", *Picasso: écrits*, p. 159: "entrailles pendues en guirlandes aux clous enfoncés dans le coeur de cette histoire aux drapeaux déchirés par les balles cris étouffés des fourchettes et cuillers dans l'affolement du sauve-qui-peut du fait concret des lignes tirées à la règle et de l'équerre du fil à plomb et du compas…".

65 Sartre, *Being and Nothingness*, pp. 601-612.

66 For a specific explanation of this term, see Georges Bataille, "Base Materialism and Gnosticism", *Visions of Excess*, pp. 45-52. ("Le bas matérialisme et la gnose", *Documents*, second year, 1, 1930, pp. 1-8.)

67 "15.2.37": "merde et merde plus merde égale à toutes merdes merde merde glaires de gloses haleine pestilentielle de la rose des vents de son anus double crème cocon filé par le parfait amour accroché à ses pustules mijotant sur le feu si doux de ses yeux horreur et désespoir…".

68 Sartre, *Being and Nothingness*, p. 612.

69 Sartre, *Being and Nothingness*, p. 606.

1 Cervantes, Miguel de, *El Cerco de Numancia*, Robert Marrast ed., Madrid: Ediciones Cátedra, SA, 1984, lines 1355-60, p. 89.

2 See *Pabellón Español: Exposición internacional de París 1937*, exh. cat., Madrid: Centro de Arte Reina Sofía, 1987. See also Stephen Spender, "Guernica", *The New Statesman and Nation*, vol. 16, no. 339, London, 1938, pp. 567-568. Spender relates his experience of viewing *Guernica* to the "second-hand experience" of the newspaper and the newsreel, "one of the most dominating realities of our time".

3 See Roland Penrose, *Picasso: His Life and Art*, London: Gollancz, 1958, p. 275.

4 Roland Penrose also notes the possible connection of the arc lamp, as well as the bull and the cock, to Bataille's images in "Rotten Sun". See Penrose, *Picasso: His Life and Art*, p. 273.

5 Bataille, Georges, "Rotten Sun", *Visions of Excess: Selected Writings, 1927-39*, Allan Stoekl ed., trans., Minneapolis: University of Minnesota Press, 1985, p. 59.

6 See *The Musée Picasso, Paris, II, Drawings, Watercolours, Gouaches, Pastels,* London: Thames and Hudson and Editions de la Réunion des musées nationaux, 1988, p. 336 and catalogue nos. 1064-1077, pp. 340-342. Domique Bozo, the first curator of the Musée Picasso, discovered these sketches, which he believed to be related to the commissioned work, after Picasso's death.

7 See Jerome Seckler, "Picasso Explains", *New Masses*, 1944 (reprinted in Dore Ashton, *Picasso on Art*, London: Thames and Hudson, 1972, p. 140). In October 1944, shortly after joining the French Communist Party, Picasso referred to *Guernica*'s "deliberate sense of propaganda—the bull represents brutality, the horse the people".

8 Artaud, Antonin, "Production and Metaphysics", *The Theatre and Its Double*, Victor Corti trans., London: Calder Publication, 2001, p. 27.

9 Artaud, "Production and Metaphysics", p. 28. Artaud aside, Picasso also had the tradition of Spanish painting and theatre, with its symbolic use of staging, on which to draw. Incidentally, Picasso created the sets for Sophocles' *Antigone*, 1922, adapted by Jean Cocteau for Charles Dullin's Atelier theatre. Picasso would have been able to observe Artaud in the part of Tiresias, at a time when he was developing his exaggerated acting style, based on Balinese theatre. See Stephen Barber, *Antonin Artaud: Blows and Bombs*, London: Faber and Faber, 1993, pp. 16-17.

10 Reinhold Hohl has compared Picasso's *Guernica* to Artaud's "Theatre of Cruelty", particularly in the sense of total theatre fusing reality, poetry and myth and the use of shock effects.

11 Penrose, *Picasso: His Life and Art*, p. 275.

12 Artaud, Antonin, "Seraphim's Theatre", *The Theatre and Its Double*, p. 96. For the original version of the quotation, see Artaud, *Le théâtre et son double suivi par Le théâtre de Séraphin*, Paris: Gallimard, 1964, p. 223. "Je veux essayer un féminin terrible. Le cri de la révolte qu'on piétine, de l'angoisse armée en guerre, et de la revendication." The text, probably written at the end of 1935, was revised and signed by Artaud "Mexico City, 5 April, 1936". It was not included in *The Theatre and Its Double*, 1938, but in another volume, *L'Air du temps*, 1948, (See note 1, pp. 250-251).

13 Artaud, "Seraphim's Theatre", p. 96. Original version: "Pour lancer ce cri je me vide. Non pas d'air, mais de la puissance même du bruit" (*Le théâtre et son double suivi par Le théâtre de Séraphin*, pp. 223-224.)

14 Artaud, "Seraphim's Theatre", p. 98. Original version: "Pour ce cri il faut que je tombe. C'est le cri du guerrier foudroyé qui dans un bruit de glaces ivre froisse en passant les murailles brisées." (*Le théâtre et son double suivi par Le théâtre de Séraphin*, p. 226.)

15 Chipp, Herschel B, *Guernica: History, Transformations, Meanings*, London: Thames and Hudson, 1989, p. 14.

16 *Picasso: écrits*, Marie-Laure Bernadac and Christine Piot eds, Paris: Réunion des musées nationaux and Éditions Gallimard, 1989, pp. 166, 168. See also the illustration of the drawing and the notes for the text "15-18 juin 1937", "Dream and Lie of Franco", second state, pp. 169, 408.

17 *Picasso: écrits*, p. 168: "fandango de lechuzas escabeche de espadas de pulpos de mal agüero estropajo de pelos de coronillas de pie en medio de la sartén en pelotas puesto sobre el cucurucho del sorbete de bacalao frito en la sarna de su corazón de cabestro—la boca llena de la jalea de chinches de sus palabras—cascabeles del plato de caracoles trenzando tripas—meñique en erección ni uva ni breva—comedia del arte de mal tejer y teñir nubes—productos de belleza del carro de la basura—rapto de las meninas en lágrimas y en lagrimones—al hombro el ataúd relleno de chorizos y de bocas—la rabia retorciendo el dibujo de la sombra que lo azota los dientes clavados en la arena y el caballo abierto de par en par al sol que lo lee a las moscas que hilvanan a los nudos de la red llena de boquerones el cohete de azucenas—farol de piojos donde está el perro nudo de ratas y escondrijo del palacio de trapos viejos—las banderas que fríen en la sartén se retuercen en el negro de la salsa de la tinta derramada en las gotas de sangre que lo fusilan—la calle sube a las nubes atada por los pies al mar de cera que pudre sus entrañas y el velo que la cubre canta y baila loco de pena—el vuelo de cañas de pesca y alhiguí alhiguí del entierro de primera del carro de mudanza—las alas rotas rodando sobre la tela de araña del pan seco y agua clara de la paella de azúcar y terciopelo que pinta el latigazo en sus mejillas—la luz se tapa los ojos delante del espejo que hace el mono y el trozo de turrón de las llamas se muerde los labios de la herida—gritos de niños gritos de mujeres gritos de pájaros gritos de flores gritos de maderas y de piedras gritos de ladrillos gritos de muebles de camas de sillas de cortinas de cazuelas de gatos y de papeles gritos de olores que se arañan gritos de humo picando en el morrillo de los gritos que cuecen en el caldero y de la lluvia de pájaros que inunda el mar que roe el hueso y se rompe los dientes mordiendo el algodón que el sol rebaña en el plato que el bolsín y la bolsa esconden en la huella que el pie deja en la roca".

18 Cited in Alfred H Barr, Jr, Picasso, *Fifty Years of His Art*, New York: The Museum of Modern Art, 1946, p. 264. Statement made originally in 1937. Published in July 1937 in an interview with Georges Sadoul, cited in Chip, *Guernica: History, Transformations, Meanings*, p. 194.

19 See Georges Bataille's essays on the social and sacrifice: "The Jesuve", c1930, "The Pineal Eye", c1930, and "The Notion of Expenditure", 1933, *Visions of Excess*, pp. 73-90, 116-29.

20 See Kathleen Brunner, "*Guernica*: the Apocalypse of Representation", *Burlington Magazine*, February 2001, pp. 80-85.

21 The Republican poet and playwright Rafael Alberti wrote a Leftist 'free version' of *Numancia* that was performed during the Battle of Madrid in December 1937. See Rafael Alberti, *Numancia,* Madrid: Ediciones Turner, SA, 1975. Alberti writes that Numancia is "an exact parallel to our republican capital, in the example of resistance, morale and spirit of the people of Madrid today, who have the same greatness and proud soul as the Numantinos." He updated the play to the time of the Civil War, dressing the defending soldiers as Civil Guards and replacing the Romans with Fascists.

22 Thomas, Hugh, *The Spanish Civil War*, third edition, Harmondsworth: Penguin Books, 1986, p. 769.

23 Russell, Frank D, *Picasso's Guernica: The Labyrinth of Narrative and Vision*, London: Thames and Hudson, 1980, pp. 113-114. Russell refers to a possible connection between *Guernica* and Numancia, as suggested to him by a Spanish painter, José Maorta. The plunging figure on the right-hand side of *Guernica* illustrates, for Russell, the legend of Numancia in which the Numantinos committed suicide by jumping from the city walls. More concerned with art historical references, he tried to draw an unconvincing parallel between the *Guernica* horse and an image on a shard of pottery from the ruins of Numancia, but otherwise left the allusion unexplored.

24 The fallen figure went through several transformations. Many have noticed the figure's similarity to a Roman soldier in Picasso's painting *The Crucifixion*, 1930, which is thought to derive, in turn, from the medieval *Apocalypse of Saint Sever,* illustrated in *Documents* 2, 1929. Roland Penrose describes this figure as "a prostrate figure wearing a Greek helmet". See Penrose, *Picasso: His Life and Art*, p. 273.

25 Shergold, N D, *A History of the Spanish Stage: From Medieval Times Until the End of the Seventeenth Century*, Oxford: Clarendon Press, 1967, p. 231-233. *Guernica*'s scenography, a medieval walled town, recalls the painted flat background of *Numancia*'s early staging. The tiled foreground, a continuation of the actual tiled pavilion courtyard where the painting was installed, recalls the Renaissance *corral* (an inner courtyard where the stage was set up), like Madrid's Corral del Príncipe, which was inaugurated by a production of Cervantes's *Cerco de Numancia* in 1580.

26 See Centro de Arte Reina Sofía, *Pabellón Español: Exposición Internacional de París 1937*, Madrid, 1987 for documentation of the literacy drive. The poet and playwright Federico García Lorca's student theatre troupe, La Barraca (The Caravan, named after the Renaissance players' travelling cart) was part of that programme. La Barraca performed Calderón's *Life Is a Dream* in the Spanish pavilion (July 1937), by which time Lorca had been murdered, p. 153.

27 Cervantes, *El Cerco de Numancia*, p. 82.

28 Cervantes, *El Cerco de Numancia*, lines 1295-1300, p. 88.

29 Cervantes, *El Cerco de Numancia*, lines 1355-1360, p. 89.

30 Seckler, Jerome, "Picasso Explains", *New Masses*, 1944 (reprinted in Ashton, *Picasso on Art*, p. 140).

31 Cervantes, *El Cerco de Numancia*, p. 123.

32 Bataille, Georges, "Nietzschean Chronicle", *Visions of Excess*, pp. 202-12. (Originally published as "Chronique Nietzschéenne", *Acéphale* 3-4, pp. 15-23.) For a description of *Numance de Cervantès*, see Jean-Louis Barrault, *Memories for Tomorrow: The Memoirs of Jean-Louis Barrault*, London, 1974, p. 89. See also Sarah Wilson, "1937: Problèmes de la peinture en marge de l'Exposition internationale", *Paris-Paris: 1937-1957*, Paris: Centre Georges Pompidou, 1981 (revised ed., Paris: Editions du Centre Georges Pompidou and Editions Gallimard, 1992, p. 75).

33 Barrault, *Memories for Tomorrow: The Memoirs of Jean-Louis Barrault*, p. 77.

34 Bataille, "Nietzschean Chronicle", p. 211. Bataille refers to Spengler, who, he claimed, had discredited the cyclical view of history.

35 Bataille expresses this leftist appropriation of Nietzsche in "Nietzsche and the Fascists" (*Acéphale* 2, January 1937, pp. 15-23, *Visions of Excess*, pp. 182-196) and the above-cited "Nietzschean Chronicle". For the latter article, André Masson contributed the title page illustration, drawn from images created for the set of Barrault's *Numance*, the bull's head and skull against a rocky sierra.

36 For Bataille's first reference to expenditure and the potlatch, see Georges Bataille, "The Notion of Expenditure", 1933, *Visions of Excess*, pp. 116-29.

37 Bataille, "Nietzschean Chronicle", p. 208. "l'objet fondamental de l'activité commune des hommes, la mort et non la nourriture ou la production des moyens de production" ("Chronique Nietzschéenne", p. 20).

38 Bataille, "Nietzschean Chronicle", p. 208. "une commune conscience de ce qu'est l'existence profonde: jeu émotionnel et déchiré de la vie avec la mort" ("Chronique Nietzschéenne", p. 21.)

39 Mauss, Marcel, *The Gift: The Form and Reason for Exchange in Archaic Societies*, W D Halls trans., London: Routledge, 1990, pp. 3, 78-80. Mauss originated the concept of 'total social fact'–his term for the organisation of 'primitive' cultures–which unites the social, the economic, the religious, the sexual, the psychological and the aesthetic aspects of a culture around the economy of the gift (the potlatch).

40 Bataille, Georges and Roger Caillois, "Note on the Foundation of a College of Sociology", *The College of Sociology*, 1937-1939, Betsy Wing trans., Minneapolis: University of Minnesota Press, 1988, p. 5. In March 1937 Bataille, along with the anthropologist Roger Caillois and the writer and ethnologist Michel Leiris (the husband of Louise Leiris, Picasso's dealer), founded the Collège de Sociologie, 1937-9, an epistemological avant-garde drawn mainly from surrealism and the fields of sociology and anthropology. Bataille defines his discipline as "Sacred Sociology", borrowing heavily from Emile Durkheim and Marcel Mauss, which aims "to establish the points of coincidence between the fundamental obsessive tendencies of individual psychology and the principal structures that govern social organisation and are in command of revolutions".

41 See Artaud, "The Theatre of Cruelty (Second Manifesto)", p. 82.

42 Bataille, "Nietzschean Chronicles", p. 212.

43 Bataille, Georges, "The Sorcerer's Apprentice", *Visions of Excess*, p. 232.

1 See Christian Zervos, *Pablo Picasso, Vol. 11*, Paris: Editions Cahiers d'art, 1960, plates 90 and 92.

2 For the text "2.8.40" see *Picasso: écrits*, pp. 228-230. The *Carnet Royan*, 1939-1940, includes a suite of sixteen French texts, 24 December 1939 to 7 June 1940. For a description of the manuscript see p. XXXVIII. The texts are written in an ordinary cardboard-cover sketchbook in black and blue-black ink, Indian ink and black pencil over 64 pages (front and back) of graph paper. A 23-page typed version of part of the suite ("17-19.8.40") with a partial translation in black pencil, kept in the Picasso archives in Paris, bears the title *La corrida*.

3 See "Notices", *Picasso: écrits*, p. 419.

4 *Picasso: écrits*, pp. 419, 421. Consult the notes on "2.8.40" for a linear clarification of each of the seven states.

5 Brassaï, *Conversations avec Picasso*, Paris: Gallimard, 1964, p. 58.

6 Brassaï, *Conversations avec Picasso*, p. 58.

7 Brassaï, *Conversations avec Picasso*, p. 58.

8 For a discussion of abstract and sensory language in metaphysics, see Jacques Derrida, "White Mythology: Metaphor in the Text of Philosophy", *Margins of Philosophy*, Alan Bass trans., New York: Harvester Wheatsheaf, 1982, pp. 210-211.

9 Bataille, Georges, "The Solar Anus", *Visions of Excess: Selected Writings, 1927-39*, Allan Stoekl ed., trans., Minneapolis: University of Minnesota Press, 1985, p. 6. The approach to vision and sexuality in Picasso's cosmological schema and Bataille's essay is strongly resonant of some aspects of Surrealism, particularly Marcel Duchamp's spiralling, pulsating *Rotoreliefs*, 1935, and *The Large Glass*, 1915-1923. See Rosalind E Krauss, *The Optical Unconscious*, Cambridge, MA: The MIT Press, 1993, pp. 96-102, 119-125.

10 Brassaï, *Conversations avec Picasso*, p. 58.

11 "2.8.40", first state, 49 recto, *Picasso: écrits*, pp. 419-420: "azucena que sube a gatas por la escalera del tejado revolcándose en las puntillas del ojaldre alas de la tijera que corta el hilo del globo que cae de bruces en el cielo y estalla…".

12 Gilot, Françoise and Carlton Lake, *Life with Picasso*, London: Virago, 1990, pp. 16-18, 25.

13 "2.8.40", fifth state, 50 recto, *Picasso: écrits*, pp. 419-420: "azucena que sube a gatas por la escalera del tejado revolcando sus alas entre las hojas del dulce que corta con sus dientes el hilo que encadena el globo que cae desamparado de bruces en el cielo y estalla…".

14 "2.8.40", sixth state, 50 verso, *Picasso: écrits*, pp. 419-421: "azucena que sube a gatas por la escalera del tejado revolcando sus alas entre las hojas de la miel que estalla al caer de bruces el globo sobre el aceite que hierve en la sartén huevo frito del abanico".

15 "2.8.40", seventh state, 50 verso, *Picasso: écrits*, pp. 420-421: "azucena que sube a gatas por la escalera del tejado revolcando entre las hojas de la miel que estalla al caer de bruces el globo sobre el aceite que hierve en la sartén huevo frito del abanico y cadena de reloj de los años agarrados a la quilla de la larga cordillera de lobos que se despega de sus manos armario pálido de luna apoyado al papel de pared que lo sostiene en sus labios mientras expira verdugo descabezado escondido detrás de la inmensa sombra arrancada del manto de la casa huyendo a caballo al galope de los crujidos del sol sobre sus pliegues campos de acelgas del mar cortado a partes iguales por las olas del olor de berengenas del color de la seda que duerme debajo de la parra que entretiene la luz con sus cuentos para que no se escape de un salto en la espiral del charco de harina de las ramas del limón

verde del plumero de cintas ahorcadas al juego convulsivo del chorreón que flota sus melenas de charol sobre el metal bruñido del amargo sabor que descarga la luz sobre su frente corre el telón y apaga los faroles".

16 *Picasso: écrits*, pp. 242-256. The original manuscript is now lost. It was written in Indian ink on pages 12-63 of a parchment-covered sketchbook (see pp. XXXVIII, 424). The text is known only through photographs found in the archives of the review *Cahiers d'art*, which published pages 12-13 of the text in the 1940-1944 number.

17 Bataille, "The Solar Anus", p. 5.

18 Bataille, "The Solar Anus", p. 9.

19 Brassaï, *Conversations avec Picasso*, p. 62. Note that Brassaï dates Picasso's move to the autumn of 1942, which differs from most other chronologies.

20 Brassaï, *Conversations avec Picasso*, p. 54 and illustrations 17, 18.

21 See Zervos, *Pablo Picasso*, plates 90 and 92.

22 *Picasso: écrits*, p. 242: "salta y brinca de entre las piernas de las ruedas de cartón del día que abre las cadenas de sus hojas un manojo de perfumes tan pesado un caldo de gallina y unas sopas de mercurio tan ligeras que el tío vivo que ordeña el vino de las alas entre las páginas del libro desmorona entre sus dientes la sangre que brota de la hoja de laurel del cuchillo herido...".

23 *Picasso: écrits*, p. 242: "de entre los labios del pitorro de las almorranas de las hojas del pedernal cantando sus letanías por estas apolilladas nubes podridas".

24 The oddity of the word "haemorrhoids" indicates Picasso's interest in specialised vocabulary and how words operate.

25 *Picasso: écrits*, p. 245. The italics correspond to Picasso's matrix text: "*salmuera* de la pata de gallo y cresta de almirez cebollina y pepinera *de las trompetas* entreabiertas *del limón agrio* y chillón *que* testaurado *gotea* de la cenefa *de las tejas* malvas arrulladoras *del* puñado de azul rosa infra *pálido* muy gordinflón gustoso y farolero y comedido enamorado novio *del azul* cariñoso fiel y cabal metido de patas en el charco de la luz ahogada en el capote colorado del hueso roido de las cañas de pescar higos muy negras y llenas hasta el borde del aire de violín del celoso color rabioso verde cinabrio pálido amante compungido del color distribuido tan parcimoniosamente sobre el andamio de hierro y las guitarras del *terciopelo* de la mano abierta del *verde botella* dibujando y midiendo a *capotazo* limpio del caracol montés y risueño verídico festivo espantoso y muy hombre gustoso *del zumo verde anaranjado* y seguro servidor *del verde* amarillo *rojizo* muy señor verde y horroroso *verde* enojado del *azul* puro y claro y *azul* negro y *oro del dorado* de oro y *plata* el muy pícaro *verde manzana del verde almendra que*...".

26 *Picasso: écrits*, p. 246: "*dulces del* blancuzco chirrido *líquido* de la gasa del emplastro mojando *del muro pegado a la roña* roñosa *del* culo sucio del *cielo*...".

27 *Picasso: écrits*, p. 254: "la luz que se estrella molida a palos encima del monstruoso telón de boca del ojo clavado a la rendija de sol *que se arrastra* al interior *del bolso negro de la amapola* azul verdoso estallando en la botella llena de alaridos los crujidos de caña rota de la carga pesada y densa del *amarillo* amarillo *al límite de su* amarillenta y *pinturera intensidad*...".

28 *Picasso: écrits*, p. 256: "*las tripas del caballo herido a cuestas acarician* la oreja y culo de *la luz que se estrella sobre el cesto de paja del sol extendido durmiendo a pata larga sobre la playa de arena y polvo de estrellas*...".

1 The original manuscript, in Indian ink in a 24-page notebook, belongs to a private collection. The place and dates of composition are recorded on the title page and page 24, "Paris mardi 14 janvier 1941" and "Paris vendredi 17 janvier 1941". A drawing entitled *Portrait de l'auteur* figures on page 1, followed on pages 4, 5 and 13 by designs for the stage sets. The manuscript was produced in a facsimile version of 250 copies in 1944 and was published by Gallimard in Paris in 1945, with re-editions in 1964, 1967 and 1973. The text and sketches are reproduced in *Picasso: écrits*, pp. 257-277. The quotations from the play cited in this section are from *Le Désir attrapé par la queue*, Paris: Gallimard, 1967 edition. The play also exists in an English translation: *Desire Caught by the Tail*, translated by Roland Penrose, London: Calder and Boyars, 1970. The translations of *Le Désir* given in this chapter are by Penrose with amendments where indicated.

2 Picasso refused to grant the rights to perform the play, even to André Malraux in 1966, as he wanted its integrity, particularly the nudity, to be respected. He made an exception, however, for Jean-Jacques Lebel, see appendix for details. See *L'Avant-Scène, 500th number*, Paris, 1972 (special "Picasso, auteur de Théâtre" number), pp. 10-11, 21-22 and *Sipario*, Milan, Summer 1967, pp. 14-16.

3 Jeanneret, Michel, *A Feast of Words: Banquets and Table Talk in the Renaissance*, Jeremy Whiteley and Emma Hughes trans., Cambridge: Polity Press, 1991, pp. 142-145.

4 Penrose, Roland, *Picasso: His Life and Work*, London: Gollancz, 1958, p. 299.

5 Penrose, *Desire Caught by the Tail*, p. 19; Picasso, *Le Désir attrapé par la queue*, p. 13: "L'Oignon, trêve de plaisanteries: nous voici bien réveillonnés à point de dire les quatre vérités premières à notre Cousine. Il faudrait s'expliquer une fois pour toutes les causes ou les conséquences de notre mariage adultérin; il ne faut pas cacher ses semelles crottées et ses rides au *gentleman rider* [in English in the text], si respectueux soit-il des convenances."

6 Daix, Pierre, *Picasso: Life and Art*, New York: HarperCollins, 1993, p. 238. Pierre Daix mentions that "Onion soup" ("soupe à l'oignon") was Picasso's nickname for Christian Zervos. The name appears on Picasso's drawing-collage *Le crayon qui parle*, 11 March 1936.

7 Penrose, *Desire Caught by the Tail*, pp. 19-20; Picasso, *Le désir attrapé par la queue*, pp. 13-15:
"Le Bout Rond: Un moment, un moment.
Le Gros Pied: Inutile, inutile.
La Tarte: Mais enfin, mais enfin, un peu de calme et laissez-moi parler.
Le Gros Pied: Bien.
Le Bout Rond: Bien, bien.
Les Deux Toutous: Gua, gua.
Le Gros Pied: Je voulais dire que si nous voulons nous entendre enfin au sujet du prix des meubles et de la location de la villa, il faudrait, et d'un absolu parfait accord, déshabiller tout de suite le silence de son complet et le mettre nu dans la soupe qui, entre parenthèses, commence à refroidir à une vitesse folle.
L'Angoisse Grasse: Je demande la parole.
L'Angoisse Maigre: Moi aussi, moi aussi.
Le Silence: Voulez-vous vous taire."

8 Plato, *The Symposium*, Harmondsworth: Penguin Books, 1951, pp. 59.

9 See the analysis of Aristophanes' speech, with reference to castration and to the death instinct, in Jacques Lacan, *Le Séminaire VIII, Le transfert*, Paris: Editions du Seuil, 1991, pp. 115-116. See also Freud's reference to *The Symposium* in "Beyond the Pleasure Principle", *On Metapsychology: The Theory of Psychoanalysis, Vol. 11, The Freud Pelican Library*, Angela Richards ed., James Strachey trans., Harmondsworth: Penguin Books, 1985, p. 331. Freud, noting the originality of Plato's theory of the origin of the sexual instinct, writes: "For it traces the origin of an instinct to a need to restore an earlier state of things". Plato's myth illustrates Freud's theory of the sexual instinct and its link to the death instinct.

10 Goux, Jean-Joseph, *Oedipus, Philosopher*, Stanford: Stanford University Press, 1993, pp. 2-3. Goux argues that the Oedipus myth is a myth of failed masculine initiation, an initiation that Oedipus avoids by using his intelligence to conquer the female monster, rather than the sword (as in Perseus's decapitation of the Medusa's head).

11 In Cervantes's "Dialogue of the Dogs" ("El coloquio de los perros"), one of the short stories of *The Exemplary Novels*, 1613, two dogs, one an Aristotelian, the other, his loquacious foil, have a philosophical dialogue which satirises early seventeenth century Spain. A French translation of the work dated 1739, no doubt a gift from a well-meaning visitor, appears on the inventory of Picasso's books kept in the Picasso archives in Paris.

12 Borràs, Maria Lluïsa, *Picabia*, London: Thames and Hudson, 1985, p. 208. The evening was named after Picabia's picture *The Cacodylic Eye*, 1921, which depicts an eye against a plain background that is covered with the signatures of other dadaists and avant-garde figures. Cacodyl was the name of an eye medication.

13 A 1923 performance of *Le Coeur à gaz* in Paris saw a scuffle caused by demonstrating surrealists, such as Breton, Péret and Eluard, which virtually ended Dada and Tzara's influence on modern art. See Maurice Nadeau, *The History of Surrealism*, Richard Howard trans., London: Plantin Publishers, 1987 (originally published in 1944), pp. 66-67.

14 Tzara, Tristan, *Le Coeur à gaz, Oeuvres Complètes, I, 1912-24*, Henri Béhar ed., Paris: Flammarion, 1975, pp. 153-180.

15 See Brassaï, *Conversations avec Picasso*, p. 179. Two days after the play's first reading at the Leirises' on 19 March 1944, Picasso invited the cast, together with Jacques Lacan, to his studio, where he kept Jarry's manuscript of *Ubu cocu*. The manuscript is now held in the archives of the Musée Picasso (MP 3659).

16 Penrose, *Desire Caught by the Tail*, p. 31; Picasso, *Le Désir attrapé par la queue*, p. 29: "Réflexion faite, rien ne vaut le ragoût de mouton. Mais j'aime beaucoup mieux le miroton ou bien le bourguignon bien fait, un jour de bonheur plein de neige, par les soins méticuleux et jaloux de ma cuisinière esclave slave hispano-mauresque et albuminurique servante et maîtresse, délayée dans les architectures odorantes de la cuisine. La poix et la glu de ses considérations détachées, rien ne vaut son regard et ses chairs hachées sur le calme plat de ses mouvements de reine. Ses sauts d'humeur, ses chauds et froids farcis de haine ne sont rien, au beau milieu du repas, que l'aiguillon du désir entrecoupé de douceurs."

17 Penrose, *Desire Caught by the Tail*, p. 31; Picasso, *Le Désir attrapé par la queue*, pp. 29-30: "les pointes de feu de ses lèvres glacées sur la paille du cachot mis à jour n'enlèvent point à la cicatrice de la blessure son caractère".

18 Penrose, *Picasso: His Life and Work*, p. 301.

19 Penrose, *Picasso: His Life and Work*, p. 301.

20 Endymion, a beautiful young shepherd, was kept in a permanent state of sleep by the adoring Selene, the Moon, so that she could visit him every night and cover him with kisses.

21 Penrose, *Desire Caught by the Tail*, pp. 34-35; Picasso, *Le Désir attrapé par la queue*, pp. 34-35: "L'Angoisse Maigre: Il est beau comme un astre. C'est un rêve repeint en couleurs d'aquarelle sur une perle. Ses cheveux ont l'art des arabesques compliquées des salles du palais de l'Alhambra et son teint a le son argentin de la cloche qui sonne le tango du soir à mes oreilles pleines d'amour. Tout son corps est rempli de la lumière de mille ampoules électriques allumées. Son pantalon est gonflé de tous les parfums d'Arabie. Ses mains sont de transparentes glaces aux pêches et aux pistaches. Les huîtres de ses yeux renferment les jardins suspendus bouche ouverte aux paroles de ses regards et la couleur d'aïoli qui l'encercle répand une si douce lumière sur sa poitrine que le chant des oiseaux qu'on entend s'y colle comme un poulpe au mât du bergantin qui, dans les remous de mon sang, navigue à son image. L'Angoisse Grasse: Je tirerais bien un coup avec lui sans qu'il le sache. La Tarte, les larmes aux yeux: Je l'aime."

22 For the dating of this work, see Elizabeth Cowling and John Golding, *Picasso: Sculptor/Painter*, London: Tate Gallery, 1994, (Illus. 102), pp. 136, 274. The image of the death's head in *Desire Caught by the Tail* may be a clue to, at the least, the conceptual origin of this work.

23 Plato, *The Symposium*, pp. 75-95.

24 Plato, *The Symposium*, p. 76. On the transition from love to desire, see Jacques Lacan, *Le Séminaire de Jacques Lacan, VIII, Le transfert, 1960-1961*, pp. 135-140.

25 On the beautiful and the death wish, see Lacan, *Le transfert*, p. 154.

26 Penrose, *Desire Caught by the Tail*, p. 47; Picasso, *Le Désir attrapé par la queue*, p. 47: "Le Gros Pied, à moitié étendu sur un lit de camp, écrivant: Crainte des sauts d'humeur de l'amour et humeurs des sauts de cabri de la rage. Couvercle mis à l'azur qui se dégage des algues couvrant la robe amidonnée de riches lambeaux de chair éveillée par la présence des flaques de pus de la femme apparue subitement étendue sur ma couche. Gagarisme du métal fondu de ses cheveux criant de douleur toute sa joie d'être prise."

27 Penrose, *Desire Caught by the Tail*, p. 48; Picasso, *Le Désir attrapé par la queue*, p. 48: "Le noir de l'encre qui enveloppe les rayons de salive du soleil qui tapent sur l'enclume des lignes du dessin acquis à prix d'or développe, dans la pointe d'aiguille de l'envie de la prendre dans ses bras, sa force acquise et ses moyens illégaux de l'atteindre."

28 Penrose, *Desire Caught by the Tail*, pp. 49-50; Picasso, *Le Désir attrapé par la queue*, pp. 50-51: "Elle s'accroupit devant le trou de souffleur et, face à la salle, pisse et chaudepisse pendant dix bonnes minutes", "Ouf! ça va mieux", "Elle pète, elle re-pète, se recoiffe, s'assied par terre et commence la savante démolition de ses doigts de pieds."

29 Picasso must have taken the idea of the prompter's box from Alfred Jarry's *Ubu cocu*, in which Ubu pushes La Conscience into a hole between two stone footrests ('trou entre deux semelles de pierres'), a description of a public lavatory. See Alfred Jarry, *Oeuvres complètes*, Michel Arrivé ed., Nouvelle Revue Française, Paris: Gallimard, 1972, p. 370.

30 Penrose, *Desire Caught by the Tail*, pp. 50-51; Picasso, *Le Désir attrapé par la queue*, p. 51: "L'âcre odeur répandue autour du fait concret établi à priori du récit n'engage le personnage destiné à cette besogne à aucune retenue. Devant sa femme et pardevant notaire, nous, le seul responsable établi et connu comme auteur honorablement connu, je n'engage ma responsabilité entière que dans les cas précis où les inquiétudes démesurées deviendraient obsédantes et meurtrières pour la vue partielle du sujet mis à table, dégoisant à plein rendement le fil à plomb de la compliquée machine à établir coûte que coûte sur les données exactes du cas déjà expérimenté par d'autres, à l'inverse de l'éclairage apporté aux points de vue sur lesquels appuyer le poids des précisions intérieures."

31 Blackburn, Simon, *The Oxford Dictionary of Philosophy*, Oxford: Oxford University Press, 1996, pp. 21-22. A priori knowledge, a highly controversial category, refers to pure thought and usually applies to logic and mathematics. A priori concepts, also contested, include time, substance, causation, number, and the self.

32 Plato, *The Symposium*, p. 100.

33 Penrose, *Desire Caught by the Tail*, p. 52; Picasso, *Le Désir attrapé par la queue*, p. 55: "Cette fille est folle et cherche à nous monter le coup avec ses manigances maniérées de princesse. Je l'aime, bien entendu, et elle me plaît. Mais de ça à faire d'elle ma femme, ma muse ou ma Vénus, il y a une longue et difficile chemin à peigner. Si sa beauté m'excite et sa puanteur m'affole, sa façon de s'habiller et ses manières maniérées m'emmerdent. Maintenant, dites-moi franchment vos pensées."

34 Plato, *The Symposium*, pp. 102-103.

35 Penrose, *Desire Caught by the Tail*, p. 53; Picasso, *Le Désir attrapé par la queue*, p. 55: "Dans son court tablier noir, ses grosses savates et sa tricotée pèlerine, tous les hommes—les vieux ouvriers, les jeunes et des messieurs—à leurs regards nous apercevions bien les feux et les chandelles allumées devant l'image dévastatrice d'elle qu'ils emportaient, brûlant dans leurs mains cachées dans leur braguette le pur diamant de la fontaine de Jouvence."

36 The age of Marie-Thérèse (born 13 July 1909) when she met Picasso was for a time a matter of dispute as she was a minor and he would have faced a possible criminal charge if their relationship had been known. In fact, even Picasso's intimate friends did not know of her existence until about 1931 or 1932. See Gasman, *Mystery, Magic and Love in Picasso, 1925-1938: Picasso and the Surrealist Poets*, pp. 318-319. In an interview with Gasman in January 1972 Marie-Thérèse revealed that Picasso secretly took her on the summer holiday he spent in Dinard with his family in 1928 and kept her in a pension for children. Her image appears in much of his work from Dinard.

37 Lacan, *Le transfert*, pp. 151-178.

38 Penrose, *Desire Caught by the Tail*, p. 54; Picasso, *Le Désir attrapé par la queue*, p. 58: "Maintenant que je suis vraiment vièrge, je m'en vais tout de suite poser les affiches lumineuses de mes seins à la portée de tous et faire mon beurre d'amour aux Halles central."

39 Caws, Mary Ann, *Dora Maar with and without Picasso*, London: Thames and Hudson, 2000, p. 31. Dora also made photograms with Picasso in 1936 and 1937, the summer Picasso and Dora spent with Man Ray, Roland Penrose and Lee Miller, pp. 116-117, 133.

40 Lacan, *Le transfert*, pp. 190-195.

41 Penrose, *Desire Caught by the Tail*, p. 54; Picasso, *Le Désir attrapé par la queue*, p. 58: "Le Gros Pied, étendu sur son lit et cherchant dessous le pot de chambre introuvable, 'Je porte dans ma poche percée la parapluie en sucre candi des angles déployés [literally with its corners opened out] de la lumière noire du soleil.'"

42 Penrose, *Desire Caught by the Tail*, p. 57; Picasso, *Le Désir attrapé par la queue*, p. 61.

43 Penrose, *Desire Caught by the Tail*, p. 57; Picasso, *Le Désir attrapé par la queue*, p. 61: "Je ne suis que l'âme congelée collée aux vitres du feu. Je frappe mon portrait contre mon front et crie la marchandise de ma douleur aux fenêtres fermées à toute miséricorde."

44 Penrose, *Desire Caught by the Tail*, p. 59; Picasso, *Le Désir attrapé par la queue*, pp. 63-64: "Quand je suis sortie ce matin de l'égout de notre maison, tout de suite, à deux pas de la grille, j'ai enlevé ma paire de gros souliers ferrés de mes ailes et, sautant dans la mare glacée de mes chagrins, je me suis laissé entraîner par les vagues loin des rives. Couchée sur le dos, je me suis étendue sur l'ordure de cette eau et j'ai tenu longtemps ma bouche ouverte pour recevoir mes larmes...."

45 Penrose, *Desire Caught by the Tail*, p. 61; Picasso, *Le Désir attrapé par la queue*, p. 66: "Vous savez, j'ai rencontré l'amour. Il a des genoux écorchés et mendie de porte en porte. Il n'a plus le sou et cherche une place de contrôleur d'autobus en banlieue. C'est triste, mais va l'aider.... il se retourne et vous pique."

46 Plato, *The Symposium*, p. 82.

47 Penrose, *Desire Caught by the Tail*, p. 61; Picasso, *Le Désir attrapé par la queue*, pp. 66-67: "Voyez, je me suis mise trop longtemps au soleil, je suis couverte de cloques." [Stage directions read:] *Elle relève sa jupe, montre son derrière et saute en riant d'un bond par la fenêtre à travers les carreaux, en cassant toutes les vitres.*

48 Penrose, *Desire Caught by the Tail*, p. 63; Picasso, *Le Désir attrapé par la queue*, p. 70: "Allumons toutes les lanternes. Lançons de toutes nos forces les vols de colombes contre les balles et fermons à double tour les maisons démolies par les bombes."

49 Penrose, *Desire Caught by the Tail*, p. 63; Picasso, *Le Désir attrapé par la queue*, p. 70: "Tout les personnages s'immobilisent d'un côté et autre de la scène. Par la fenêtre du fond de la pièce, en l'ouvrant d'un coup, rentre une boule d'or de la grandeur d'un homme, qui éclaire toute la pièce et aveugle les personnages, qui sortent de leur poche un mouchoir et se bandent les yeux et, étendant le bras droit, se montrent du doigt les uns aux autres, criant tous à la fois et plusiers fois: Toi! Toi! Toi! Sur la grosse boule d'or apparaissent les lettres du mot: Personne."

50 Jacques Derrida calls attention to the double meaning of the word "bandé"—"blindfolded" and sexually "erect" or "hard"—in his essay on blindness and truth in art, *Memoirs of the Blind: The Self-Portrait and Other Ruins*, Pascale-Anne Brault and Michael Naas trans., Chicago, Il: The University of Chicago Press, 1993, pp. 12-13. Derrida compares blindfolding to a willed blindness, like a game of blind-man's buff in which the blindfolded person seeks the other. The blindfolded man leaves himself open to error and falling.

The Dialectic
The Four Little Girls, 1947-1948

51 Plato, *The Symposium*, pp. 99, 112-113. See Lacan, *Le transfert,* pp. 179-190. At the end of *The Symposium*, Alcibiades enters and changes the rules of the proceedings. Instead of praising love, the speaker is to praise the person to his right. The theme is also borne out in the three-way relationship between Alcibiades, Socrates and Agathon, the new love of Socrates and rival of Alcibiades.

52 See Pierre Daix, *Picasso: Life and Art*, p. 261.

53 Pierre Malo, in his account of a visit to Picasso's studio at the end of August 1941, observed "a mocking death's head in the place of the sponge-bowl" ("Picasseries et Picasso", *Comoedia*, 30 August 1941, p. 6). Quoted in Elizabeth Cowling, John Golding, *Picasso: Sculptor/Painter*, Tate Gallery, London, 1994, p. 274.

54 Accounts of the all-night event appear in some detail in Simone de Beauvoir, *La force de l'age*, Paris: Gallimard, 1960, pp. 655-657; and Elizabeth Roudinesco, *Jacques Lacan: Esquisse d'une vie, histoire d'un système de pensée,* Paris: Librairie Arthème Fayard, 1993, pp. 226-227.

55 Brassaï, *Conversations avec Picasso*, pp. 176-181.

1 Picasso, Pablo, *Les quatre petites filles, pièce en six actes*, (*The Four Little Girls, a play in six acts*) with a presentation by Michel Leiris on the back cover, Paris: Nouvelle Revue Française and Éditions Gallimard, 1968. The original manuscript is written in red and blue crayon on 23 double sheets of *papier vélin* covered with two plain double sheets of paper. It is kept in the archives of the Musée Picasso, Paris. The play is reproduced in *Picasso: écrits*, pp. 297-327. An English version of the play, *The Four Little Girls*, is translated by Roland Penrose, London: Calder & Boyars, 1970. The illustrations included in this volume of the little girls dancing around a maypole are studies for Picasso's *War and Peace* panels, 1952, in the deconsecrated chapel at Vallauris. I reproduce the Penrose translation with amendments where indicated.

2 See Gertje R. Utley, "Joie de vivre in a fragile arcadia", *Picasso: The Communist Years*, New Haven: Yale University Press, 2000, pp. 85-100. For a catalogue of Picasso's work for the PCF, see Gérard Gosselin, et al., *Picasso et la presse*, Paris: Editions Cercle d'Art and L'Humanité, 2000.

3 See Georges Ramié, *Catalogue of the Edited Ceramic Works 1947-1971*, Vallauris and Lyon, 1988 and *Picasso's Ceramics*, London: Thames & Hudson, 1975. See also *Picasso: Painter and Sculptor in Clay*, exh. cat., London: Royal Academy of Arts, 1998.

4 Penrose, *The Four Little Girls*, p. 70; Picasso, *Les quatre petites filles*, p. 84: "Petite Fille IV: Aujourd'hui le dix-sept du mois de mai de l'année mil neuf cent quarante-huit, notre père a pris son premier bain et hier, beau dimanche, est allé voir à Nîmes une course de taureaux avec quelques amis, mangé un plat de riz à l'espagnole et bu aux éprouvettes du vin à oenologie." Françoise Gilot describes a Sunday at the Nîmes bullfights with Picasso, his son Paulo and some of their friends, among whom were Michel Leiris and Georges Bataille They ate a customary lunch of *paella* together before the *corrida* began. See Françoise Gilot and Carlton Lake, *Life with Picasso*, New York: McGraw Hill, 1964, pp. 227-228.

5 Penrose, *The Four Little Girls*, p. 83; Picasso, *Les quatre petites filles*, p. 98: "Petite Fille III: Bouche noire du soleil remplie de cendre".

6 Penrose, *The Four Little Girls*, p. 33; Picasso, *Les quatre petites filles*, p. 34: "Petite Fille I: Voilà, un grand soleil roule lentement sur la scène jusques à nos pieds où il s'étale de tout son long et nous lèche les mains."

7 Penrose, *The Four Little Girls*, pp. 29-30; Picasso, *Les quatre petites filles*, pp. 28-29: "Petite Fille II: Nous sommes couvertes de lumière. Petite Fille IV: Nous sommes salies de lumière. Petite Fille II: Je suis brûlée. Petite Fille I: Je suis glacée de lumière."

8 See Jacques Derrida, "*Ousia* and *Gramme*: Note on a Note from *Being and Time*", *Margins of Philosophy*, Alan Bass trans., New York: Harvester Wheatsheaf, 1982, pp. 29-67. Derrida demonstrates that Aristotle's concept of time is a 'vulgar paradox'. In his analysis of the nature of space and time, Derrida continues, Aristotle presents the possibility that time can be denied, based on the division of time into parts, none of which exist in the present (pp. 39-40). Hegel's "Philosophy of Nature" conceives Aristotle's paradox as a dialectic created by space negating, or doubling itself. The first negation is the point, and with each negation, the point becomes the line, and the line, the plane. As Derrida argues, Aristotle's paradox, reiterated in the texts of Kant, Hegel and Bergson, cannot be resolved with the tools of classical metaphysics.

9 Clark, Kenneth, *The Nude: A Study of Ideal Art*, Harmondsworth: Penguin Books, 1986, p. 13.

10 Penrose, *The Four Little Girls*, pp. 81-82; Picasso, *Les quatre petites filles*, p. 82.

11 Penrose, *The Four Little Girls*, pp. 18, 21; Picasso, *Les quatres petites filles*, p. 15: "Petite Fille I: Arrangez-vous, arrangez-vous la vie. Moi j'enveloppe la craie de mes envies du manteau déchiré et plein de taches de l'encre noire coulant à gorge ouverte des mains aveugles cherchant la bouche de la plaie."

12 Penrose, *The Four Little Girls*, p. 17; Picasso, *Les quatre petites filles*, p. 13: "Nous n'irons plus au bois, et les lauriers sont coupés voilà ira les ramasser. Entrons dans la danse, voilà comme on danse, dansez, chantez, embrassez qui vous voudrez."

13 The song "Les lauriers sont coupés" provides the title for the Symbolist writer Edouard Dujarin's 1888 novel, renowned as the supposed prototype of the interior monologue used by James Joyce. Dujardin's novel describes the unsuccessful attempts of a young Parisian man to court a pretty girl.

14 Penrose, *The Four Little Girls*, p. 21; Picasso, *Les quatres petites filles*, p. 16: "Arrange tes cheveux, ils flament et vont mettre le feu à la chaine de révérences grattées à la chevelure emmêlée des cloches léchées par le mistral."

15 Penrose, *The Four Little Girls*, p. 21; Picasso, *Les quatres petites filles*, p. 16: "Vous ne m'aurez pas vivante et vous ne me voyez pas. Je suis morte."

16 Penrose, *The Four Little Girls*, p. 25; Picasso, *Les quatres petites filles*, p. 22: "Tu ne me feras pas croire—et si je dis croire j'exagère—que son départ et la synthétique projection de son image soit même diluée dans le bouillon imaginaire de cet après-midi sujet à suite d'éclatantes révélations et audacieuses discussions cursives."

17 Penrose, *The Four Little Girls*, pp. 22-23; Picasso, *Les quatre petites filles*, pp. 18-19: "Petite Fille II: Je cueille les pamplemousses, je les mange, je crache les pépins, je m'essuie du revers de la main les lèvres et j'allume les festons des lanternes de mes rires, les incomparables fromages que je vous prie d'agréer bien sincèrement à vos pieds et je signe."

18 Penrose, *The Four Little Girls*, pp. 61, 65, 67; Picasso, *Les quatre petites filles*, pp. 74, 75, 79: "Petite Fille IV: soleil écrasé sur l'étoffe brodée en amande au plat de riz"; "drap de lit plié en diagonal festonné d'oeillets et d'iris"; "robe de soie... bordée de branches de mimosas, d'héliotropes, de narcisses, d'oeillets, d'épis de blé".

19 The notion that the world is rational and ordered and that order is intrinsic to nature itself and not the work of the divine, comes from the pre-Socratics. See Jonathan Barnes, *Early Greek Philosophy*, Harmondsworth: Penguin Books, 1987, pp. 16-17.

20 Penrose, *The Four Little Girls*, p. 25; Picasso, *Les quatre petites filles*, p. 23: "La pluie qui monte peu à peu dure déjà dix siècles et compose méticuleusement la page peinte si minutieusement à petits signes et lignes torves défaisant et noeuds gordiens et fiches anthropométriques, toutes responsabilités et conséquences du jeu imposé de l'autre rive,—là elle nous a donné tant de joies...".

21 Penrose, *The Four Little Girls*, p. 34; Picasso, *Les quatre petites filles*, p. 36: "Petite Fille II: Les spirales des citrons, le grand carré blanc des oranges, les losanges en citron, des ovales parfaits, des cercles exaspérés des roses lilas des tomates chantées, chuchotées par l'olive du violet caché dans le sirop de mûres."

22 Penrose, *The Four Little Girls*, pp. 41-42; Picasso, *Les quatre petites filles*, pp. 45-46: "Petite Fille III: elle descend les marches de la maison, tenant une poupée plus grande qu'elle attachée par des chaînes de guirlandes de fleurs et de feuilles; un tablier jaune. Oiseau blanc à carreaux bleu amarante et bleu citron, ligne perpendiculaire du bleu azuréal moyen irritant du blanc répandu à grands cuillerées sur la tache lilas du large jaune citron répandu corps et biens sur l'ogive fermée du centre éclatant du grand cercle fermé à double tour des laques émeraude du silence caché entre les plis de l'oeuf pondu par la chèvre. (Elle arrange la poupée enchaînée par les guirlandes de fleurs dans la barque et l'attache au mât, se couche par terre sur le dos et tette la chèvre en la caressant.) Beau jeune homme, bel amoureux, mon amant, mon soleil, mon courroux, mon centurion, mon cheval furieux, mon mensonge, mes mains de beurre en spirale, la délicieuse montée et la descente attachée aux chaines du manège à la fête citron pressé dans la gueule fermée de l'acide nitrique de la tendre colombe qui s'ouvre en éventail au centre de la fournaise du baquet de goudron qui fume. (Elle se relève, détache la chèvre et l'égorge, la prend dans ses bras et danse.)"

23 See Sarah Wilson, "Paris Post War: In Search of the Absolute," *Paris Post War: Art and Existentialism 1945-55*, London: Tate Gallery, 1993, pp. 33-34.

24 Aristotle's *Physics* (203b6-11, 13-30) quoted in Barnes, *Early Greek Philosophy*, pp. 75-76.

25 Penrose, *The Four Little Girls*, p. 44; Picasso, *Les quatre petites filles*, p. 49: "Petite Fille IV: Ici la page est blanche, vide, éteinte. Le silence enveloppe de cendre ses pas, une grande flaque blanche molle dépose de ses doigts pâles son crachat sur le bord du drap tendu sur le cadavre."

26 Penrose, *The Four Little Girls*, p. 74; Picasso, *Les quatres petites filles*, p. 86: "Petite Fille IV: Silence dévêtu des foules des lampes d'argent ardentes l'éclairant à giorno de ses coups d'éventail, la danse qui choit sur la fleur qui se noie détaille ses rires au creux de sa main détachant la boucle de sa sandale."

27 Penrose, *The Four Little Girls*, p. 82; Picasso, *Les quatres petites filles*, p. 97: "Petite Fille III: Le vide sort ses griffes et mord au voile tendu devant l'image."

28 Penrose, *The Four Little Girls*, p. 82; Picasso, *Les quatres petites filles*, p. 97: "Petite Fille I: Le silence s'étire sur la bulle de savon du rêve enseveli dans les acrobaties versées des palmes fouettées durement jusqu'au sang."

29 Penrose, *The Four Little Girls*, p. 83; Picasso, *Les quatres petites filles*, p. 99: "Petite Fille I: Fenêtre ouverte au blanc immaculé de la page marquée au centre du miel d'abeilles du mot rire...".

30 Penrose, *The Four Little Girls*, p. 89; Picasso, *Les quatres petites filles*, p. 109: "Les Quatre Petites Filles, lisant dans un livre.—la porte ouverte de l'oubli frappant contre le ciel ses mares puantes—".

31 Penrose, *The Four Little Girls*, p. 56; Picasso, *Les quatres petites filles*, p. 65: "Petite Fille IV: L'ombre de l'aube marque de l'ongle au coin de la page son bouquet d'anénomes."

32 Penrose, *The Four Little Girls*, p. 61; Picasso, *Les quatres petites filles*, p. 73: "Petite Fille IV: Le matin trempe ses allusions et ses chars blonds d'âcres acidulées rampantes étoiles aux pattes noires des axes, pointes et virgules fixés à la croisée détachées hurlante de tant d'ocres et pâles festons défaits aux fentes de poussières et raies huilant la marche du puits jeté au feu, approvisant le gris éclatant, pourvoyant la courge cueillie au piège, ses éclaboussantes illusions et ses allusions mensongères aux rideaux cachés à la cantonade."

33 Penrose, *The Four Little Girls*, p. 74; Picasso, *Les quatres petites filles*, p. 87: "Changement de décor. La scène est peinte en blanc; rideau de fond, coulisses, herses sont couverts de toutes les lettres de l'alphabet et de chiffres en gros caractères peints de toutes les couleurs. Le sol est aussi peint de la même façon. Au milieu, un lit où les trois petites filles I, II, IV sont couchées. D'énormes chiens ailés rôdent sur la scène autour du lit."

34 Penrose, *The Four Little Girls*, p. 75; Picasso, *Les quatres petites filles*, p. 88: "Sautent les petites filles du lit, nues. Elles étendent par terre un grand lac bleu entouré de fleurs et s'y baignent. Du milieu du lac sort la petite fille III nue aussi, les cheveux couverts de fleurs et entourée de fleurs au cou, aux poignets, aux chevilles, à la ceinture; elle danse au milieu, tenant la poupée dans ses bras et tenant la chèvre en laisse. Les chiens ailés s'envolent. Des reporters photographes entrent en foule et photographient de tous cotés la scène. Le rideau tombe."

35 See Penrose, *Picasso: His Life and Work*, pp. 312-314.

36 See Derrida and Maurizio Ferraris, *A Taste for the Secret*, pp. 138-142.

37 Penrose, *The Four Little Girls*, p. 51; Picasso, *Les quatres petites filles*, p. 57: "Petite Fille II: La cendre jetée en pâture aux aigles du poulailler font de bronze des ailes du cheval traînant la charrue sur le chant de diamant et enchaîne aux lanternes les mélodies de la pointe du burin griffant le miel du cuivre."

38 Penrose, *The Four Little Girls*, p. 57; Picasso, *Les quatres petites filles*, p. 66: "Petite Fille II: Gribouillis, gribouillis, gribouillis passant l'éponge mouillée de craie sur l'air et la chanson...".

39 Penrose, *The Four Little Girls*, p. 66; Picasso, *Les quatres petites filles*, p. 78: "Petite Fille I: Voici la note: trois paquets de fil blanc à coudre et repriser à point mort la catastrophique image révélée par l'acide, à chaque marche le genou éclairant la route d'écorchures."

40 See Jacques Derrida, "To Unsense the Subjectile", *The Secret Art of Antonin Artaud*, 1998, pp. 136-145. Derrida discusses Artaud's attack on the subjectile by sewing, which involves piercing, perforating, penetrating the skin, and stitching, in the surgical sense, Derrida suggests, leaving scars. Artaud writes: "The figures on the inert page said nothing under my hand. They offered themselves to me like millstones which would not inspire the drawing, and which I could probe, cut, scrape, file, sew, unsew, shred, slash, and stitch without ever complaining through father or through mother." (text of February 1947). Derrida himself uses the phrase "the catastrophe of the subjectile" for the frenzied attacks Artaud carries out on the surface (p. 144).

41 Derrida theorises the notion of "catastrophe", a violent change that occurs by chance to overturn a system, such as the system of representation or language. The concept comes from Lucretius and the atomist philosophers, a tradition that has particular relevance in modern science. Picasso's poetic descriptions have a striking affinity with the ideas of Lucretius in *On the Nature of Things*, an epic poem that attempts a rational, rather than a religious explanation of the origin of nature. See Christopher Johnson, *System and Writing in the Philosophy of Jacques Derrida*, Cambridge: Cambridge University Press, 1993, pp. 112-117, 161.

42 Penrose, *The Four Little Girls*, p. 90; Picasso, *Les quatres petites filles*, p. 111: "Petite Fille II: La rose de l'oeillet rit de toutes ses dents l'histoire. Elle écoute et déja réfléchit aux conséquences finales de fils tressés si finement pour faire écran et table rase de toute rage contenue aux si longuement attendues aurores."

43 See Ferraris, "What is There?", Derrida and Ferraris, *A Taste for the Secret*, Cambridge: Polity Press, pp. 136-144. Ferraris, responding to Derrida's notion of the "trace", examines the *tabula* as the mediator between mind and world, or any binary concept.

44 Penrose, *The Four Little Girls*, p. 84; Picasso, *Les quatres petites filles*, p. 100: "Petite Fille II: Salaison d'anchois des larges routes de souvenirs hachés menus sur le marbre couvert de graffiti de tant d'aurores".

45 Ferraris, "What is There?", p. 138.

46 Ferraris, "What is There?", pp. 139-140.

47 Ferraris, "What is There?", pp. 144-145. Ferraris, with reference to Derrida (*Khora*), defines the chora as "the pure potency of retention that is at the origin of all construction".

48 Ferraris, "What is There?", pp. 138-139.

49 Penrose, *The Four Little Girls*, p. 94; Picasso, *Les quatre petites filles*, pp. 112-113: "La nuit tombe. Des étoiles. La lune. Tous les astres. Des grillons. Des grenouilles, des crapauds. Quelques cigales. Des rossignols. Des lucioles. Un intense parfum de jasmins remplit la salle et on entend au loin aboyer un chien. Après, tout le jardin s'allume, chaque feuille est une flamme de bougie, chaque fleur est un lampion de sa couleur, chaque fruit est une torche et les rubans des branches des arbres sont en lumières de différentes flammes. Les étoiles filantes tombent du ciel en harpons et plantent leurs épées qui s'ouvrent en rosaces et en coupes de feu. Les quatres petites filles jouent à saute-mouton et rient, rient et chantent."

50 Penrose, *The Four Little Girls*, p. 94; Picasso, *Les quatres petites filles*, pp. 113-114: "Elles se couchent par terre et s'endorment. Des arbres, des fleurs, des fruits, partout le sang coule, qui fait des flaques et inonde la scène. Poussant de terre, formant un carré, quatre grandes feuilles blanches enferment les quatre petites filles. Par transparence, en tournant, apparaîtront successivement, écrits dans chacune des feuilles, 'PETITE FILLE I', 'PETITE FILLE II,' 'PETITE FILLE III', 'PETITE FILLE IV'."

51 Penrose, *The Four Little Girls*, p. 95; Picasso, *Les quatres petites filles*, p. 114: "Noir complet. Après lumière, la scène: la remplissant entièrement, intérieur d'un cube entièrement peint en blanc, au milieu par terre un verre plein de vin rouge."

52 For a discussion of the geometric graph (a Klein Group, Lévi-Strauss's "structure", Lacan's L Schema) at the origin of modernist or abstract art (the grid, the monochrome, the all-over, the *mise-en-abyme*), its logic and its ideologies, see Rosalind Krauss, *The Optical Unconscious*, Cambridge, MA: London, England, The MIT Press, 1993, pp. 13-27.

53 See Francoise Gilot and Carlton Lake, *Life with Picasso*, McGraw-Hill, Inc., New York, 1964, p. 210.

The Phantom
The Burial of the Count of Orgaz, 1957-1959

1 Parmelin, Hélène, *Picasso dit*, Paris: Editions du Cercle d'Art and Editions Gonthier, 1966, pp. 14-15. Parmelin, the wife of the Communist painter Edouard Pignon, was close to Picasso in the last two decades of his life.

2 See Anne Baldassari, *Picasso and Photography: The Dark Mirror*, Deke Dusinberre trans., Paris: Flammarion, 1997.

3 See Bernard Stiegler and Jacques Derrida, *Echographies of Television: Filmed Interviews*, trans., Jennifer Bajorek, London: Polity Press, 2002, pp. 96-98; 113-121. "Echographies", the French word for "ultrasound" (see Ch. 6, note 4, p. 170), draws together the discourses of teletechnology, replication, inheritance, the phantom, belief and knowledge. On the subject of the phantom or spectre and representation, Derrida refers to Roland Barthe's *Camera Lucida: Reflections on Photography* (Richard Howard trans., London: Johathan Cape, 1982).

4 See Jacques Derrida, *Deconstruction Engaged: The Sydney Seminars*, eds., Paul Patton and Terry Smith, Sydney: Power Publications, pp. 77-78. Derrida refers to the possibility that "technology or *techné* is already originally in place in our own body".

5 See Baldassari, *Picasso and Photography: The Dark Mirror*, p. 22. As Baldassari has discovered in her research, Picasso worked from reproductions from his early career. A print of *The Burial of the Count of Orgaz* from Picasso's art school days was found among his store of reproductions of Old Masters. The print was faded, due probably to the fact, according to Baldassari, that it had hung for a long time on his studio wall.

6 Picasso, Pablo, *El Entierro del Conde de Orgaz*, Barcelona: Editorial Gustavo Gili, SA, (Ediciones de la Cometa), 1969, a boxed edition with 12 etchings and three aquatints of 1966-1967, plus an etching of Picasso's poem-drawing "Trozo de almíbar" ("Piece of Syrup"), and an introduction by Rafael Alberti, "No digo más que lo que no digo" ("I'm not saying more than I'm saying"). The covering page, designed by Picasso especially for the edition, bears the title and the author's name drawn thickly in Indian ink, underneath which is depicted a flying kite, the date 23.4.69, and some indistinct words. The manuscript, known only in its facsimile version, is written in green, blue, red and black pencil on 11 sheets of *papier vélin* folded in half, in Picasso's trademark child-like scribbling. A French version, *L'Enterrement du Conte d'Orgaz,* translated and with a coda by Alejo Carpentier, was published by Gallimard in the *serie blanche* in 1978. The text appears in *Picasso: écrits*, pp. 350-367.

7 These engravings form part of a larger series of 68 works dated between 6 November and 19 December 1966, 12 of which illustrate an edition of Jean Cocteau's play, *Le Cocu magnifique* (Editions de l'Atelier Crommelynck, 1968). Some of the titles refer to the "cocu" or cuckold and have theatrical settings.

8 See Mikhail Bakhtin's *Rabelais and His World*, Helene Iswolsky trans., Cambridge, MA: MIT Press, 1968. Picasso's *Burial of the Count of Orgaz* can be characterised as 'carnivalesque', a term that originates with the Russian linguist and dissident Mikhail Bakhtin. For Bakhtin, the carnivalesque is a primordial force and an organising principle of representation, even of life itself (p. xviii). He developed his theories on the carnivalesque in 1934-1935 during the Stalinisation of Russian culture and the establishment of Socialist Realism as the state-dictated style, which he opposed. See also Julia Kristeva, "Word, Dialogue and Novel", *Desire in Language: A Semiotic Approach to Literature and Art*, Leon S. Roudiez, ed., Oxford: Basil Blackwell, 1982, pp. 82-89. Kristeva introduced Bakhtin's theories to the Parisian avant-garde through her writings on linguistics and psychoanalysis.

9 The anonymous picaresque novel *Lazarillo de Tormes* (c1555), the satirical 'autobiography' of an ignorant serving boy and his rise in the social order, and Cervantes's *Don Quijote* (1605, 1615), the first modern novel, are the direct antecedents of the *Burial*.

10 Leiris, Michel, "Picasso the Writer, or Poetry Unhinged," *Picasso: Collected Writings*, New York: Abbeville Press, p. xi.

11 "A.M." is an abbreviation of "Alpes Maritimes", a postal address that refers to the region where the mountains meet the Mediterranean.

12 See John Richardson, *A Life of Picasso: Vol I, 1881-1906*, New York: Random House, 1991, p. 33.

13 *Picasso: écrits*, pp. 351-352:
"1 aquí no hay más que aceite y ropa vieja.
2 hijo de puta puta cuco y recuco tajo reuma de lobo y búho cojo.
0 niño de flores pestañejas y comidilla encima del cartón de afeites del clavo torcido abierto por la punta del cuchillo.
2 ratoncito Pérez vestido de cura regando la piel del traje de tinieblas
1 a la fin de que habiendo recibido el sobre abierto y sin sello se lo pueda comer el cartero o su abuela sin tener que darle cuentas a nadie tan contento."

14 *Picasso: écrits*, pp. 351-352:
"2 yo no digo que lo que no digo no lo digo por decir que no lo digo.
1 un montón de digo un montón de dime un montón de decir de no decir como un montón de castañuelas rezando sus antorchas y sus huevos fritos muy despacito."

15 *Picasso: écrits*, p. 352:
"1 se sabe lo que se sabe se sabe lo sabido lo que ya no se sabe es sabido y olvidado lo que es sabido y no vivido lo visto lo entrevisto lo nunca visto y lo querido ver y visto en una mancha de vino encima de la mesa debajo del vaso vacío al lado de un cuchillo y de unas migajitas de pan
2 yo lo he creído así otra vez la luz se apaga si la enciendes la luz no necesita luz para ver claro
1 no digas tonterías baila y canta y no me cuentes cuentos Cachupino [a *cachupín* was a Spanish settler in the New World]."

16 For an analysis of the *nouveau roman*, see the essays in Alain Robbe-Grillet, *Pour un nouveau roman*, Paris: Les Editions de Minuit, 1961.

17 Prince, Gerald, "The Nouveau Roman", *A New History of French Literature*, Denis Hollier ed., Cambridge, MA: Harvard University Press, 1989, p. 988.

18 Prince, "The Nouveau Roman", p. 991. For an analysis of the 'modernity' of the Hispano-Arabic tradition in Spanish literature, see Juan Goytisolo, "Medievalism and Modernity: the Archpriest of Hita and Ourselves", *Saracen Chronicles*, Helen Lane trans., London, Quartet Books, 1992.

19 "12.1.57", *Picasso: écrits*, p. 352: "le vide le plus complet sur la scène personnages 0—00—le plus important complètement en dehors de la question des signes convenu pica pica y matasuegras."

20 "27.1.57", *Picasso: écrits*, p. 352: "apparition du vieux con et recherche dans les boîtes à ordures du peu et trop de réalité du quain quain fête nationale feux d'artifice bals défilés militaires et ecclésiastiques illuminations"

21 Beckett's *Endgame* (*Fin de partie*), directed by Roger Blin, was in rehearsal in Paris in December 1956 and January 1957 and opened at the Royal Court in London in April 1957. See James Knowlson, *Damned to Fame: The Life of Samuel Beckett*, London: Bloomsbury, 1996, pp. 431-433.

22 See Robbe-Grillet, "Samuel Beckett ou la présence sur la scène", *Pour un nouveau roman*, pp. 95-107.

23 Mérimée, Prosper, *Carmen*, Paris: La Bibliothèque Française, 1949. Picasso provided 38 engravings and four sugar aquatints, dating from May to November 1948, for this edition.

24 *Picasso: écrits*, p. 353. "14.8.57": "Don Diego Firme Don Ramón Don Pedro Don Gonzalo Don Juez Don Peregrino Don Flavio y Don Gustavo y Don Rico Don Clavel Don Morcilla y Don Rato Don Ricardo Don Rugido Don Gozo Don Rubio Don Moreno Don Cano al borde de la circunferencia abierta comen la seda que llueve el caño que se maman a gritos los hilos de oro del festín de mochuelos las franjas de agujas plantadas boca abajo encima de la mesa llena de onzas de plata encima a izquierda del abanico de refrescos puesto a la ventana que da al puerto lleno de jazmines los trozos de leño de las casullas y las patas de gallo del rebaño longanizan las llaves del plumero de aceite de los cantos y chirridos que cuecen entre los dedos de las alas de la cabra."

25 See Richardson, *A Life of Picasso: Vol I*, p. 213. Picasso parodies El Greco's *The Burial* in two other works. *The Burial of Casagemas (Evocation)*, 1901, depicts nudes and prostitutes above the shrouded body of Picasso's friend Casagemas, who committed suicide. An etching from the *347* series, 30 June 1968 (I), portrays El Greco's son holding a platter of chicken, with a nude Virgin Mary on the left-hand side and a disproportionately large portrait head of El Greco on the right.

26 *Picasso: écrits*, p. 353. "14.8.57": "La mujer del cartero se fue con su primo a los toros, el cartero se las guilló con la hermana de su cuñada Amalia y el sobrino ni se supo lo que hizo durante toda la tarde y a qué hora llegó a su casa. No fue aquella noche ni al día siguiente cuando se armó el lío sino el día del santo de la tía Regüeldo en medio del banquete que estalló el merengue. La hija del Perdaguino de la blusa se tiró un pedo y sacándose de la blusa las tetas se levantó las faldas y nos enseñó el conejo. Figúrate la cara del cura y las mañas del sobrinito las chicas del cabrero las putillas de enfrente y las monjas se hacían cruces y se morían de risa de tantos relámpagos y truenos"

27 Richardson, *A Life of Picasso: Vol. I*, p. 451.

28 See Richardson, *A Life of Picasso: Vol. I*, pp. 438-448.

29 See Baldassari, *Picasso and Photography: The Dark Mirror*, pp. 74-77.

30 "14.8.57", *Picasso: écrits*, pp. 353-354: "las cuatro niñas en sus camas enterrando al Conde de Orgaz el niño tocando el piano colgando atado por el cuello montado a caballo vestido de cocinero con su bonete (de luto) tiene en su mano izquierda una sartén como escudo—(el caballo gualdrapas negras y plata) esto no tiene nada que ver con las Meninas

colgando de los dos garfios del techo un jamón y chorizos

Modesto Castilla hijo natural de D. Ramón Pérez Cortales

D. de S. y V. poniendo su paleta-espejo enfrente del espejo clavado en la pared en el fondo del cuarto

el personaje en la puerta es Goya pintando haciéndose un retrato con su sombrero bonete de cocinero y sus pantalones rayados como Courbet y yo—sirviéndose de una sarten como paleta

la cuarta niña empezando por la izquierda montada

sobre un caballo de gualdrapas negras y adornos
de plata arreglada de picador

encima del cuadro un mochuelo que vino una noche
a matar palomas en el cuarto donde pinto

todos los palomos

sobre las teclas del piano la colilla de un cigarrillo
encendido
y los dos guardias civiles detrás de las Meninas

en el cielo del entierro del C. de Orgaz Pepeillo–
Gallito y Manolete

en sus camas las Meninas juegan a enterrar al
Conde de Orgaz"

31 Penrose, *Picasso: His Life and Work*, p. 374.
32 Parmelin, *Picasso dit*, p. 42.
33 Penrose, *Picasso: His Life and Work*, p. 322.
34 Penrose, *Picasso: His Life and Work*, p. 370.
35 See Richardson, *A Life of Picasso: Vol I*, p. 191.
36 See Françoise Gilot and Carlton Lake, *Life with Picasso*, London: Virago, 1990, p. 193. Gilot recounts that on a special trip to the Louvre with Picasso in 1949 he was invited to compare one or two of the paintings he had donated to the French state and which were held in store there to, among others, Courbet's *The Studio*.
37 Picasso, *Les Ménines de la vie*, Jaime Sabartès, preface.
38 For an art historical analysis of *Las Meninas*, see Jonathan Brown, "The Meaning of *Las Meninas*", *Images and Ideas in Seventeenth-Century Spanish Painting*, Princeton, New Jersey: Princeton University Press, pp. 87-110.
39 See Picasso's 1923 interview with Marius de Zayas, "Picasso Speaks", reproduced in Herschel B Chipp, *Theories of Modern Art*, Berkeley, Los Angeles: University of California Press, 1968, p. 264. (Originally published in English in *The Arts, vol 3*, May 1923, New York, pp. 315-326.)
40 Picasso, *Les Ménines de la vie*, Jaime Sabartès, preface, Paris: Editions Cercle d'Art, 1958, n.p..
41 Leiris, Michel, "Picasso and *Las Meninas* by Velázquez", *A Picasso Anthology: Documents, Criticism, Reminiscences*, Marilyn McCully, ed., with Michael Raeburn, trans., London, 1981, p. 255. (Originally published in *Picasso: Les Ménines 1957*, Galerie Louise Leiris, Paris, 1959, n.p.)
42 Brown, "The Meaning of *Las Meninas*", pp. 101-102.
43 Brown, "The Meaning of *Las Meninas*", p. 109.
44 I refer to the tendency towards the 'scientific' and the objective in the human sciences, which took its lead from Claude Lévi-Strauss's *Elementary Structures of Kinship*, revised ed., James Harle Bell, John Richard von Sturmer and Rodney Needham trans., London: Eyre & Spottiswoode, 1969 (Paris, Presses Universitaires Françaises, 1949).
45 Brown, "The Meaning of *Las Meninas*", pp 97-98. *Las Meninas* can be interpreted within the context of baroque illusionism, in which Velázquez, who had architectural training, was well versed.
46 Foucault, Michel, *The Order of Things: An Archaeology of the Human Sciences*, London: Routledge, 1991, pp. 3-16. See also Chapter 3, "Representing", pp. 46-77.
47 Foucault, *The Order of Things*, p. 9.
48 Foucault, *The Order of Things*, p. 9.
49 Brown, "The Meaning of *Las Meninas*", p. 91.
50 Brown, "The Meaning of *Las Meninas*", pp. 92-93, 98-99.

51 Foucault's methodology in *The Order of Things*, a new approach to the history of knowledge based on "archaeology", displaces the human subject as the object of knowledge.
52 Leiris, "Picasso and *Las Meninas* by Velázquez", p. 255.
53 Leiris, "Picasso and *Las Meninas* of Velázquez", p. 257.
54 Leiris, "Picasso and *Las Meninas* of Velázquez", p. 257.
55 Leiris, "Picasso and *Las Meninas* of Velázquez", p. 257.
56 Picasso produces one small painting of the Infanta on 30 December 1957 to complete the *Meninas* series. In December he also begins his commission for a mural for UNESCO, *The Fall of Icarus*, completed September 1958.
57 *Picasso: écrits*, pp. 360-361: "pero a estas horas ya de las chicas de abajo hasta la tía Juana borrachas todas y rascándose la cosa y desnudas de día de fiesta no hacían más que mirar el reloj y abanicarse el chocho con las ganas que tenían de fornicar todas con el primer cartero que llegase a la alcaldía con su burro a cuestas y su mujer dentro de la barriga a armar la de San Quintín con los muchachos del puerto que aquí ya no hubo más manera que hacer frío de lo caliente y caliente de lo frío y encender farolillos y los pitos de bengala y freír los buñuelos y los churros en la sartén de lágrimas rodando sus cañas de azúcar por esos trigos y no fue lío el que se armó cuando la Filomena se puso de pie encima de la mesa y empezó a mearse y hacer nudos con las banderillas de luto de los fideos la más fea y la más rica contando y recontando sus penas cantaba la copla de los dedos debajo de la mesa con su primo pero el muy majadero del tío Gumersindo haciendo como el que no le ve se subió de prisa y corriendo al monte puso sus redes en las matas y sin reclamo ni jilguero lanzó el cimbel y sus enredos y allí fue lo gordo y lo mejor del cuento ni hubo tiros ni suspiros la chica no estaba para dramas ni comedias y el cuento de nunca acabar ya estaba seco y rancio y la espuma que lo esmaltaba olía a jazmines y a claveles y a nardos que el frío que estallaba el desnudo del santo crujía y aplastaba la carne del saco lleno de agua que paseaba la ojiva de la espalda trasera del montón de tejas rotas tiradas al borde del mar de rocas del carbón azul de su mirada la muy picarona que es así como le gustan al cura sus huevos fritos y sus papas capítulo primero ojo de búho crudo aquí sigue y enchufa la novela por esta vez no muy lista ni tonta y no muy ejemplar pues la carta llegada y puesta al mismo día al buzón sin sello ni trompeta hizo el ramo de oliva y la paloma como el que se traga un hueso y se chupa la planta del pie como un besugo y qué lástima que después de tantos gritos y fandangos las niñas del señor cura pudiesen sacar sus bellezas y mañas del catre de chinches cuando se rompió el agujero por en medio que ni la más lista hubiese hecho mejor a pesar de los pesares en la cama–cartel de toros noche a noche a noche los trigos verdes y el dorado del marco azul intrigan detrás del velo de la persiana abierta la puerta cerrada de sus ojos negros pero mucho antes más que a la luz que estercola el blanco de terciopelo que roe la hoja de la navaja tiembla y rueda la llama del candil sobre la mitad de la mano puesta patas arriba sobre el trozo de tapiz de la seda de su brazo extendido a lo largo del arroyo de la pluma dibujando del color de su recuerdo su voz de arco iris y el perfume de soles fritos y el olor de pescado y sandía y el aire de cigarro puro y almejas y albahaca más tarde a las dos y media o las tres de la madrugada al lado de la playa en Barcelona en la Barceloneta una noche de San Juan envuelta en trozos de papel de seda".

58 For a similar approach to writing, see the nouveau roman novelist Robert Pinget's *Mahu ou le Matériau* (*Mahu or the Material*, 1952, cited in Robbe-Grillet, "Un Roman qui s'invente lui-même", *Pour un nouveau roman*, pp. 108-112.
59 *Picasso: écrits*, p. 366: "Esta familia es un ejemplo y aun hoy se cuentan muchas cosas que verdad o mentira hay que tener en cuenta para hacer la reseña de la corrida de esta humanidad primitiva de tarjeta postal."
60 The final passage of the *Burial* expresses a strikingly modern idea, summed up in the words of Roland Barthes, that the text is "a construction of layers (or levels, or systems), whose body contains, finally, no heart, no kernel, no secret, no irreducible principle, nothing except the infinity of its own envelopes— which envelop nothing other than the unity of its own surfaces". Quoted in Jonathan Culler, *Barthes*, London, Fontana Press, 1990, pp. 82-83. (Originally published in "Style and its Image", *Literary Style: a Symposium*, S Chatman, ed., New York, Oxford University Press, 1971, p. 10.)
61 Cooper, Douglas, *Les Déjeuners*, Paris, Cercle d'Art, 1962. The large series comprises 27 paintings, 140 drawings, three lino-cuts, as well as ten cardboard maquettes for sculptures dated August 1959-July 1962.
62 One theory of Velázquez's *Las Meninas* has it that the painting, due to its realism and spontaneity, is itself a kind of snapshot, the depiction of an impromptu family gathering that interrupts the painting of the formal portrait of the King and Queen. See Brown, "The Meaning of *Las Meninas*", p. 88. See also Picasso, *Les Ménines de la vie*, Sabartès, preface, n.p..
63 See Bernard Stiegler, "The Discrete Image" in *Echographies of Television*, pp. 153-163.
64 On this "technological" experience of seeing proper to the body itself, refer once again to Derrida, *Deconstruction Engaged*, p. 78.
65 See Baldassari, *Picasso and Photography: The Dark Mirror*, pp. 74-124. See also Rosalind E Krauss, *The Picasso Papers*, London: Thames and Hudson, 1998, pp. 89-212. Krauss analyses the effect of the 'photomechanical' on Picasso's work, c1915-1920, particularly his 'photographic' portraits and his late cubist collage.
66 See Man Ray, "Picasso Photographe", *Cahiers d'art*, nos. 6-7, 1937, p. 165.
67 Parmelin, Hélène, *Picasso dit*, pp. 130-134.
68 Krauss, Rosalind, *The Optical Unconscious*, Cambridge, MA: The MIT Press, 1993, pp. 197-202. Picasso owned a television from 1961 onwards and this medium is associated with his work at Nôtre-Dame-de-Vie, his farmhouse and studio, from that year.
69 Krauss, *The Optical Unconscious*, pp. 223-233. Krauss refers to the *Dejeuners* sketchbooks of July 1961.
70 Parmelin, Hélène, *Picasso dit*, p. 54-57, 69. Poussin's painting, along with that of David, form the basis of Picasso's series *Rape of the Sabines*, after Poussin, 1962-3. The paintings, a *Guernica* or *War and Peace* for the time, was exhibited at the Salon de Mai under the auspices of the French Communist Party in May 1963.
71 Parmelin, *Picasso dit*, p. 54.
72 Parmelin, *Picasso dit*, pp. 53-54.
73 Parmelin, *Picasso dit*, p. 54.
74 Stiegler and Derrida, "Spectrographies", *Echographies of Television*, pp. 113-121. Barthes' commentary in *Camera Lucida*, cited here, takes as a point of departure the author's viewing a photograph of his mother, who had recently died.

75 See Jacques Derrida, *Deconstruction Engaged:*
 The Sydney Seminars, pp. 76-77. In his discussion
 of technology and inheritance, Derrida distinguishes
 between passive repetition and "iterability", which
 means "repetition and difference, and alteration, and
 singularity". An active transformation of what is
 inherited must take place, as with Picasso. "So at
 the heart of the experience of inheritence you have
 a decision to reaffirm, to select, to filter and to
 interpret," Derrida writes.

Coda

76 Picasso, Pablo, "Statement 1923", *Theories of*
 Modern Art, Herschel B. Chipp, ed., pp. 264-265.
 (Quoted from "Picasso Speaks", interview with
 Marius de Zayas, *The Arts*, New York, May 1923,
 pp. 315-326.)

Picture credits

Introduction

The Crucifixion, 7 February 1930, Musée Picasso, Paris, 51.5 x 66.5 cm, © Photo RMN–René-Gabriel Ojéda, Succession Picasso/DACS 2004.

All other images in the Introduction are thumbnails of images reproduced in the rest of the book.

Melancholia, Metaphysics, Measurement

Albrecht Dürer, *Melencolia I*, 1514, 23.9 x 16.8 cm, © The British Museum.

Minotauromachia, March-April 1935, Musée Picasso, Paris, 50 x 70 cm, © Photo RMN–Gérard Blot, Succession Picasso/DACS 2004.

Halasz Gyula Brassaï, *Entrance to Boisgeloup* (*Entrée a Boisgeloup*), 1932, Musée Picasso, Paris, © Photo RMN–Daniel Arnaudet, Estate Brassaï–RMN.

The Rotten Sun

Boisgeloup 18 avril XXXV, page I, 18 April 1935, Musée Picasso, Paris, © Photo RMN–Madeleine Coursaget, Succession Picasso/DACS 2004.

"9, 11 octobre XXXVI", *Study of head and two toothed eyes* (*Etude de tête et deux yeux dentés*), 9, 11 October 1936, Musée Picasso, Paris, © Photo RMN–Béatrice Hatala, Succession Picasso/DACS 2004.

Vincent Van Gogh, *The Sower*, 1888, © Van Gogh Museum/Vincent Van Gogh Foundation, Amsterdam.

Boisgeloup 18 avril XXXV, page XXXIV, helio-graph made four years after the text, 9 May 1939, Musée Picasso, Paris, © Photo RMN–Madeleine Coursaget, Succession Picasso/DACS 2004.

"24-25-26 noviembre XXXV", first state, 24-26 November 1935, Musée Picasso, Paris. © Succession Picasso/DACS 2004.

"24-25-26 noviembre XXXV", second state, 24-25-26 November 1935, Musée Picasso, Paris, © Photo RMN–Coursaget, Succession Picasso/DACS 2004.

"24 diciembre XXXV", first state, typewritten and manuscript page, 24 December 1935, Musée Picasso, Paris, © Photo RMN, Succession Picasso/DACS 2004.

The Trauma

Guernica: Composition Study I, 1 May 1937, 21 x 26.9 cm, Reina Sofía Museum, Madrid, © Museo Nacional Centro de Arte Reina Sofía Photographic Archive, Madrid, Succession Picasso/DACS 2004.

Dream and Lie of Franco I, (*Sueño y mentira de Franco I*), 8 January 1937, 31.4 x 42.1 cm, Musée Picasso, © Photo RMN–Béatrice Hatala, Succession Picasso/DACS 2004.

Dream and Lie of Franco II, (*Sueño y mentira de Franco II*), 9 January-7 June 1937, 31.4 x 42.1 cm, Musée Picasso, Paris, © Photo RMN–Béatrice Hatala, Succession Picasso/DACS 2004.

The Studio: The Painter and His Model (*L'atelier: le peintre et son modèle*), 18 April 1937, 18 x 28 cm, Musée Picasso, Paris, © Photo RMN–Béatrice Hatala, Succession Picasso/DACS 2004.

Dora Maar, *Guernica in progress*, state II, May 1937, Musée Picasso, Paris, © Photo RMN, Franck Raux, DACS 2004.

Woman with a Candle

Woman with a Candle, Fight between Bull and Horse (*Femme à la bougie, combat entre le taureau et le cheval*), 31.5 x 40.5 cm, Boisgeloup, 24 July 1934, © Photo RMN/© Jean-Gilles Berizzi, Succession Picasso/DACS 2004.

Wounded Minotaur, Horsemen and Figures (*Minotaure blessé, cavalier et personnages*), 8 May 1936, 50 x 65 cm, Musée Picasso, Paris, © Photo RMN, Succession Picasso/DACS 2004.

The Remains of the Minotaur in Harlequin Costume (*La dépouille du Minotaure en costume d'arlequin*), 44.5 x 54.5 cm, 28 May 1936, Musée Picasso, Paris, © Photo RMN, Succession Picasso/DACS 2004.

Woman in Front of a Dresser (*Femme devant un dressoir et poèmes en français*), 10 April 1936, Musée Picasso, Paris, © Photo RMN–Béatrice Hatala, Succession Picasso/DACS 2004.

Young Girl Drawing in an Interior (*Jeune fille dessinant dans un intérieur*), 17 February 1935, 17.1 x 25.3cm, Musée Picasso, Paris, © Photo RMN–Thierry Le Mage, Succession Picasso/DACS 2004.

"15.2.37", "25 janvier-25 février 1937" suite, 15 February 1937, Musée Picasso, Paris, © Photo RMN–Coursaget, Succession Picasso/DACS 2004.

The Studio

The Studio: The Painter and His Model: Arm Holding a Hammer and Sickle (*L'atelier: le peintre et son modèle, bras tenant une faucille et un marteau*), 19 April 1937, 18 x 28 cm, Musée Picasso, Paris, © Photo RMN, Succession Picasso/DACS 2004.

"Dream and Lie of Franco" ("Sueño y mentira de Franco"), 15-18 June 1937, Musée Picasso, Paris. © Photo RMN, Succession Picasso/DACS 2004.

Guernica: Composition Study IV, 1 May 1937, Reina Sofía Museum, Madrid, © Museo Nacional Centro de Arte Reina Sofía Photographic Archive, Madrid, Succession Picasso/DACS 2004.

Guernica: Composition Study VII, 9 May 1937, 24 x 45.3 cm, Reina Sofía Museum, Madrid, © Museo Nacional Centro de Arte Reina Sofía Photographic Archive, Madrid, Succession Picasso/DACS 2004.

Mother with Dead Child IV (*Madre con niño muerto IV*), 28 May 1937, 23.1 x 29.2 cm, Reina Sofía Museum, Madrid, © Museo Nacional Centro de Arte Reina Sofía Photographic Archive, Madrid, Succession Picasso/DACS 2004.

Falling Man (*Hombre Cayendo*), 27 May 1937, 23.2 x 29.3cm, Reina Sofía Museum, Madrid, © Museo Nacional Centro de Arte Reina Sofía Photographic Archive, Madrid, Succession Picasso/DACS 2004.

Numance de Cervantès, 22 April-6 May 1937, documentation of the Jean-Louis Barrault production, Théâtre Antoine, Paris, courtesy Roger Violet, Paris.

Dora Maar, *Picasso painting Guernica*, May 1937, Reina Sofía Museum, Madrid, © Museo Nacional Centro de Arte Reina Sofía Photographic Archive, Madrid, Succession Picasso/DACS 2004.

Guernica, 1 May-4 June 1937, 349.3 x 776.6 cm, Reina Sofía Museum, Madrid, © Archivo Fotográfico Museo Nacional Centro de Arte Reina Sofía, Madrid, Succession Picasso/DACS 2004.

The Fall

"24.7.40", *Royan Notebook (Carnet Royan)*, 24 July 1940, Musée Picasso, Paris, © Photo RMN–Béatrice Hatala, Succession Picasso/DACS 2004.

Halasz Gyula Brassaï, *Pigeon on the steps of Picasso's studio* (*Un pigeon sur une marche de l'escalier, atelier des Grands-Augustins*), 1943 Musée Picasso, Paris, © Photo RMN–Franck Raux, Estate Brassaï–RMN.

"2.8.40", *Royan Notebook (Carnet Royan)*, pages 49 recto, 49 verso, 50 recto, 50 verso, 2 August 1940, Musée Picasso, Paris, © Photo RMN–Coursaget, Succession Picasso/DACS 2004.

"7.11.40", *Parchment Notebook (Carnet parchemin)*, 7 November 1940, Musée Picasso, Paris, © Photo RMN–Coursaget, Succession Picasso/DACS 2004.

The Banquet

Desire Caught By the Tail, Portrait of the Author (*Le désir attrapé par le queue, Portrait de l'auteur*), 14-17 January 1941, private collection, © Photo RMN–Michèle Bellot, Succession Picasso/DACS 2004.

Desire Caught By the Tail (*Le désir attrapé par le queue*), Act I, Scene 1, 14-17 January 1941, private collection, © Photo RMN–René-Gabriel Ojeda, Succession Picasso/DACS 2004.

Desire Caught By the Tail (*Le désir attrapé par le queue*), Act II, 14-17 January 1941, private collection, © Photo RMN–Michèle Bellot, Succession Picasso/DACS 2004.

Desire Caught By the Tail (*Le désir attrapé par le queue*), Act IV, 14-17 January 1941, private collection, © Photo RMN–Michèle Bellot, Succession Picasso/DACS 2004.

Death's Head (*Tête de mort*), 1943, sculpture photographed by Brassaï, Musée Picasso, Paris. © Photo RMN–Daniel Arnaudet, Estate Brassaï–RMN.

Halasz Gyula Brassaï, *Gathering of Actors for* Desire Caught By the Tail (*Groupe de lecture de la pièce de Picasso* Le désir atrrapé par la queue), 1944, Musée Picasso, Paris, © Photo RMN–Béatrice Hatala, Estate Brassaï–RMN.

The Dialectic

The Four Little Girls (*Les quatre petites filles*), title page, 24 November 1947-13 August 1948, Musée Picasso, Paris, © Photo RMN–Béatrice Hatala, Succession Picasso/DACS 2004.

The Four Little Girls (*Les quatre petites filles*), page 1, 24 November 1947-13 August 1948, Musée Picasso, Paris, © Photo RMN–Béatrice Hatala, Succession Picasso/DACS 2004.

The Four Little Girls (*Les quatre petites filles*), page LXXXIII, 24 November 1947-13 August 1948, Musée Picasso, Paris, © Photo RMN, Succession Picasso/DACS 2004.

Seated Tanagra, 1947, photo courtesy of Fondation Almine and Bernard Ruiz Picasso, © Succession Picasso/DACS 2004.

Study for War and Peace (*Etude pour La Guerre et la Paix*), 4 May 1952, 26 x 20 cm, Musée Picasso, Paris, © Photo RMN–Béatrice Hatala, Succession Picasso/DACS 2004.

P Manciet, *Picasso at the pottery wheel* (*Picasso travaillant la céramique*), 1947, Musée Picasso, Paris, © Photo RMN/Droits réservés.

Hand on Striped Tablecloth, 1947-1948, Photo courtesy of Images Modernes, Paris, © Succession Picasso/DACS 2004.

The Kitchen (*La cuisine*), 1948, © Photo RMN/Franck Raux, Succession Picasso/DACS 2004.

The Phantom

Cover of 1969 facsimile of *The Burial of the Count of Orgaz* (*El Entierro del Conde Orgaz*), Museu Picasso, Barcelona, © Photo Arxiu Fotografio de Museus, Ajuntament do Barcelona, Succession Picasso/DACS 2004.

"Circus figures: the parade," II ("Personnages de cirque: la parade", II), 17 April 1967, © Photo Arxiu Fotografio de Museus, Ajuntament do Barcelona, Succession Picasso/DACS 2004.

"In the theatre: the Cocu brandishing Zeus's 'thunderbolt'" ("Au théâtre: le Cocu brandissant la 'Foudre de Zeus'"), 3 December 1966, © Photo Arxiu Fotografio de Museus, Ajuntament do Barcelona, Succession Picasso/DACS 2004.

El Greco, *The Burial of the Count of Orgaz*, 1586-1588, 487.5 x 360 cm, Santo Tomé, Spain/www.bridgman.co.uk, © Bridgeman Art Library.

"6.1.57 Cannes A.M.", *The Burial of the Count of Orgaz* (*El Entierro del Conde de Orgaz*), 6 January 1957, Musée Picasso, Paris, © Photo RMN, Succession Picasso/DACS 2004.

"14.8.57", *The Burial of the Count of Orgaz* (*El Entierro del Conde de Orgaz*), 14 August 1957, Musée Picasso, Paris, © Photo RMN, Succession Picasso/DACS 2004.

The Piano (*Le Piano*), 17 October 1957, 130 x 97 cm, © Photo Arxiu Fotografio de Museus, Ajuntament do Barcelona, Succession Picasso/DACS 2004.

The Studio: The Pigeons (*L'atelier: Les pigeons*), 11 September 1957, 130 x 97 cm, © Photo Arxiu Fotografio de Museus, Ajuntament do Barcelona, Succession Picasso/DACS 2004.

Diego Velázquez, *Las Meninas*, 1656, 138 x 276 cm, © Museo National del Prado, Spain.

Las Meninas, 17 August 1957, 194 x 260 cm, © Photo Arxiu Fotografio de Museus, Ajuntament do Barcelona, Succession Picasso/DACS 2004.

Las Meninas, 15 September 1957, 129 x 161 cm, © Photo Arxiu Fotografio de Museus, Ajuntament do Barcelona, Succession Picasso/DACS 2004.

Las Meninas, 18 September 1957, 129 x 161 cm, © Photo Arxiu Fotografio de Museus, Ajuntament do Barcelona, Succession Picasso/DACS 2004.

Las Meninas, 19 September 1957, 162 x 130 cm, © Photo Arxiu Fotografio de Museus, Ajuntament do Barcelona, Succession Picasso/DACS 2004.

"2.12.57", "16.1.58", *The Burial of the Count of Orgaz* (*El Entierro del Conde de Orgaz*), 2 December 1957, 16 January 1958, Musée Picasso, Paris. © Photo RMN, Succession Picasso/DACS 2004.

Self-portrait in the studio of the villa Les Voiliers, (*Auto portrait dans l'atelier de la villa "Les Voiliers"*), Royan, c1939-1940, Musée Picasso, Paris,© Photo RMN/ Madeleine Coursaget, Succession Picasso/DACS 2004.

Cristina García Rodero, *St John's Day: Bonfires, Alicante*, 23 June 1989, © Cristina García Rodero/ Agence VU, Paris.

Appendix

Desire Caught by the Tail (*Le désir attrapé par le queue*), poster from 1967 version and photographs from the production, courtesy of Jean-Jaques Lebel, © Jean-Jaques Lebel.

© 2004 Black Dog Publishing Limited, the artists and author
All rights reserved

Text by Kathleen Brunner
Edited by Catherine Grant
Picture research by Teresa Castro, Oriana Fox and Vicky Fox
Designed by Studio AS

Black Dog Publishing Limited
Unit 4.4 Tea Building
56 Shoreditch High Street
London E1 6JJ

Tel: +44 (0)20 7613 1922
Fax: +44 (0)20 7613 1944
Email: info@bdp.demon.co.uk

www.bdpworld.com

■■■ Black Dog Publishing
Architecture Art Design Fashion History
Photography Theory and Things